THE AUDUBON SOCIETY BOOK OF WILD BIRDS

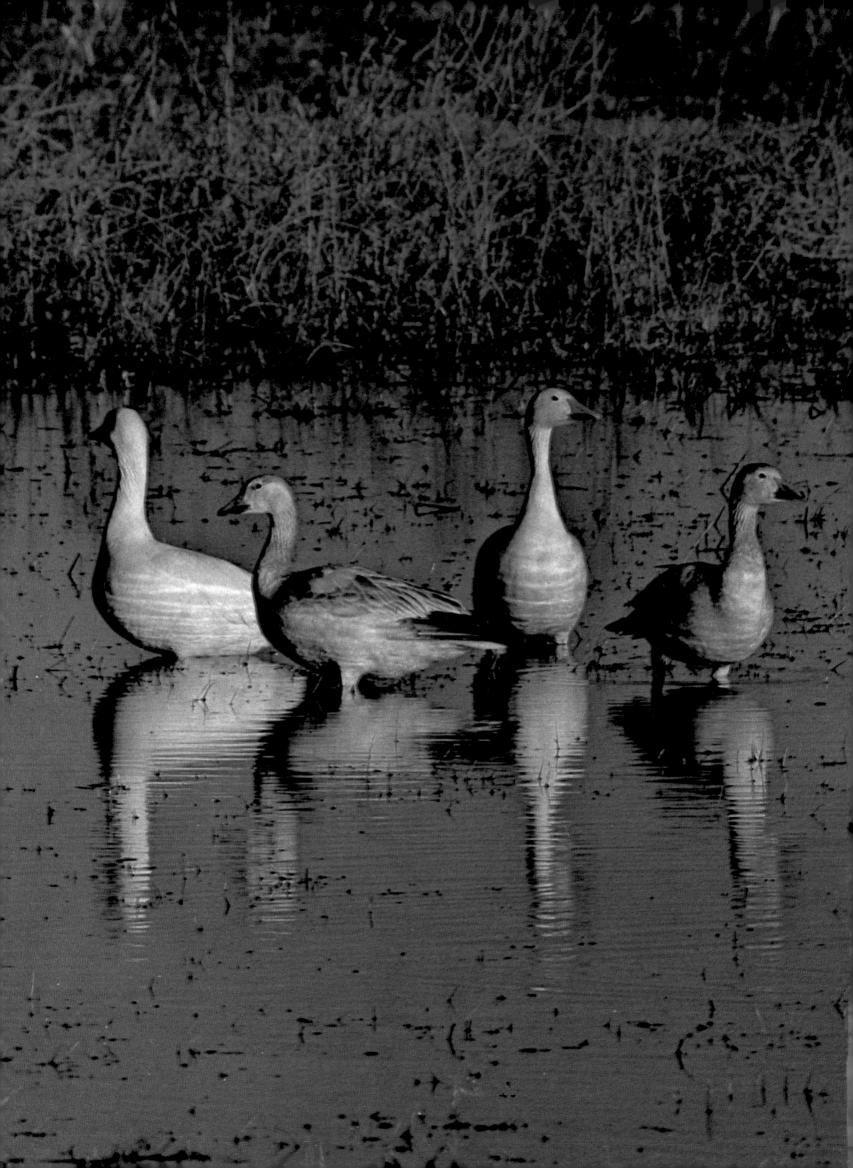

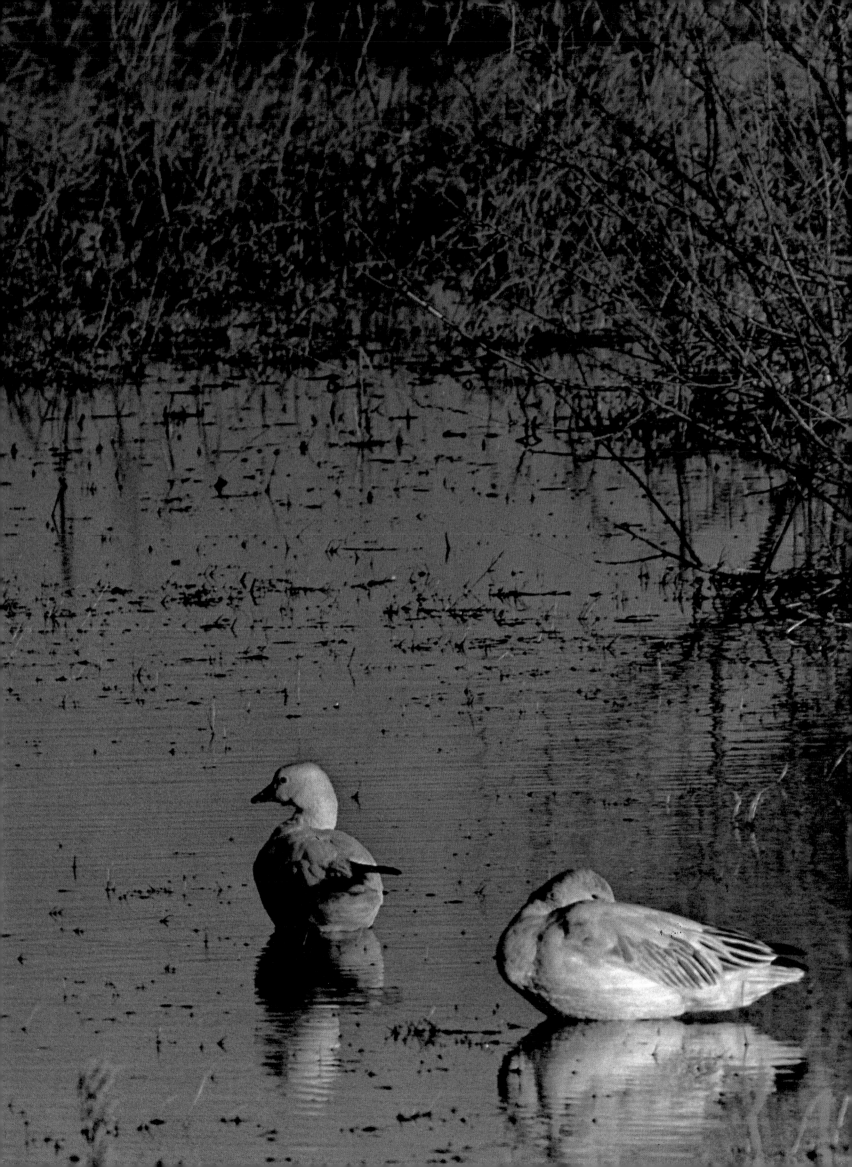

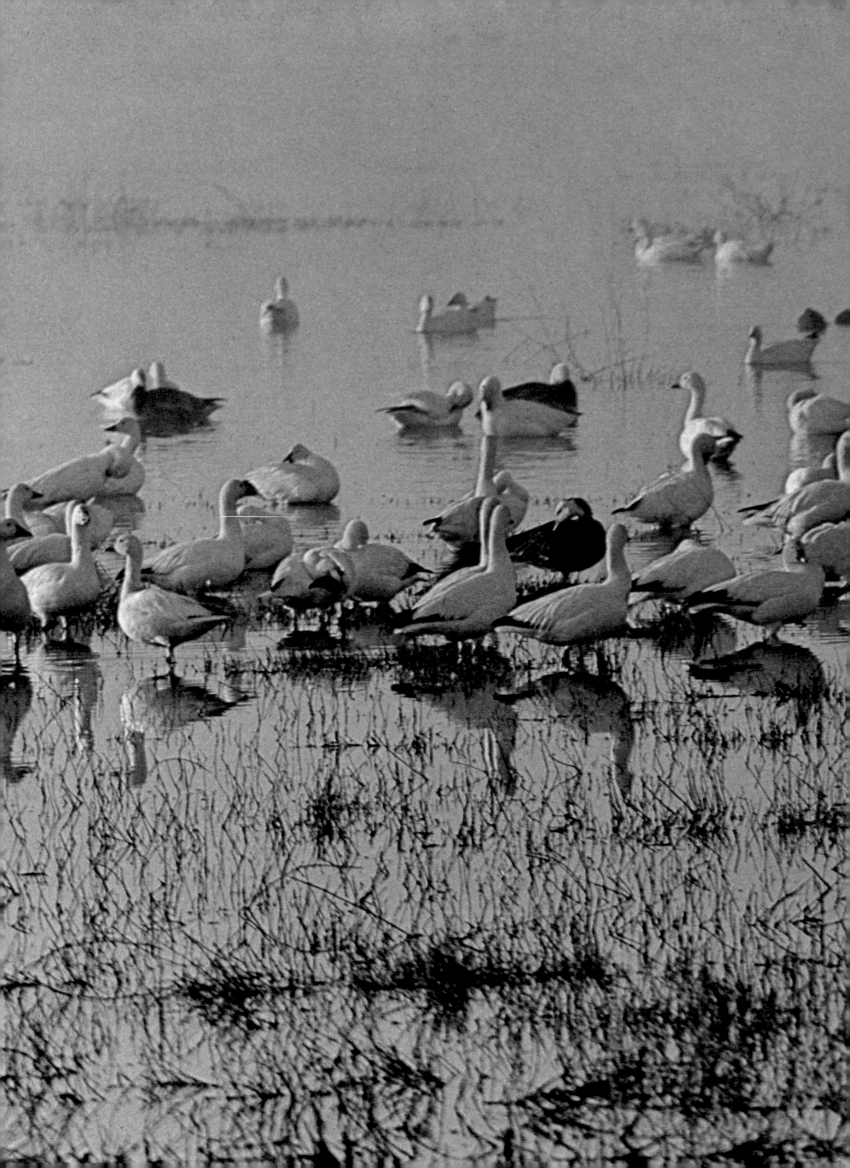

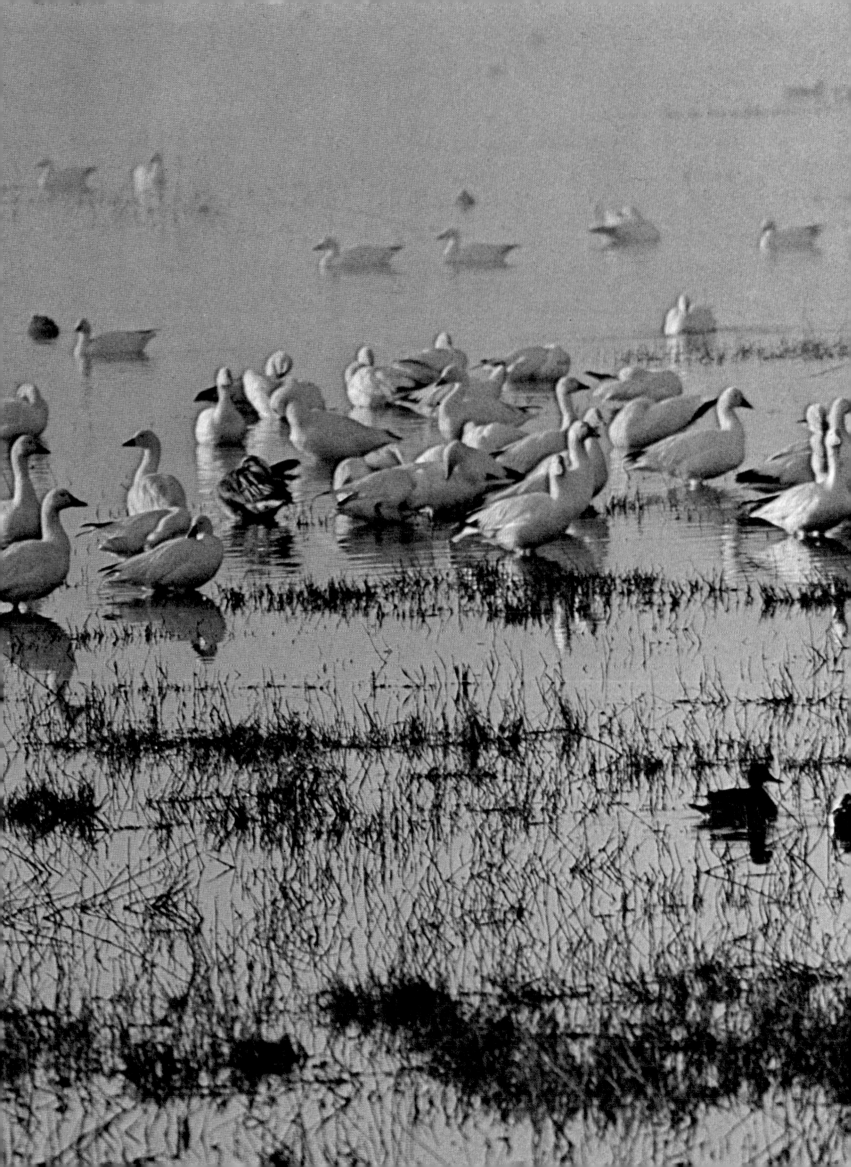

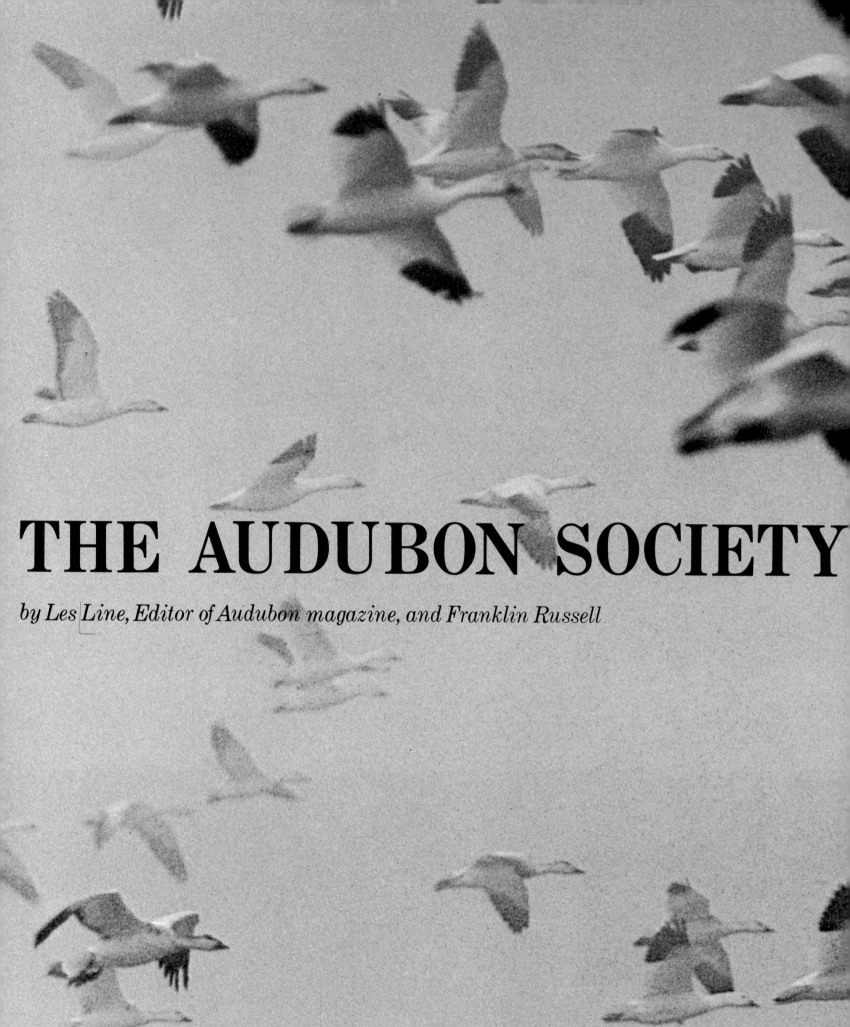

THE AUDUBON SOCIETY

by Les Line, Editor of Audubon magazine, and Franklin Russell

A Chanticleer Press Edition

BOOK OF WILD BIRDS

HARRY N. ABRAMS, INC., PUBLISHERS, NEW YORK

Library of Congress Catalog Card Number: 76-17306
Line, Les.
The Audubon Society Book of Wild Birds
1. Birds Pictorial Works I. Russell, Franklin
1922 joint author. II. National Audubon Society
III. Title
QL674.L54 598.2 76-17306
ISBN 0-8109-0661-9
Second Printing

Prepared and produced by Chanticleer Press, Inc.
Color reproductions by Nievergelt Repro AG, Zurich, Switzerland
Printed and bound by Amilcare Pizzi, S.p.A., Milan, Italy

Chanticleer Staff:
Publisher: Paul Steiner
Editor-in-Chief: Milton Rugoff
Managing Editor: Gudrun Buettner
Picture Editor: Ann Guilfoyle
Editorial Assistant: Mary Suffudy
Production: Helga Lose
Design: Massimo Vignelli

*Note on Illustration Numbers: All illustrations are numbered
according to the pages on which they appear.*

First frontispiece: *Snow geese (Anser caerulescens)
rest on a New Mexico pond.* (Gary R. Zahm)
Second frontispiece and title page: *Flocks of snow geese on
a foggy morning* (both Gary R. Zahm)
Overleaf: *A winter wren (Troglodytes troglodytes) at its
nest in a haystack* (S.C. Porter/Bruce Coleman, Inc.)

Contents

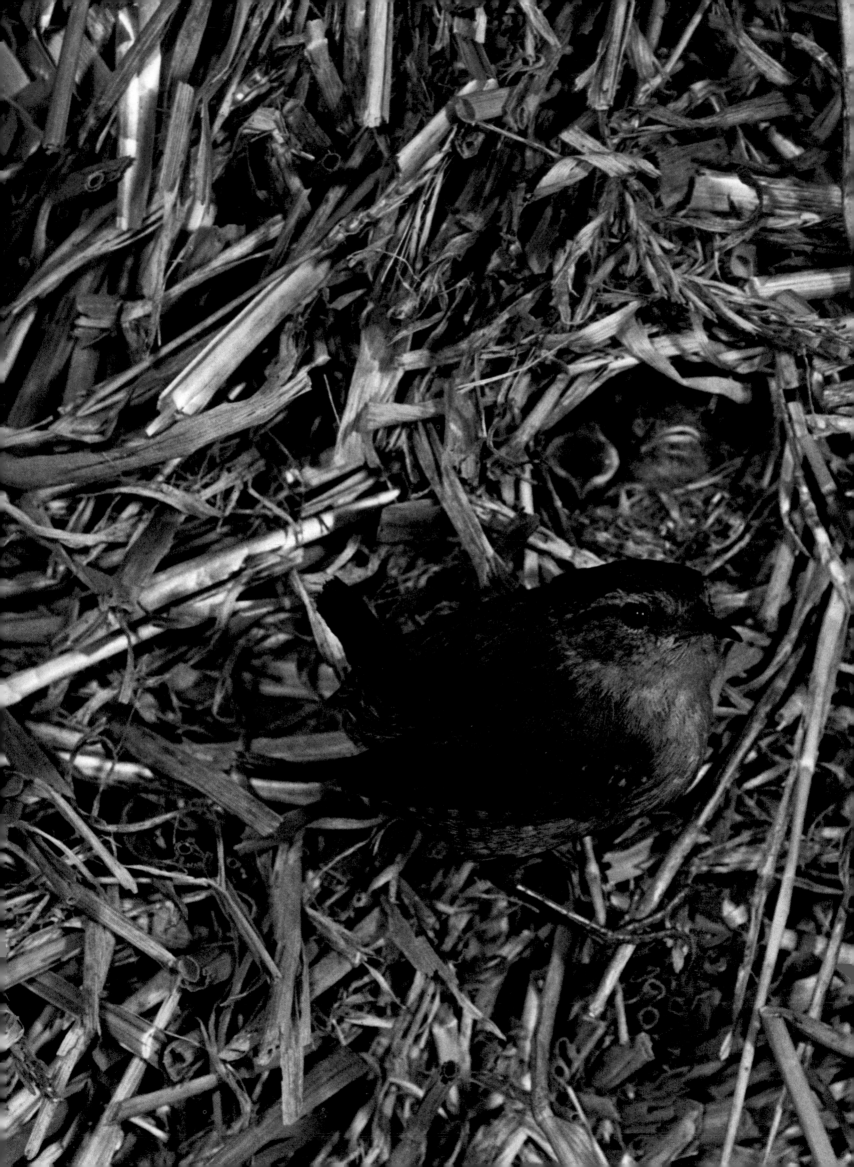

For John and Hazel Line, my parents, who helped beyond the call of duty

Preface: To Behold a Bird

"Everyone is born with a bird in his heart," Frank M. Chapman said a good many years ago. Chapman is the man who, in 1899, launched a modest journal of popular ornithology called *Bird-Lore*. Over more than three-quarters of a century (including thirty-six years under his editorship), it has evolved into the magazine known today as *Audubon*. What he meant was that all of us have the potential of becoming dedicated birdwatchers. Indeed, no one, not even the city-dweller, can go through life without being exposed regularly to the wonders of birds, be they only smog-begrimed pigeons and starlings.

To free that bird in the heart, what is needed is an unforgettable experience. Roger Tory Peterson, the most famous birdwatcher of all, calls this "the spark." Often, he notes, "it is a particular bird that sets off the chain reaction that makes an ornithologist." Nearly always, he adds, one's latent interest in birds is awakened by the age of ten or eleven. Peterson offered several examples in his personal collection of memorable writings about birds, *The Bird Watcher's Anthology*, now regrettably out of print.

For the great American naturalist John Burroughs, the spark was provided by a black-throated blue warbler, one of those bright-feathered avian sprites that flit through the greening woodlands of North America each spring. "Years ago, when quite a youth," Burroughs wrote, "I was rambling in the woods one Sunday with my brothers gathering black birch, wintergreens, etc., when, as we reclined upon the ground, gazing vaguely up into the trees, I caught sight of a bird that paused a moment on a branch above me, the like of which I had never before seen or heard of. I saw it a moment as the flickering leaves parted, noted the white spot on its wing, and it was gone. How the thought of it clung to me afterward! It was a revelation. It was the first intimation I had had that the woods we knew so well held birds that we knew not at all. Were our eyes and ears so dull then?"

In the case of Sir Julian Huxley, the spark was struck by a familiar tree-chiseler of the European forests. "One morning of late winter, crossing the laundry-yard of my aunt's country house, I saw a green woodpecker on the grass only a few yards from me," the noted British biologist recalled. "I had just time to take in the sight of it before the bird was off to the wood beyond the hedge. The green woodpecker is a common enough bird; but I had never seen one close. Here I saw every striking detail: the rich green of the wings, the flash of bright yellow on the back when he flew, the pale glittering eye, the scarlet nape, the strange moustache of black and red; and the effect was as if I had seen a bird of paradise, even a phoenix. I was thrilled with the sudden realization that here, under my

nose, in the familiar woods and fields, lived strange and beautiful creatures of whose strangeness and beauty I had been lamentably unaware."

One of the most distinguished bird men of the late nineteenth century was Eliot Coues, an authority on the avifauna of the American West and among the compilers of the first edition, in 1886, of the American Ornithologists' Union *Check-List of North American Birds*. His fire was tindered as a small child while "strolling through an orchard one bright morning in June, filled with mute wonder at beauties felt, but neither questioned nor understood. A shout from an older companion—'There goes a scarlet tanager!'—and the child was straining eager, wistful eyes after something that had flashed upon his senses for a moment as if from another world, it seemed so bright, so beautiful, so strange. 'What is a scarlet tanger?' mused the child, whose consciousness had flown with the wonderful apparition on wings of ecstasy; but the bees hummed on, the scent of flowers floated by, the sunbeam passed across the greensward, and there was no reply—nothing but the echo of a mute appeal to Nature, stirring the very depths with an inward thrill. That night the vision came again in dreamland, where the strangest things are truest and known the best; the child was startled by a ball of fire, and fanned to rest again by a sable wing. The wax was soft then, and the impression grew indelible. Nor would I blur it if I could."

I am certain that most of us who have discovered the bird in our own heart—and we number in the millions—could, upon reflection, tell a similar story, though probably with less literary élan than John Burroughs, Sir Julian or Eliot Coues. For me, the bird that ignited the flame was neither as delicately lovely as a black-throated blue warbler, nor as strikingly distinctive as a green woodpecker, nor as brilliant a specter against the summer foliage as a scarlet tanager. It was, instead, a rare wild goose that was really a duck, and only a commonplace barnyard fowl at that. The incident, moreover, was decidedly embarrassing to one of the best field birders in Michigan. Worse, there was a large audience.

Perhaps all this occurred because the spark came much later in my life than Roger Peterson would normally expect. True, I was quite cognizant of the birdlife around my boyhood home in a small Michigan farming community. House wrens nested every summer in our backyard, filling a hollow-log birdhouse that hung from my mother's clothesline with sticks, filling the breeze with bubbling song—and with angry chatter every Monday when there was wash to be hung. A careful search in the hedge nearby would usually uncover the nest of a chipping sparrow, the grass cup lined with animal hairs that came from unguessed-at sources (probably, upon reflection, from the cattle pens several blocks away, down by the railroad tracks) and cradling four tiny and fragile eggs. Empty halves of blue-green shells on the grass beneath the sugar maples that flanked our street meant that baby robins had hatched somewhere above, and invariably a nestling would flee its natal home a day or two too early, before it could fly, and have to be rescued from a stalking cat, though I was never sure that the parent robins appreciated any human intervention on behalf of their offspring. On warm still mornings in May and June I would awaken, in my upstairs room, to the doleful cooing of mourning doves, a bird down the street answering a bird across the vacant lot answering a bird up the street, an endlessly echoed four-note lament. And those afternoons after school I might lie on my back in the shade of a towering elm (the inevitable victim a few years later of beetle-borne disease) and watch the comings and goings of a pair of Baltimore orioles whose pendulous nest, it seemed, was always woven to the most fragile twig, yet always survived the gusting and sometimes violent winds of spring thunderstorms.

Like all boys growing up in rural America, I also had my treasured Daisy air rifle to carry on adventures into the "wilderness" beyond the village limits, into secret places that, also quite inevitably, have since been overrun by subdivisions lived in by my grown-up schoolmates and by

strangers who never explored those long-ago woodlots and ravines and creeks and thus cannot, on an all-too-infrequent visit home to see family and old friends, feel a twinge of remorse at their loss. So with copper BBs, at a nickel a tube, I took a small toll of the scrubby house sparrows that bred nonstop in a neighbor's chicken barn—a small toll because my trusty imitation of Red Ryder's lever-action Winchester could hardly measure up to the original when it came to accuracy, and because my sparrow-hunting had to be done surreptitiously since "Bunch," the village policeman, frowned on activities that tended to leave house windows pocked by straying pellets.

I mention this because, in a thoughtless instant while crossing a pasture on one of my youthful safaris, I aimed my air rifle at a killdeer which had been surprised from its nest and was giving its noisy, flashy broken-wing act to lure me away from its precious clutch of eggs. And, almost impossibly at such a distance and with such a toy, I killed it. Holding the killdeer's warm body in my hand, seeing through tears the beauty of its feathering, that golden-red rump, the broad black bands on a pure white breast, the crimson ring around its eye, I vowed that I would never again shoot at any protected bird. It was a vow I never broke.

That incident, given my more than casual awareness of the birdlife about my home and my love of the out-of-doors, should have produced the spark. And I am convinced, looking back over a span of thirty years, that it did indeed leave an ember smoldering. But for another twelve years my only real interest in birds was in the pheasants and grouse and ducks that, in season, I stalked with weapons far more deadly than a BB gun, and wrote about as a hunting and fishing columnist for a succession of newspapers.

I will make no apologies here for the fact that I was a hunter. In truth, many of the invaluable lessons about natural history that I gleaned while afield with gun, bow, or fishing rod could never have been duplicated in the classroom, nor acquired from books, nor learned from the casual contact with nature that the occasional birdwatcher gets while checking off species on his or her life list. Crouching concealed in a blind built of scrub oak branches, waiting for hours for a wary deer to come within range of your arrows, one has a lot of time to observe and ponder the mysterious ways of nature. Moreover, by that cold drizzly night in November 1959 when the rare goose that wasn't dropped into my life—and changed it—I was spending a number of hours, on and off the job, writing about hunting and fishing and conservation matters. And now and then I would dream about one day pursuing a full-time career as an outdoor journalist.

My job at the time was as chief photographer for a Michigan newspaper of modest circulation but excellent professional reputation, the *Midland Daily News*. My main responsibility was toting a Speed Graphic to fires, car wrecks, football games, ground-breakings, grand openings, award banquets, check passings and all other events of real or imagined public interest in and around our city of 25,000 people. But any small-town newspaperman wears more than one editorial hat. (At the suburban Detroit weekly for which I previously worked, I had no less than ten "beats," ranging from high school sports to real estate news.) Since the Midland publisher was a noted sportsman and conservationist, each Thursday we carried a full page of outdoor news—a feature usually found only in much larger metropolitan papers. Because of my obvious interest in the subject, our city-raised sports editor gladly passed to me the extra title of outdoor editor. Which meant, at that time, filling the space (less advertisements) with canned news releases from the state conservation department and makers of sporting arms and fishing tackle, reporting on the activities of the local game warden, and running pictures of the biggest fish or biggest buck deer taken by local anglers or hunters.

Of the local birdwatchers or nature-lovers, I had little knowledge and no

particular interest. The wife of a hunting companion always carried
a small green-bound book called *A Field Guide to the Birds*, by someone
named Peterson, and was always peering into the trees with her
binoculars and flipping through pages filled with little drawings of little
birds that all looked alike. It seemed a silly way to spend one's time.
The only bird "guide" I needed was a booklet published by the U.S. Fish
and Wildlife Service, called "Ducks at a Distance," which tried to
show waterfowl shooters how to tell a corn-fed mallard from a fish-eating
merganser, because mallards taste a heckuvalot better; or how to
tell a protected canvasback from a legal scaup, because shooting "cans" was
not only bad for conservation but expensive if you were caught. I
stuffed that booklet in my jacket pocket that clammy night when I got
a call from the police dispatcher that some kind of wild goose had landed
on a city street, and did I want to take a picture?
It does happen, of course. Migrating waterfowl sometimes become
confused or simply exhausted when flying in bad weather, mistake a slick
and shiny highway for a river, and get in trouble when they plop down on
the hard blacktop. Some species, like mergansers, simply can't
take flight again from land. The police cruiser had left when I arrived on
the scene, but there was the bird—pure white except for black wing tips
and, as I could see with my flashlight as I carefully approached it,
pink legs and a knobby, pinkish bill. It looked like a snow goose—a common
enough species in our area in the fall—except that it was much too small,
only about the size of a mallard. So the only thing it could be,
according to that federal booklet, was Ross' goose, about which I knew
little except that it wintered somewhere in California and thus was
a long way from anyplace it belonged. I figured the Audubon Society
ought to know about it. And I remembered a name, Eugene Kenaga.
I had never met Gene Kenaga, who is an entomologist—an expert on insects
and pesticides—for Dow Chemical Company, and who at the time was
an officer of the Michigan Audubon Society and editor of the Michigan Bird
Survey, which means that his ornithological credentials were
exemplary. I took a couple of flash pictures of the goose, rushed to a pay
telephone, learned from Kenaga's wife that he was playing handball
at the community recreation center just a few blocks away from where my
rare bird had landed, had him summoned from the shower, and
although he was utterly incredulous at my identification of a Ross' goose,
I convinced him to take a look. A few minutes later we were chasing
the frightened bird up the street, across backyards, down the next street,
finally cornering it at a picket fence and bundling it back to
Kenaga's car.
The expert was puzzled. The bird was indeed too small to be a snow goose,
it did *look* like the picture of a Ross' goose, except that Ross'
goose is the rarest of all North American geese, nesting high in the
Canadian Arctic, migrating each autumn to the Central Valley of California.
But then migrating birds do get blown astray by storms, and some
pretty strange sightings have occurred. Thus the front page
headline the next day read: "Rare Goose Visits Midland." The story, with
my byline, quoted Kenaga as agreeing with the identification and
said that a copy of the accompanying photograph had been rushed to a
waterfowl authority at Michigan State University for
confirmation.
The duck man at the university was Miles D. Pirnie, and when I called him
the next morning he said yes, he had just received my picture by
special delivery. Did he agree, I asked, that we had a Ross' goose
in Midland?
No, he said with a chuckle, what we had was a Muscovy duck. I said I had
never heard of that kind of duck, and where did it come from.
A Muscovy duck, he patiently replied, is an ordinary barnyard duck that
was domesticated long ago from a wild species found throughout
Latin America. They are strong fliers, he added, and if their wings aren't
kept clipped they sometimes get wanderlust. Our bird probably had

joined a passing flight of wild waterfowl, gotten tired after several miles of unusual exercise, and dropped out—in the middle of town. Yes, he admitted, it did look a *little* like a Ross' goose, but it surely wasn't one. In fact, that would be just about impossible.

The follow-up story, in a small measure of mercy for the slightly tarnished reputations of Midland's leading bird authority and the *Daily News'* own outdoor "expert," ran on an inside page. As for the barnyard duck nee rare goose, now being held captive in Kenaga's garage, I decided that as recompense for our troubles we should dine on roast duck. But on the day of the planned execution and feast, at the instant its cage was opened, the bird burst loose, flapped through the open garage door—and flew out over yellowing fields into the cloudless sky, either to bedevil some other birdwatcher or sportsman or to return to the safety of the farm.

Our dinner was gone, my face was still flushed with embarrassment at having led Kenaga astray by insisting we had found a Ross' goose. But the latent ember had been fanned into flames. I knew, perhaps in part for self-protection, that I had to learn some of the fine points about bird identification and distribution. I decided unilaterally that Kenaga would be my teacher, although he was quite understandably reluctant after the misadventure of the ungoose. I bought my first copy of Peterson's guide and a decent pair of binoculars, coaxed and badgered Kenaga into letting me come along on his field trips, became reasonably adept at identifying those little birds that all looked alike, obtained a bird-banding license, made a few legitimate (but minor) ornithological discoveries on my own, got deeply involved in Michigan Audubon Society affairs, took over as editor of the state Audubon newsletter, and a few years later landed the best job in the world. The editorship of *Audubon*.

So what if the bird in my heart, when finally set free, turned out to be some farmer's wayward fowl and not a black-throated blue warbler or a scarlet tanager? It is a cliché, I know, and it certainly is not always true, but there *are* times when the end justifies the means, and I am in favor of almost any means that sparks a person's interest in birdlife. I also know that a lot of people, like I once did, still consider birds a silly avocation, or at best a form of escapism. If the latter is true, Roger Tory Peterson once said, it is not an escape from reality but a flight from unreal things—"from a gadget civilization which man has built to insulate himself against the world. In an artificial world is it any wonder birds have such appeal? Birds are, perhaps, the most eloquent expression of reality."

Brooks Atkinson, a famous New York City drama critic who, though the world of the Broadway stage was always his first love, has often written with unusual perception about the world of nature, expanded on that very theme in his essay "The Bird Habit." There are many natural history subjects, he noted, whose study can help one "find his place in the universe. Life has become so mechanized, life is so lacking in flavor, that anything learned about anything rescues people from the boredom of civil obedience. In a technological age the man who knows where the bergamot grows in some brushy back field or knows when and where to look for the Pleiades is a revolutionary. He has published his declaration of independence."

As for man's special fascination with birds, this in Atkinson's view happens because "the essential part of their being eludes us. Although they coexist with us on this eroded planet, they live independently of us with a self-sufficiency that is almost a rebuke." Moreover, "the success of birds in the proliferation of life challenges our view of ourselves. Their life began before human beings started to walk upright."

And although we are deep into the technologically profound twentieth century, he continued, "we do not know much about the inner drives of birds. We are still baffled by the purposes, the origins, and methods of bird migration."

The book you are holding does not attempt to reply to any of those many questions whose answers still evade ornithologists. It is purely a visual celebration of the *essence* of birds, a gathering together under one cover of the finest color photographs of birdlife to be found anywhere and everywhere in the world. It is my way of helping to strike "the spark" in others who have not yet discovered the bird in their heart. It is also my way of adding fuel, though perhaps that is unnecessary, to the fires that burn brightly in so many of us who have discovered the wonder, if not the being, of birds.

Because this is, first and foremost, a collection of images on film, I have departed at times from the traditional ways of organizing books about birds. That is, I have not strictly followed taxonomic groupings of birds by orders, families, and genera, but rather have assembled the fifteen chapters by habits and habitats as well as scientific classifications. Thus you will find the common nighthawk alongside the barn owl, for both are nocturnal hunters; and the chapter on cavity-nesting birds includes portraits of woodpeckers and a wood warbler.

I realize that discovering pictures of kingfishers in a chapter devoted largely to such oceanic fishing birds as pelicans and gannets may confound scientists who prefer their world organized according to Linnaeus and his successors, but I ask their indulgence. No affront is intended, for without the continuing efforts of professional ornithologists both in the field and in the laboratories, our knowledge about—and thus appreciation of—the wonders of birdlife would be poor indeed.

Nor is this book by any means all-encompassing. While no volume of such overwhelming beauty has previously been produced—included herein are 200 magnificent photographs of 174 species from every continent, and all but a very few pictures are of wild birds in their natural habitat—this is merely a sampling, and a personal one at that, of the incredible variety of birdlife on earth. There are, after all, nearly 8600 species of birds, new species are still being discovered, and hundreds of species in the remote reaches of Africa, Asia, and Central and South America have never been adequately photographed—if at all.

Finally, this book required a team effort. Ann Guilfoyle, *Audubon* senior editor and the person who knows better than anyone else in the publishing world where the best nature pictures are to be found, gathered thousands of transparencies from hundreds of photographers, took the cream off the top, and then she and I spent many long evenings debating the final choices. The decisions in many cases were agonizing. Franklin Russell, one of the most expressive of nature writers, shared the authorship; while I wrote the captions for 200 photographs, he penned the essays that eloquently begin the fifteen chapters. The expert help of John Farrand Jr., of the Department of Ornithology at the American Museum of Natural History, was enlisted to check factual accuracy and to confirm the identification of photographs. The staff of Chanticleer Press was endlessly helpful, but in particular this book could not have come into existence where it not for the unwavering belief of Paul Steiner, from its very conception, that we could produce the most spectacular book about birds ever published. Thus his willingness to agree to my costly demands that various chapters *had* to be expanded so that we could include more once-in-a-lifetime pictures, and his insistence on the finest printing obtainable.

Les Line

The Audubon Society Book of Wild Birds

Wildfowl in the Millions

At midnight the haunting cries of Canada geese on migration drop down to the dusky earth. Their voices speak of great distances traveled, of remote territories to be reached, the will of the winged creature to find its place on earth. They pass on, the cries fade, and the human listener is left with a transcendent emotion of wildness and of freedom. The cries speak in a language that cannot be quite translated.

The Canada geese are masters of the rich waterfowl country of the American continent, that great network of lakes, rivers, sloughs, ponds, swamps, marshes, potholes, deltas and tundra lands that sprawl all across the Northern Hemisphere. This hemisphere hosts most of the ducks and geese and swans of the world, but waterfowl flourish on every continent except Antarctica. Though it is suspected that waterfowl probably originated in the tropics, or even in the Southern Hemisphere, the North is the stage for their most spectacular congregations—the Mississippi delta in spring, prairie sloughs in the fall.

Waterfowl have spread far and wide on powerful wings and swift motion. The canvasback duck, esteemed by duck hunters everywhere, can sustain speeds close to eighty miles an hour. A flock of trumpeter swans passing low overhead makes its own thunder in the air. Hundreds of thousands of waterfowl rising together from their Mississippi resting grounds fill the sky with a mass of striving forms.

What is a waterfowl, as gathered here in these pictures? It is a loose community of many qualities. Waterfowl express opposites in every extreme. The northern pintail

duck has colonized practically the entire Northern Hemisphere. The Madagascar white-eye lives in only a few remote lakes on the island. The nene goose of Hawaii has become so specialized that it lives only in the mountains. The South American upland goose rarely ventures below 11,000 feet. The kelp goose is limited to the southern tip of Chile. The blue-winged goose can live only in the northern Ethiopian highlands above 8000 feet. The Auckland Island merganser, now probably extinct, was limited to a group of tiny islands 400 miles south of New Zealand with no related species anywhere near it.

The hordes of North American ducks, geese and swans are all roughly homogeneous, at least in appearance, but this is not necessarily an indicator of the rest of the world's waterfowl. The graceful Orinoco goose grazes on meadowlands in South America but, with its shortish neck, it looks like a duck. The Magellan goose, with its subtly striped plumage, short neck and tiny beak, looks like a grouse or partridge. The radjah shelduck, black-backed and white-headed, looks more like a gull than a duck, and the comb duck, with a semi-circular protuberance rising from its upper beak, its purplish-bluish plumage and spotted white head, appears more like some exotic bird of paradise than any waterfowl. The primitive loons of North America and screamers of South America each occupy specially restricted environments.

During the long evolutionary development of waterfowl, these water-loving birds have fitted themselves precisely into countless widely separated environments. Although America's waterfowl hordes conform to the world they occupy—as witnessed, perhaps, by the trumpeter swan with a body weight of forty pounds and a wingspan of eight feet, they are far distant in time and place from the African pygmy goose, which is not much bigger than a robin.

In behavior, at least, the waterfowl come closer together as a group. There is an ebullience, a gaiety perhaps, that infectiously passes to the human watcher, whether the watching is done in Madagascar or along the Mississippi. This is best seen among all the waterfowl during the courtship period. Ducks and geese twist their heads, double their necks, grunt, whistle, scoop up water, throw it over their backs, splash water at their females, rear up, shake their heads, raise their tails, preen their wings to display beautiful speculum

colors, cough, flap their wings, raise crests, make ceremonial flights. The deep-throated trombone cries of swans sound as background music to much of the courtship. The loons go through hardly any courtship at all, since their rituals, and perhaps their pairing, were completed the previous fall, often in spectacular displays between fighting males, including swimming underwater with only a wingtip showing like a shark's fin.

The ruddy ducks of North America blow up their necks and rise on their tails almost vertically, as do the loons when fighting, then with great speed beat their bills against their tightly inflated necks. This makes a drumming sound as the air is forced from their breast feathers and the blows reverberate against the hollow neck. Bubbles form at the front of their bodies and this, combined with their blue bills, their white cheeks and their general clownlike appearance, makes their display a study in unconscious humor.

Many waterfowl use common enough methods of getting their food, such as dabbling in shallow mud or among duckweeds, or upending to use long necks to reach vegetable food on the bottom. But many waterfowl are not vegetarian. They relish red meat. Mergansers have toothed beaks that can deftly seize and hold fleeing fish in fast-running streams. The sea ducks may go down more than 200 feet, often under pack ice, and use both their wings and their feet to literally "fly" through the dark waters in search of deep-placed shellfish beds. They swallow the shellfish whole and spit out the shells when the flesh inside them has been digested.

All waterfowl swim superbly, but none as well as the loon. It is not related to any of the ducks or geese, and probably sprang millions of years ago from the great gull family. It has gone far beyond any duck in its capacity to dive, to perform acrobatics, to be complete master of submarine life. Only the penguins of the Southern Hemisphere can equal or surpass the loon in this skill.

Yet specialist skills are not necessarily the possession of the highly evolved. The screamers are pure waterfowl creatures, mostly as large as geese, but their physical characteristics are, in part, so primitive that they have been classified as close to the extinct *Archaeopteryx*. They have webless feet, like wading birds, and formidable spurs on their wings that can put dogs to

flight. They can swim excellently and can climb on the leaves of floating plants like marsh birds. They perch in trees, and seek refuge in trees rather than the wide open spaces.

Today it is thought that the ducks, the geese and the screamers have some common ancestor, a view made sensible by the link of the Australian magpie goose, which resembles the screamers in its molting and also in having no webs on its feet, and for its habit of perching in trees. The screamers suggest this relationship when they cry out in gooselike voices, but then contradict it when they utter their characteristic cry, a sound so deep in their throats that it resembles heavy drumming in the distance.

The great capacity of waterfowl to travel, to move at will and in masses, catches and holds the human imagination. Australian waterfowl migrate far to find breeding places in temporary floodwaters. African waterfowl migrate east, west, north and south. The northern shoveler leaves northern Europe, migrates to central Africa. The blue-winged teal breeds in the United States and Canada and has reached as far south as Argentina.

The loons, despite their preeminent swimming powers and their reluctance to fly from their northern lake breeding homes, also travel widely. The loons of Siberia leave the Black Sea in April and head for northern Siberia. The North American loons fly thousands of miles in their north-south migrations. And so, it might be midnight in the Midwest of the United States, and the blizzard is just about finished, when an acute ear hears the sound of voices coming down from the murk above. The waterfowl are on the move. They will find their place on their earth just as surely as the blizzard will end and the new day will come. Or so we must hope, from our helpless watching and listening position on the ground.

25. An emperor goose (Anser canagicus) drinks from a rushing stream on the tundra of coastal Alaska. Although not an uncommon species on its breeding grounds in Alaska and Russian Siberia, the emperor goose is rarely seen by naturalists, for it spends its entire life in virtually uninhabited lands on both sides of the Bering Sea and Chukchi Sea, and only rarely does one stray as far south as Oregon or California. A small and handsome goose, the emperor in summer grazes marshes and even feasts on tundra berries; in winter it is truly a sea goose, foraging over beaches and mudflats for shellfish and seaweed.

26 overleaf. A flock of snow geese (Anser caerulescens) grazes a snowy grainfield at a wildlife refuge in New Mexico. Snow geese breed across the coastal Arctic, from Siberia to western Greenland, and concentrate in vast flocks each winter along the coasts of the United States—from Chesapeake Bay and Currituck Sound to the Gulf of Mexico to Puget Sound and the farmlands of California's Central Valley. For years scientists debated the differences between the snow goose and the so-called blue goose, but experts presently consider the blue only a dark color phase of the former. When they are nesting, as many as 1200 pairs of snow geese jam into one square mile of tundra.

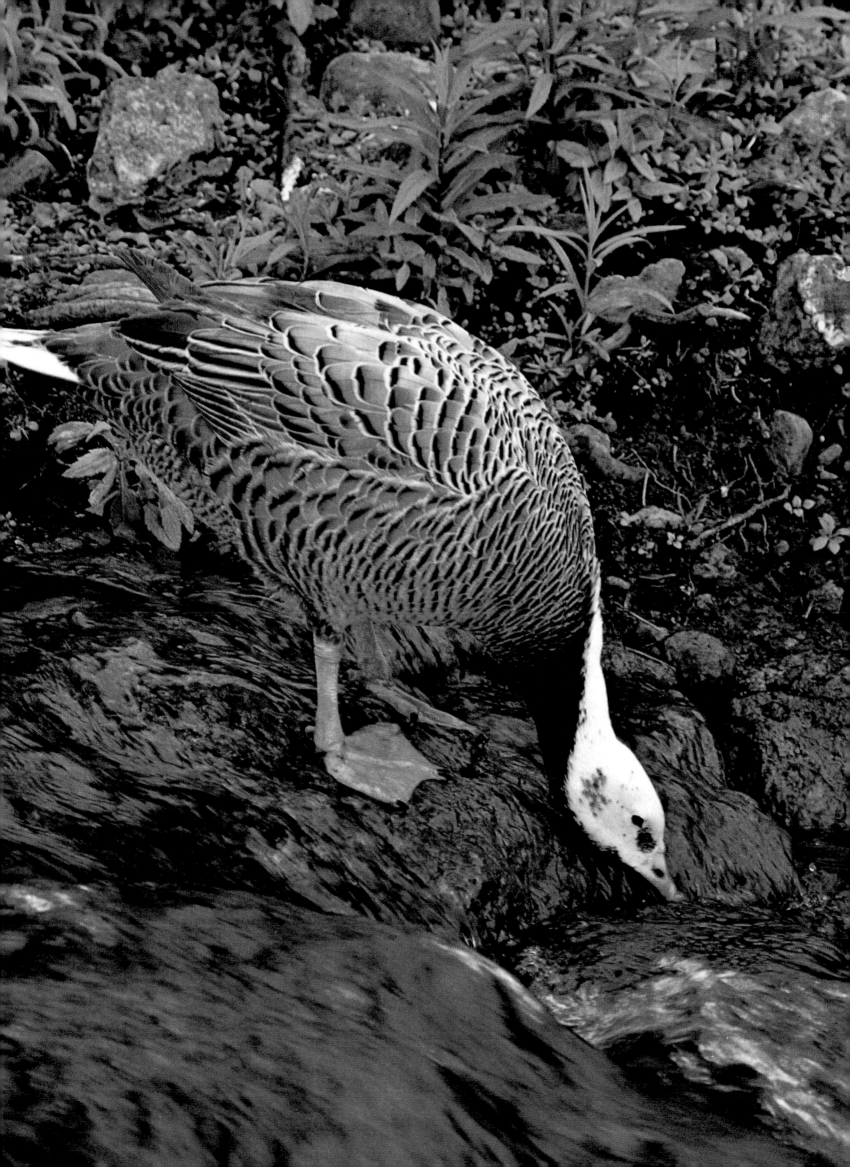

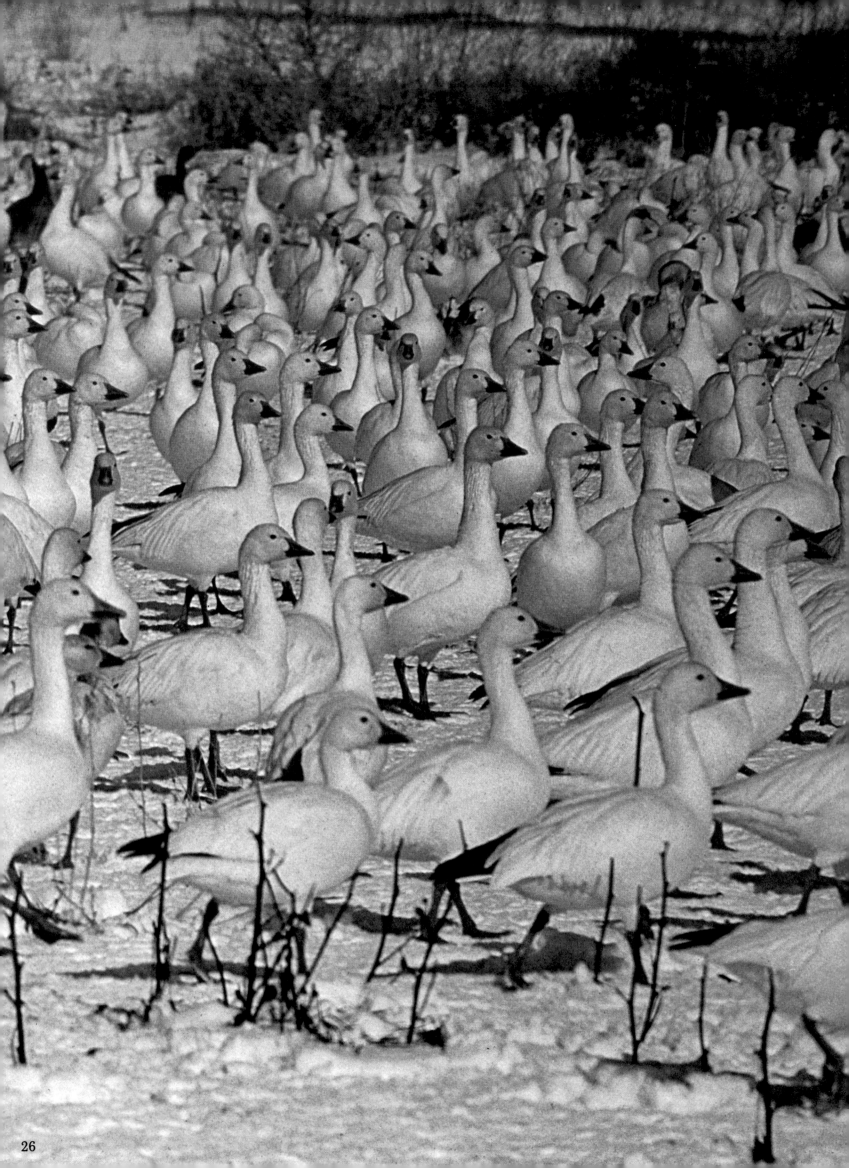

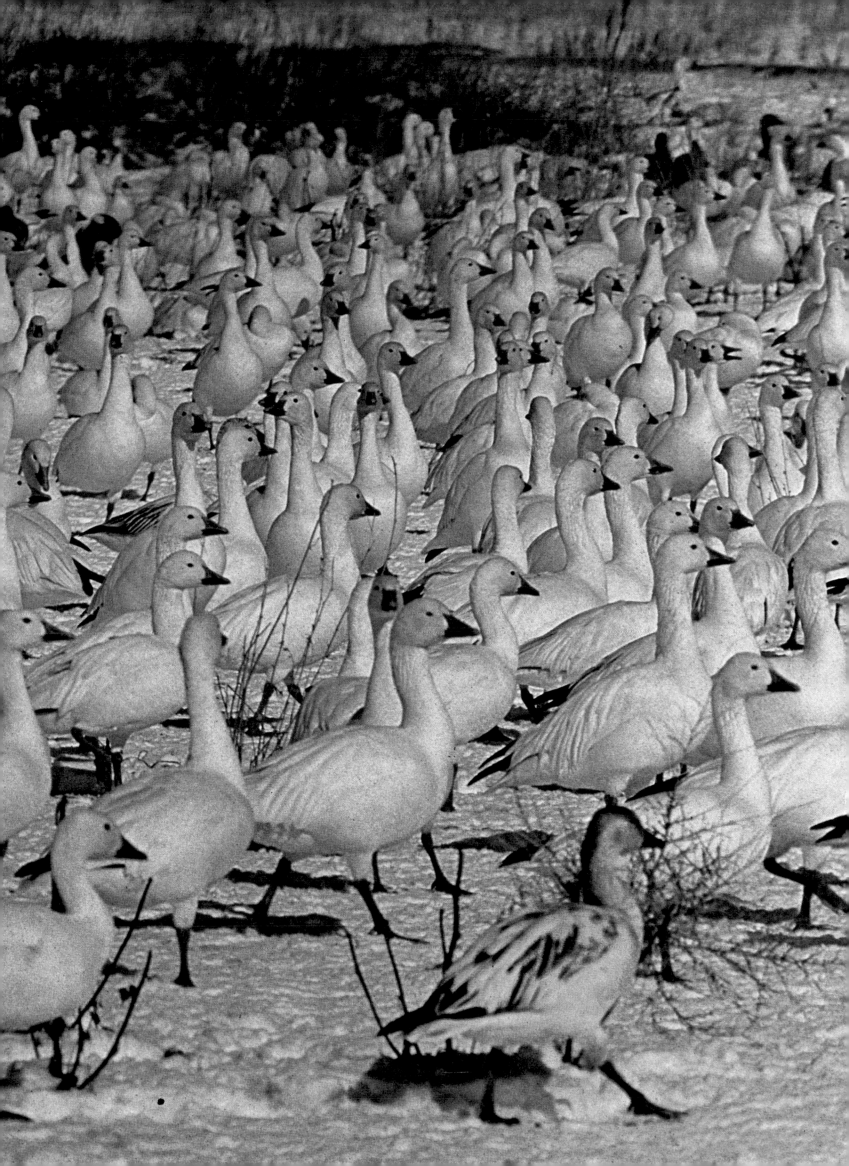

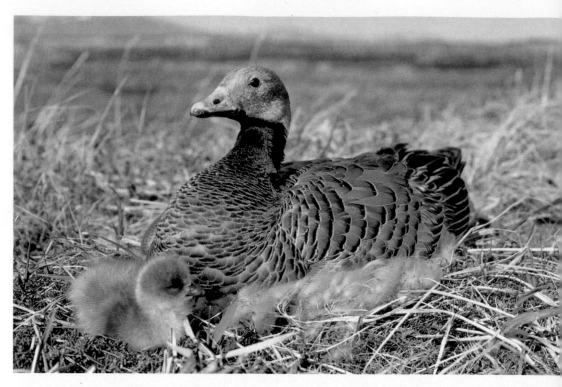

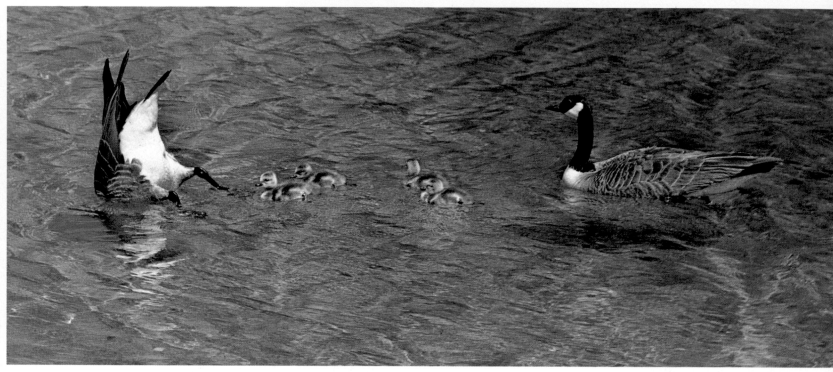

28 *above. Nesting emperor geese must defend their eggs and goslings from the tundra's voracious predators—parasitic jaegers, glaucous gulls and Arctic foxes. Already mated when she arrives in late May on the breeding grounds, the female emperor lays five or six eggs in a scrape lined with her down and with grass and leaves. The young birds feed at first on aquatic insects and marsh grass, then move to upland areas with flocks of molted and thus flightless adults to graze and eat berries. By early August both young and adult geese are flying and ready for a short migration to wintering areas in the Aleutians or at Commander Island.*
28 *below. A female Canada goose* (Branta canadensis), *leading her*

brood and mate across a shallow pond, tips up to feed on aquatic plants growing on the bottom. This is North America's most successful goose, for its original northern nesting range has been expanded throughout the continent by game managers and conservationists who have begun new breeding flocks. It is also the best-known American wildfowl, for its deep clear call is certain to cause a listener to turn his eyes skyward in search of the familiar V formation of migrating honkers.

29 *below. A small flock of Magellan or upland geese (Chloephaga picta) fly across the barren landscape of Carcass Island in the Falkland archipelago. A South American species found from Chile and southern Argentina to Tierra del Fuego and the Falklands, the Magellan goose is a sheldgoose and belongs to a branch of the evolutionary tree of the waterfowl family that is more closely related to the typical ducks than to true geese. In many of the sheldgeese, the two sexes have widely different plumages as well as voices—the males whistle, the females quack.*

30 *overleaf. A greylag goose (Anser anser) beats powerful wings—the wingspan of this heavy bird is sixty-two inches—as it takes off from a* marsh in Denmark. *The wild ancestor of the common barnyard goose, the greylag is Europe's most widespread goose and the only species that breeds south of Scandinavia. There are two races: an eastern form with a pink bill, a western form with an orange bill. Nesting in loose colonies on marshes or lakes with extensive beds of reeds, or on sheltered islands, the greylag congregates in winter on marshes and stubblefields, and the nasal gabbling of a distant flock suggests the baaing of sheep.*

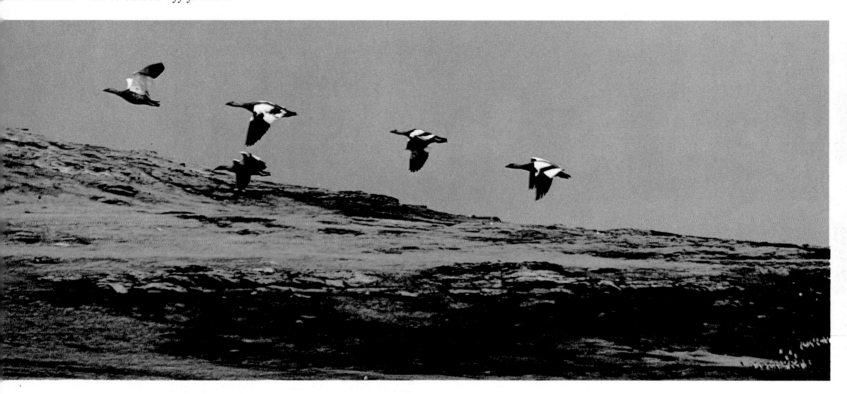

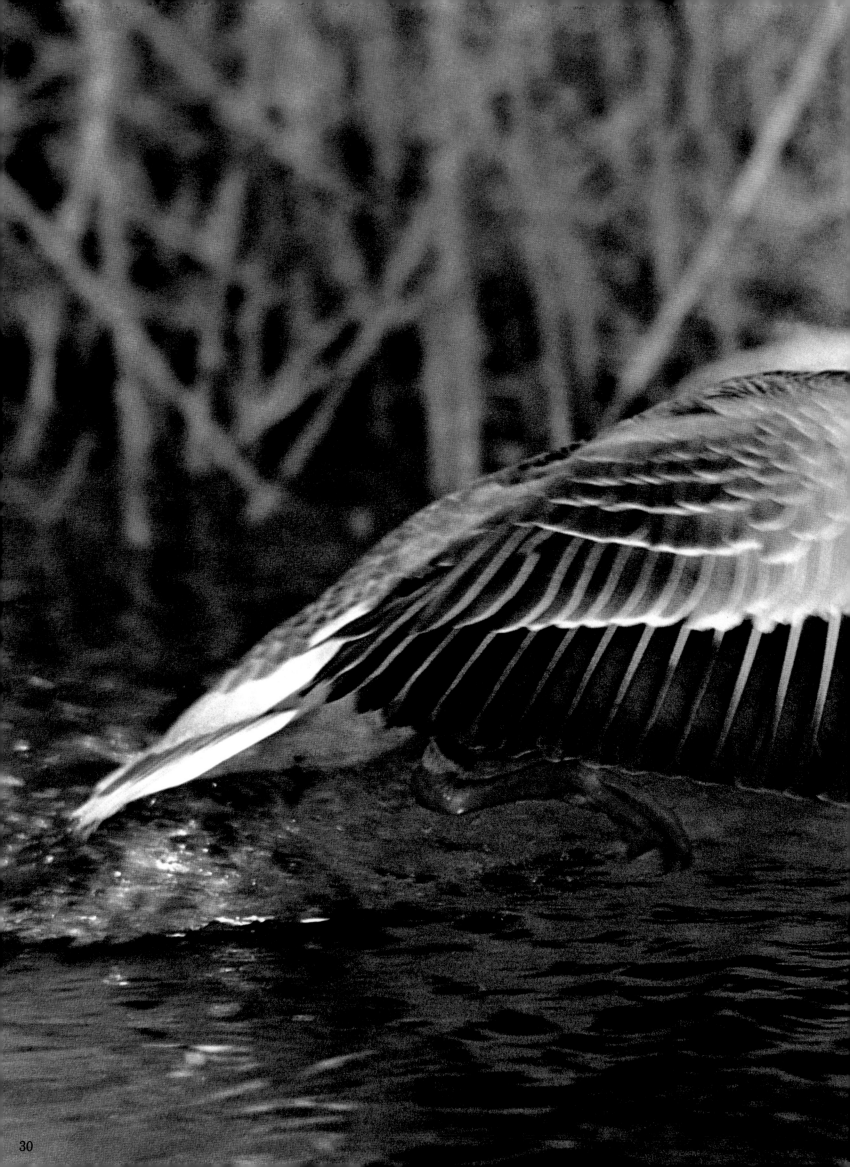

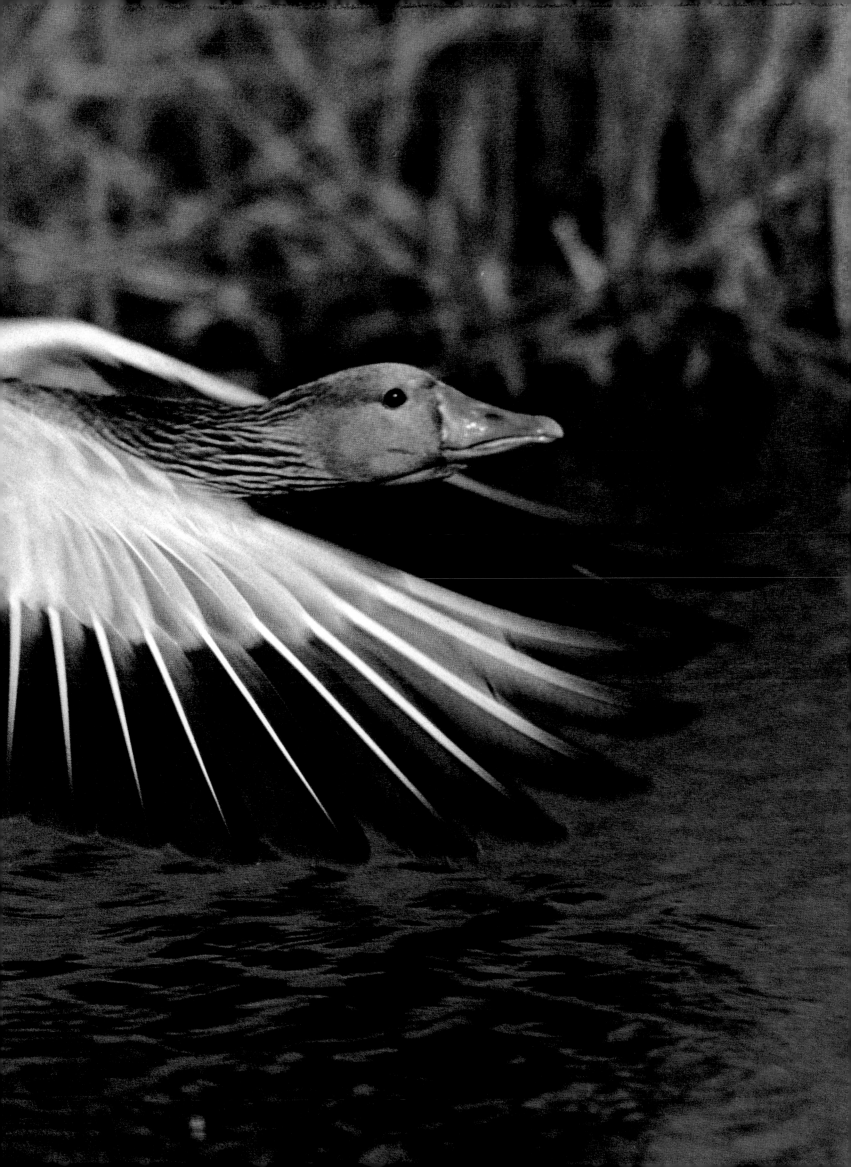

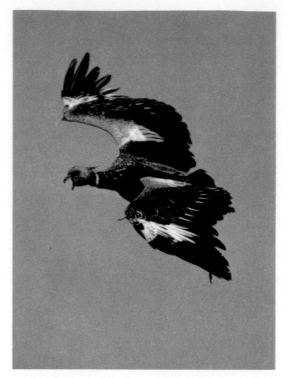

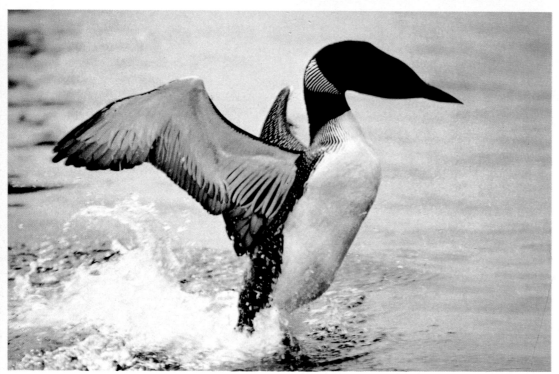

33 *right. Partially domesticated since the Middle Ages, the mute swan* (Cygnus olor) *is not only the most widespread of the three species of swans in Europe, it is now flourishing in the United States, where birds escaped from private estates and started feral populations.*

34 *overleaf. A pair of trumpeter swans* (Olor buccinator) *wing past the mist-shrouded conifer-clad mountains that flank an Alaskan lake where they nest. Largest of all swans, and once found in vast numbers, the trumpeter was nearly shot into extinction by market hunters, but has made a heartening comeback under strict protection.*

32 *above. A layer of air sacs under the skin, and hollow bones, allow the crested screamer* (Chauna torquata) *to circle high above the South American pampas for hours on end. Although hardly a speck in the sky, the screamer's ringing cry is audible for miles, and the chorus of a flock of these strangest of all waterfowl is deafening.*

32 *below. A common loon* (Gavia immer) *rears up with its bill poised like a dagger, presenting a formidable front to a predator threatening its nest alongside a lake in northern Maine.*

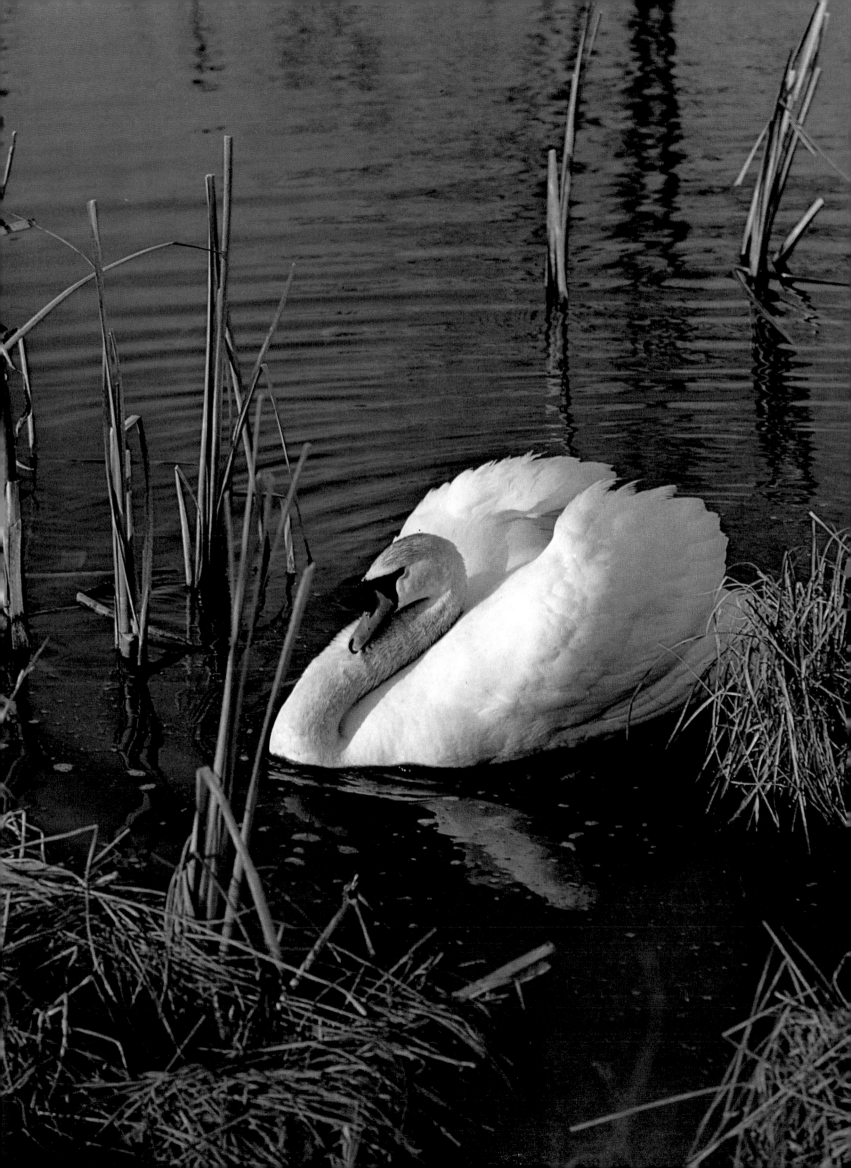

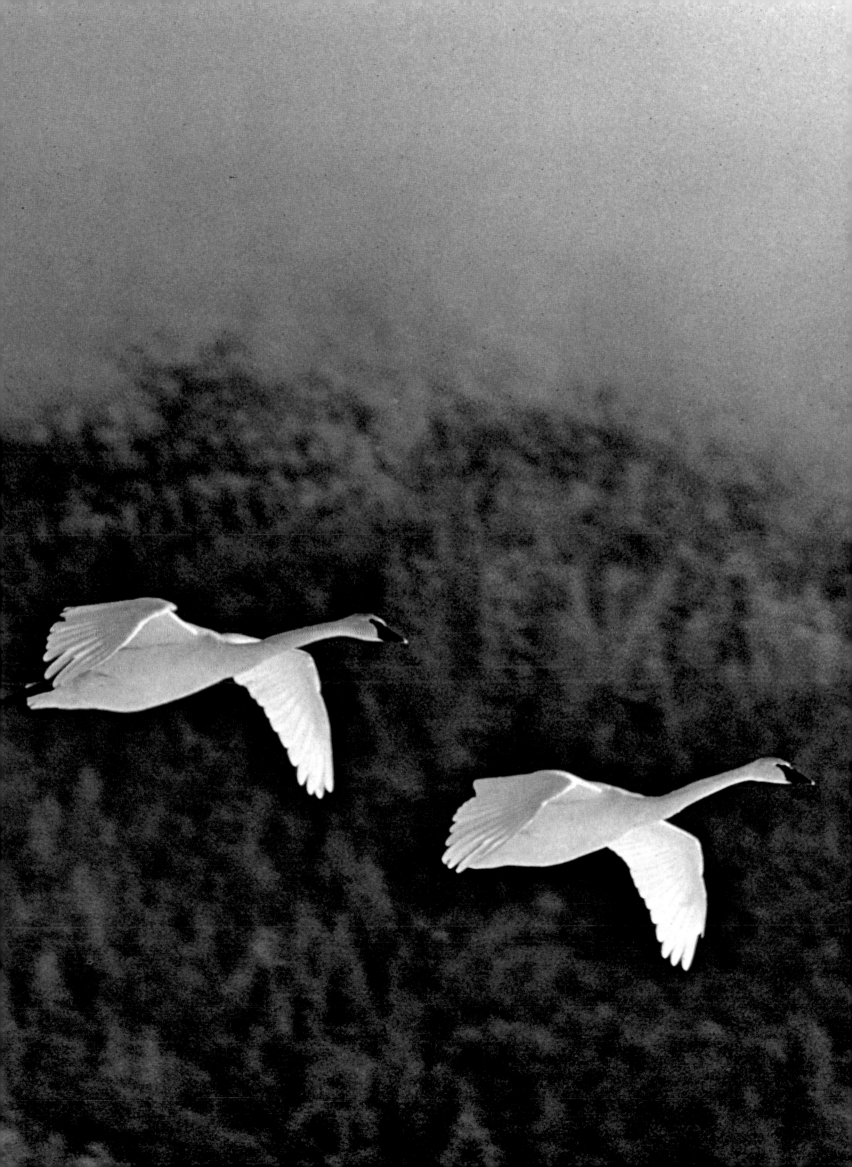

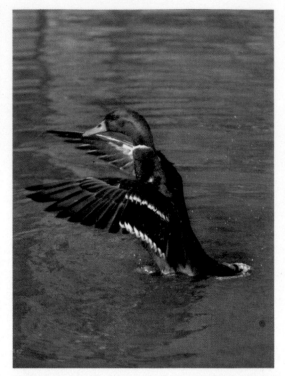

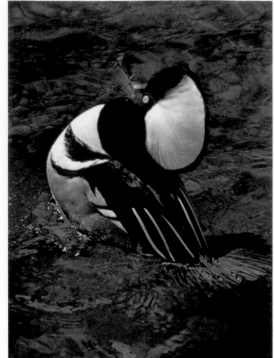

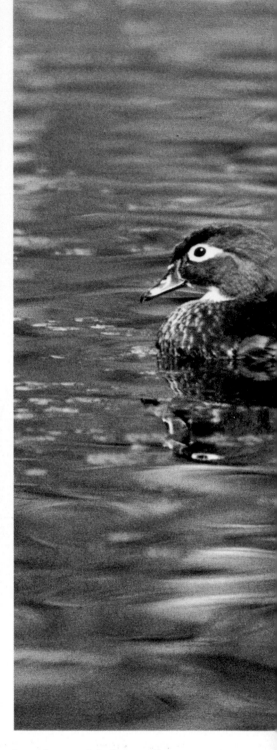

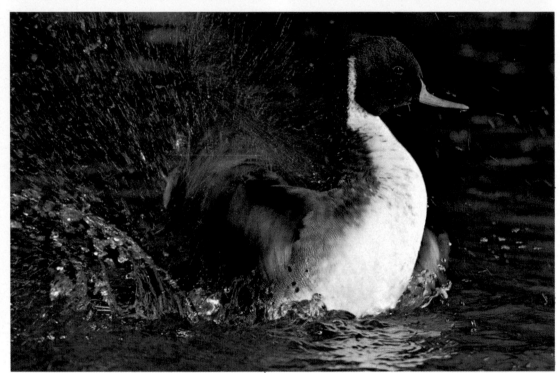

36 *left above. Without question the mallard* (Anas platyrhynchos) *is the most abundant wild duck in the world and the male mallard, with its green head and metallic blue wing patches, the most familiar of all. The range of the mallard covers virtually the entire Northern Hemisphere, and it is the proto-typical dabbling duck, foraging in shallow waters by dipping its head to the bottom and pointing its tail skyward.*

36 *right above. Displaying its finery for the benefit of a potential mate, a male hooded merganser* (Lophodytes cucullatus) *tilts back and erects its black-bordered white crest. Because their bills are serrated, an adapta-tion for eating fish, mergansers are sometimes called sawbills. This*

handsome bird, smallest merganser in North America, nests in tree cavities in swampy forests or near woodland lakes and streams.

36 *below left. Like this drake pintail* (Anas acuta), *all waterfowl must bathe and preen frequently to maintain their waterproof plumage, and even newly hatched birds per-form the exact grooming movements of their parents. Preening not only spreads oil over the feathers from a gland at the base of the tail, but it maintains the interlocking struc-ture of the feather barbs that keeps out water. Like the mallard, the pintail is found across the northern half of the world.*

37 *above. A gaudy male wood duck* (Aix sponsa) *reflects the colors of budding trees reflected in a woodland*

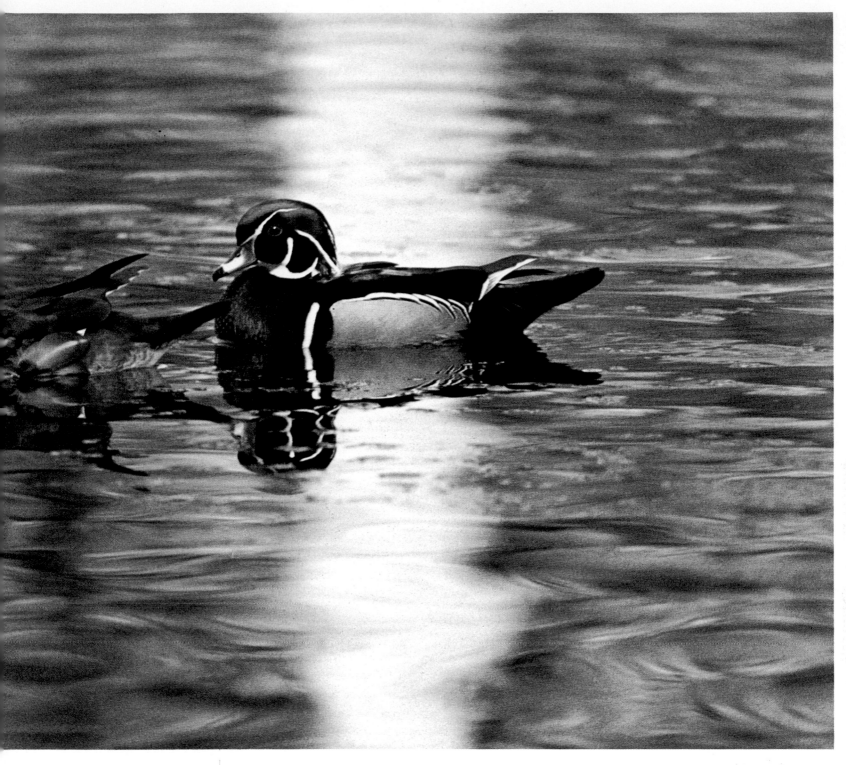

pool. His relatively drab mate will soon be incubating a dozen or more eggs in a natural cavity or man-made nesting box. The wood duck was once severely reduced in numbers because of the destruction of swamp forests, but conservation measures happily have restored it to common status—if North America's most beautiful duck could ever be considered "common."

38 overleaf. Bright pink bills distinguish these otherwise drably colored Cape teal (Anas capensis) at rest near the shore of Lake Nakuru in Kenya. A familiar bird on Africa's brackish and soda lakes, the Cape teal is one of the few species of ducks in which the male actively helps his mate in rearing their young.

Waders with Elegance

In the cool green stillness of the evening marsh, a statuesque, solitary, long-legged blue bird inclines its head slightly and then, with a rapier thrust, drives its long beak into shallow water and impales a fish. In the 120° heat of an East African valley, three million graceful flamingos live in a lake of poisonous water.

The great blue heron of North America and the flamingos of Africa are opposites in a grouping of creatures known as wading birds. They are united, in the eyes of man at least, by a common quality—elegance. They include an odd assortment of creatures. South American spoonbills, the tips of their beaks splayed out flat, prowl the mudflats of Brazil and Argentina in search of tiny crustaceans buried in the mud. Scarlet ibis, floating silently on broad wings, match their gorgeous crimson bodies with Caribbean sunsets as they come planing in to landings along the shores of Venezuela, the Guianas and Trinidad.

The elegant waders include many different families, as pictured here, but there is more uniformity among their physical forms than among the waterfowl. They may be as beautiful as the ibis or the flamingos, as commonplace as storks or as extravagant as cranes or egrets in their nuptial displays. Or they may be as ugly as the marabou storks of Africa. But all share the long legs, distinctive beaks, pear-shaped bodies, erect poses, capacity to glide and soar and cover great distances.

Length of leg has given these birds a place in nearly all the shallowish waters everywhere—estuaries, lakes,

ponds, marshes, swamps and bogs. They range throughout North and South America, all Africa except the most arid areas, all of Europe, Asia, and the Antipodes. In places they have made themselves more or less independent of water; Indian storks can endure drought for months and hunt in dust rather than in meadows or mud. The storks of Europe have adapted to man, nesting in the tops of his house chimneys, their nests reused over the centuries.

Wherever they appear before man's eyes, these statuesque birds have a very special effect on the imagination. Mankind has never had any difficulty in identifying them with the human form and activity. In ancient Egypt the sacred ibis was presumed to embody the god Thoth, the deity of wisdom, and the god himself was given the head of an ibis.

The great inland waterways and southern swamps of North America give the elegant waders one of their main havens, and they provide us with a sustaining spectacle. Many waders, mostly the egrets, are only recently liberated from a century-long exploitation of plumes, the delicate nuptial feathers that were used to decorate women's hats. Now, although the water worlds are shrinking, the waders still provide one of the real treats of bird-watching. Like all the long-legged birds, they are extremely graceful. Their flight is more like sailing with a following wind than the flight of other birds. In the American South, the white ibis wait until very late in the evening to roost, and then come pumping low across the water, often set against the brilliance of a spectacular Florida evening sky display. All at once they turn upward and land in stunted mangrove bushes. There they stand silently, great white fruits added to the vegetation. Night falls around them.

Nowhere do these long-legged birds fail to provide spectacle. The sandhill cranes fly in hundreds of thousands in their northern migration to the Arctic from New Mexico and west Texas, stopping along their way at one of their favorite refuges, the winding shallows and sandbanks of the Platte River. There, they spread out in loose congregations. But in the Great Rift Valley of East Africa, the lesser flamingo occupies a sharply different country where no kind of bird appears to be welcome and few other birds have been able to survive. To man, this is

some of the most hostile territory on earth. But it is also oddly beautiful. There is no water outlet. The waters, concentrated through ages of evaporation and derived from volcanic rocks, have been transformed to crystalline soda. Some algae have managed to stake living places in the soda water, which in some areas is colored a deep blue, pale green, the color of claret or rich blood-red. The soda crystals have formed in floes in some parts, and they float on the foul-smelling, bitterly poisonous water. Nonetheless, the flamingos are at ease there, spotless in plumage, graceful in flight. They dabble in the terrible water, straining the soda to get the algae out of it.

The flamingos have made their place in one highly restricted environment, whereas the buff-backed heron or, as it is more commonly called in the Americas, the cattle egret, has done precisely the reverse. This ubiquitous African bird is seen in almost all landscapes where there are grazing animals near water, either domesticated or wild, such as cattle, hippo, crocodiles, waterbucks. Somehow the cattle egret has made it across the Atlantic, to colonize parts of South America and, more recently, to take up residence along the eastern shores of North America, where it is slowly moving north in search of new territories.

The cattle egret, like all its wading colleagues, is a specialist. The great blue heron of North America, jabbing that slender knifelike bill at the body of a fish, is wielding a highly developed tool. The spoonbills have their specialist tools, beaks flattened at the end and adapted for rapid back and forth probings of the water in which large numbers of small creatures can be gathered quickly. Despite their peculiar beaks and rather gross forms, they are closely related to the beautiful and graceful ibis. Their beaks give them a far wider range of hunting opportunities than the more specialized marabous, and they are spread much wider around the world. The roseate spoonbill is found along the Gulf Coast toward Texas and through much of Mexico and Central America. The African spoonbill has colonized most of the African continent, and other spoonbill species have spread through much of India, the Middle East, China, Indonesia, Australia and New Zealand.

Some of the waders have associated themselves closely with man, particularly the white stork, known in German folklore as *Adebar*, which means carrier of

good fortune. These storks comfortably occupy two totally different environments at the northern and southern limits of their range. In Europe, where they frequently breed in villages and even in the center of quite large towns, they fly from town to open fields to hunt earthworms in the moist German meadows. While they are particularly attracted to open fields and are especially fond of crickets, they can also fish, with deft sideways movements of their beaks.

But at the southern, nonbreeding end of their range they have no difficulty in hunting in quite dry areas, particularly when the grasshoppers are swarming. Then they spread themselves out in thousands, over valleys, hills and plains, walking forward with intense concentration, occasionally stabbing at their prey, and rising above their fellow hunters to leapfrog onward in pursuit of the swarming insects.

The elegant waders, whatever their form, will always remain a delight to any human observer even though only a small part of their lives may be open to the landbound watcher. They exemplify the same spirit as the waterfowl in their wide-ranging flights, their freedom to move great distances at will. They create memorable vignettes as they wing on into the sunset or the purple night, leaving us with a comfortable feeling of the natural world as it should be.

When the whooping cranes come to Texas from their remote Canadian breeding grounds, their bugling cries speak of a wader threatened with extinction. When the white storks migrate into Africa from Europe, they often soar to great altitudes, more than 12,000 feet at times, which helps them avoid the many predatory eagles of the continent. If an eagle does appear, the storks lower their legs, close their wings and drop like stones. When the fall has taken them beyond the reach of the eagle, they gracefully open their wings and swoop away into normal flight and safety.

45. *The great blue heron* (Ardea herodias) *dines on a long menu of animal life—insects, salamanders, frogs, mice, snakes, eels, an occasional marsh bird, and of course fish—but usually much smaller than the catfish this bird has speared with its long, sharp bill. The four-foot-tall GBH, as it is known in birdwatchers' shorthand, also frequents a long list of habitats: both saltwater and freshwater marshes, the shores of both ocean bays and inland lakes, large and small streams, meadows, farmers' fields. It either stalks its prey through the shallows or stands poised like a statue, waiting for some victim to come near. Great blue herons nest in colonies across North America, from Alaska to Mexico, often in the company of other waterbirds.*

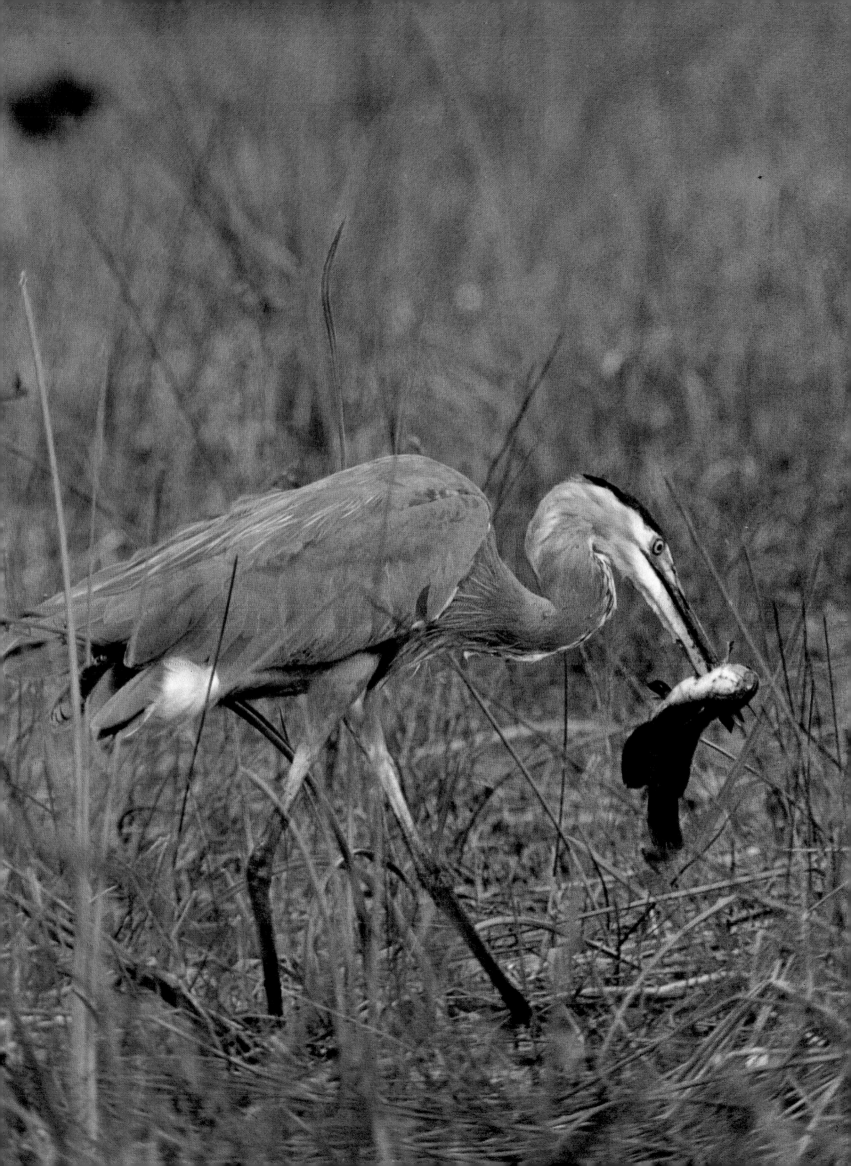

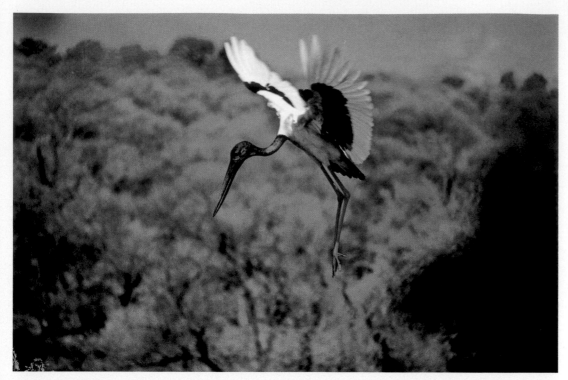

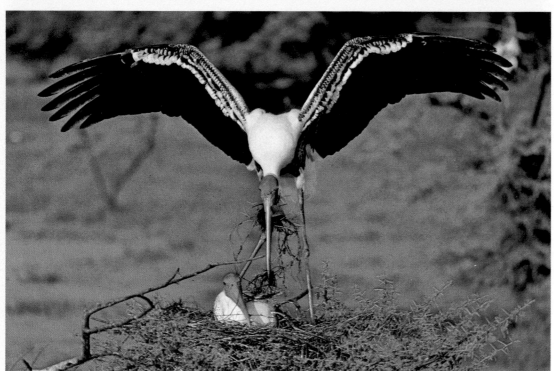

47 *right.* The nest platform of a pair of painted storks, in a twisted, isolated acacia tree in a Bharatpur marsh, overlooks a nest mound containing two sarus crane eggs. The striking black-and-white plumage of the painted stork is accented by pink wing feathers and an orange face.
48 *overleaf. A pair of sarus cranes* (Grus antigone) *engage in a mutual calling display to warn other cranes away from their nesting territory. Standing five feet tall, this stately bird is the largest of the world's fourteen species of cranes.*

46 *above. Bharatpur Bird Sanctuary in northern India has been called one of the world's greatest breeding preserves for waterbirds. Among the many species attracted to its low inundated forest is the black-necked stork* (Xenorhynchus asiaticus), *tallest of all Asiatic storks, towering nearly five feet.*
46 *below. In the breeding season Bharatpur's trees literally bend under the weight of massed nesting platforms of storks, spoonbills, ibis, egrets, herons, shags, darters. This painted stork* (Ibis leucocephalus) *is bringing food to its half-grown offspring.*

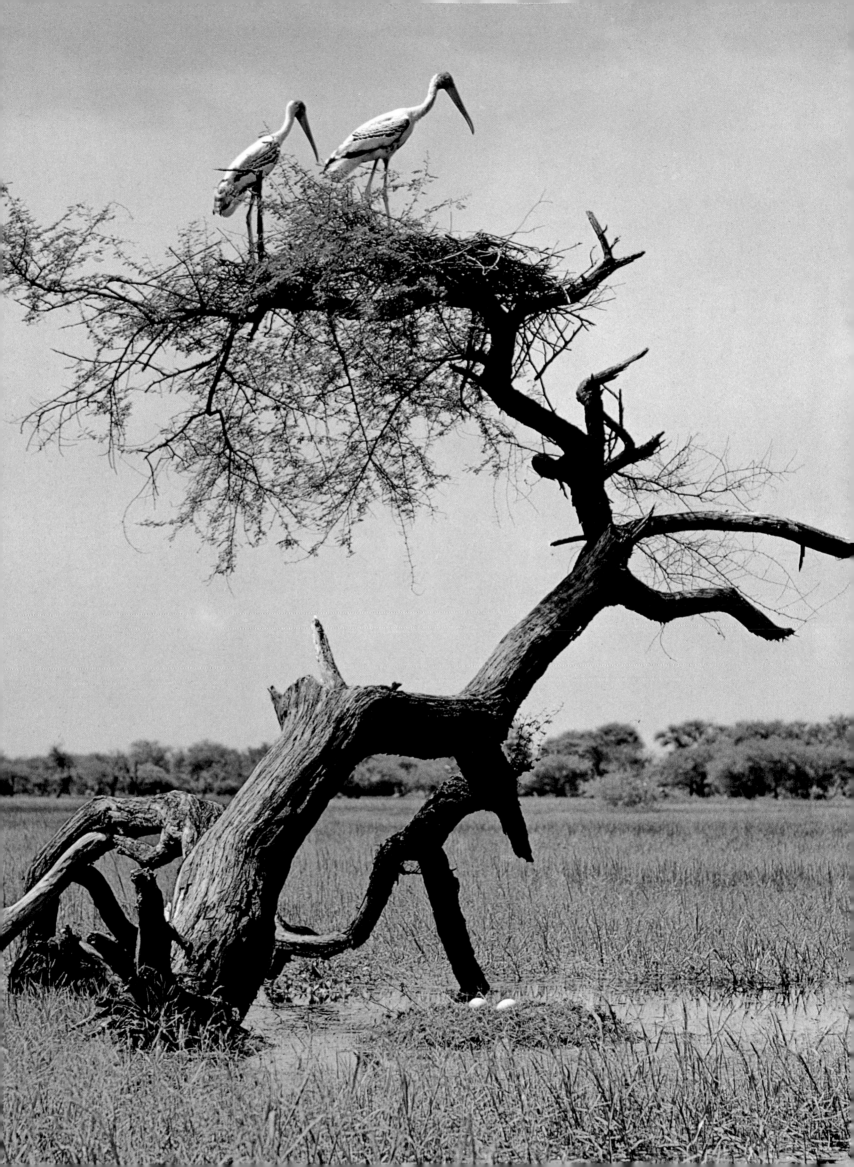

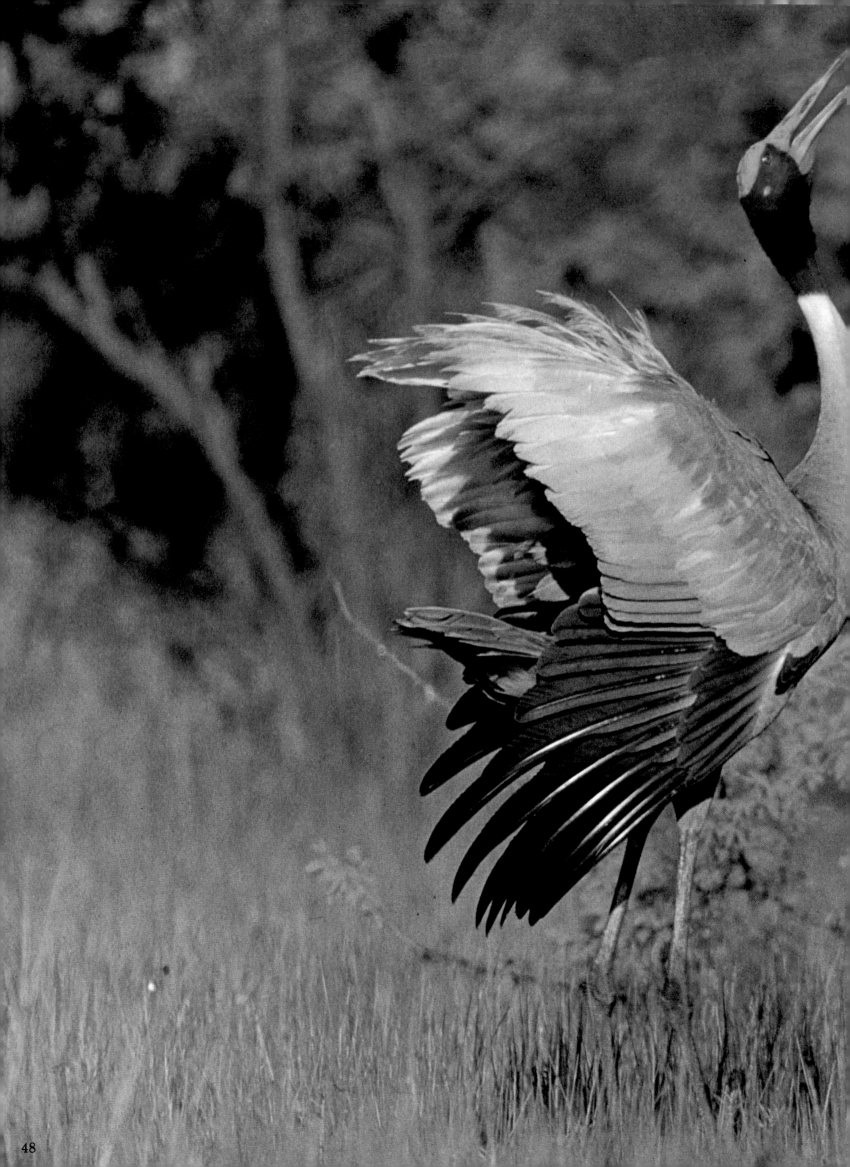

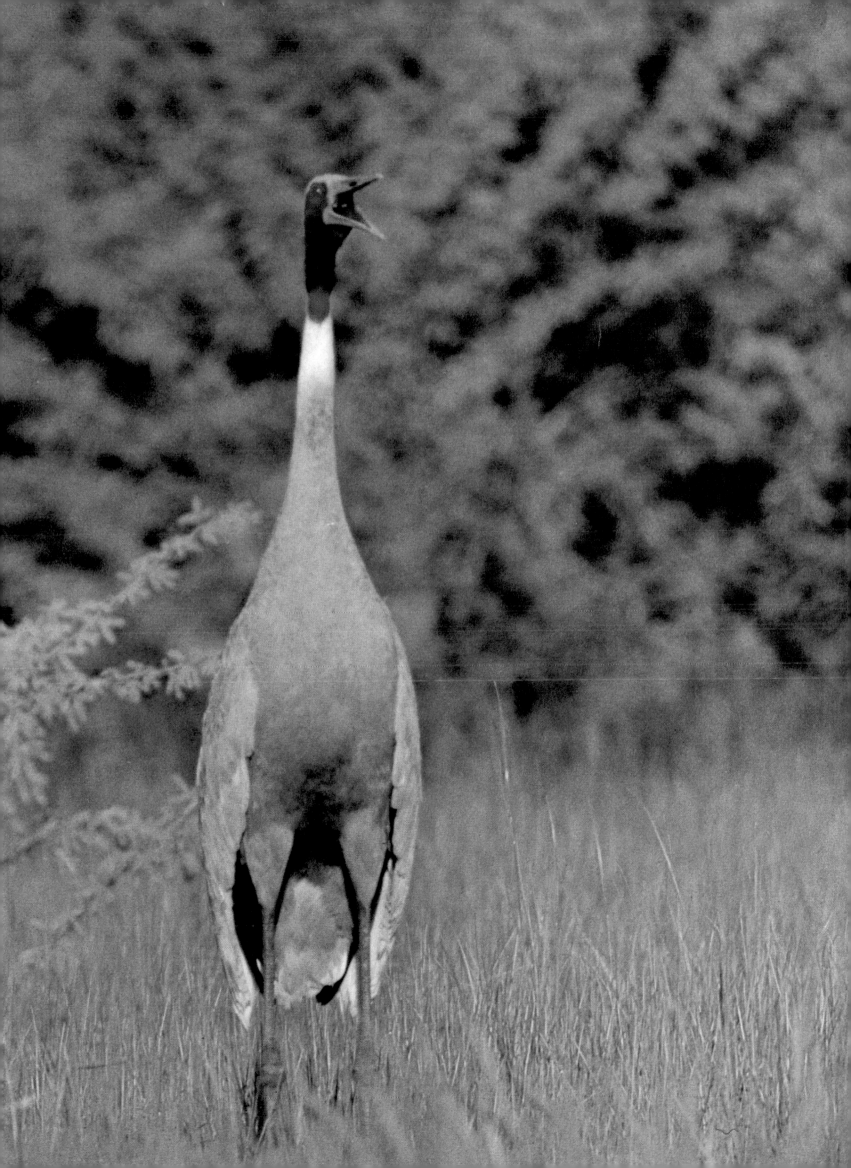

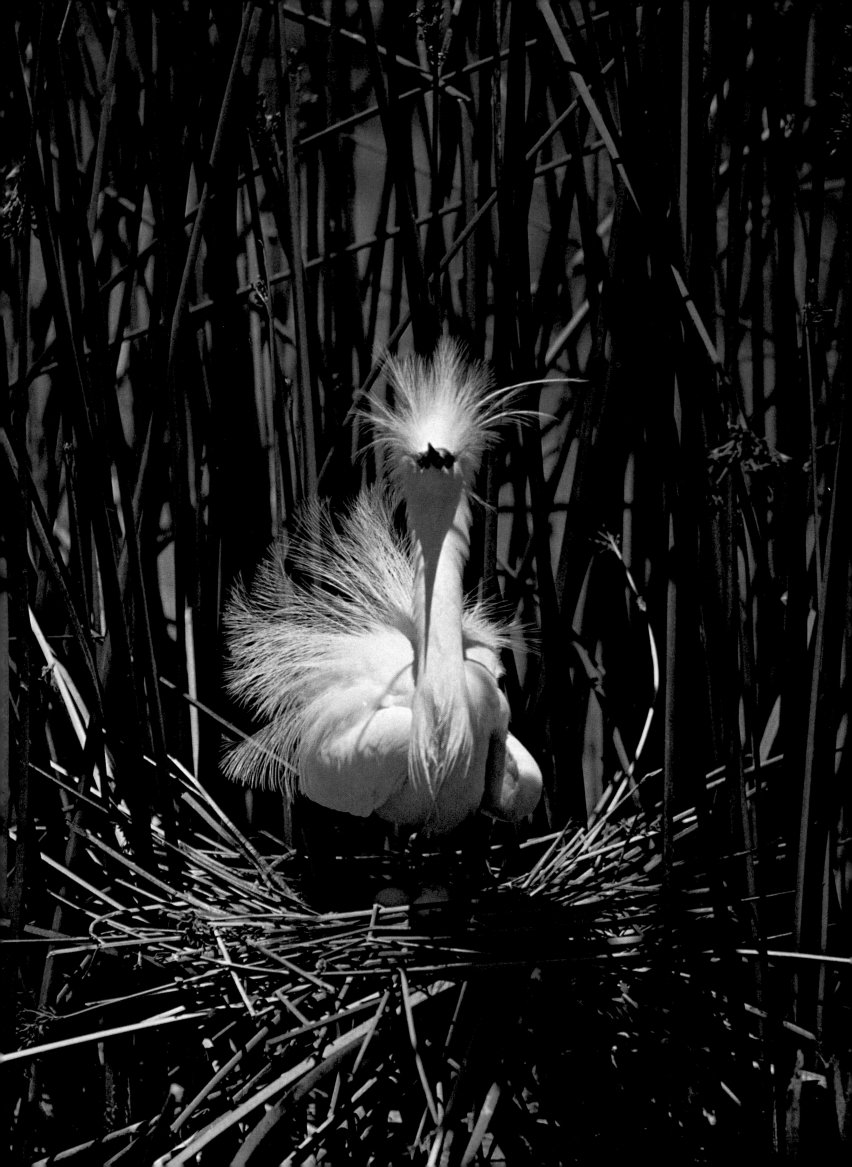

50 *left. A snowy egret (Egretta thula), loveliest of all New World herons, displays the nuptial plumage that nearly led to its extinction in the early 1900s. Plume hunters, supplying feathers to the millinery trade, relentlessly slaughtered both snowy and great egrets—and many other species—until the carnage was halted by the fledgling Audubon Society movement.*

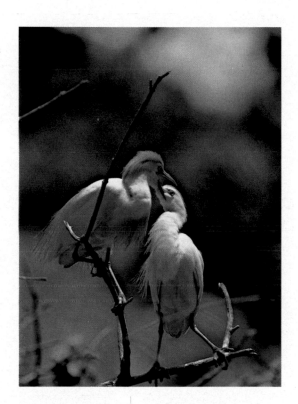

51. *Tawny plumes mean breeding readiness for the cattle egret* (Ardeola ibis), *a small heron native to Eurasia and Africa. By its own efforts it has colonized North and South America and Australia. It forages on insects stirred up by the feet of domestic livestock.*

52 *overleaf. A jungle lagoon in Brazil attracts courting great egrets* (Casmerodius albus). *All herons have patches of powder-down feathers that fray into a dust, which the birds use to maintain their plumage.*

54 *second overleaf. Scarlet ibis* (Eudocimus ruber) *are like flames in the dense green of a jungle swamp in South America.*

A handsome bird, it too has suffered at the hands of man—killed for its feathers as well as its meat.

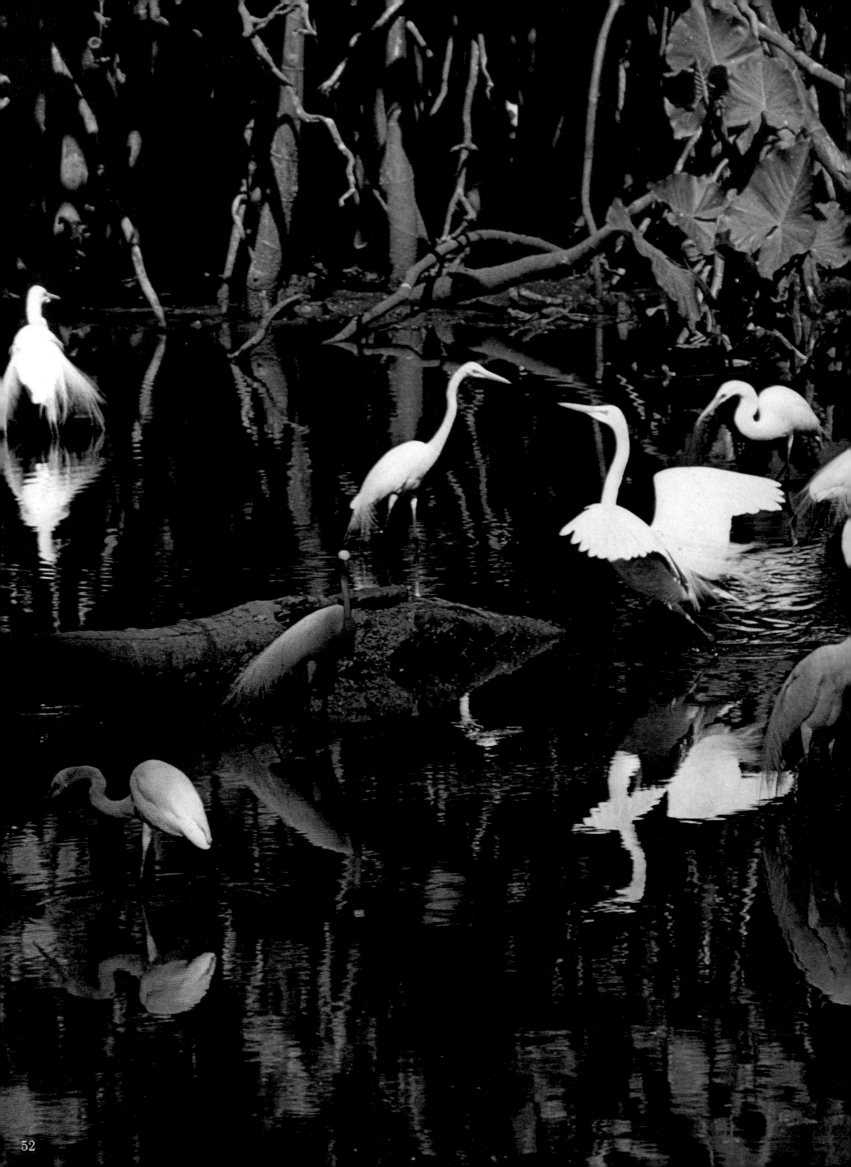

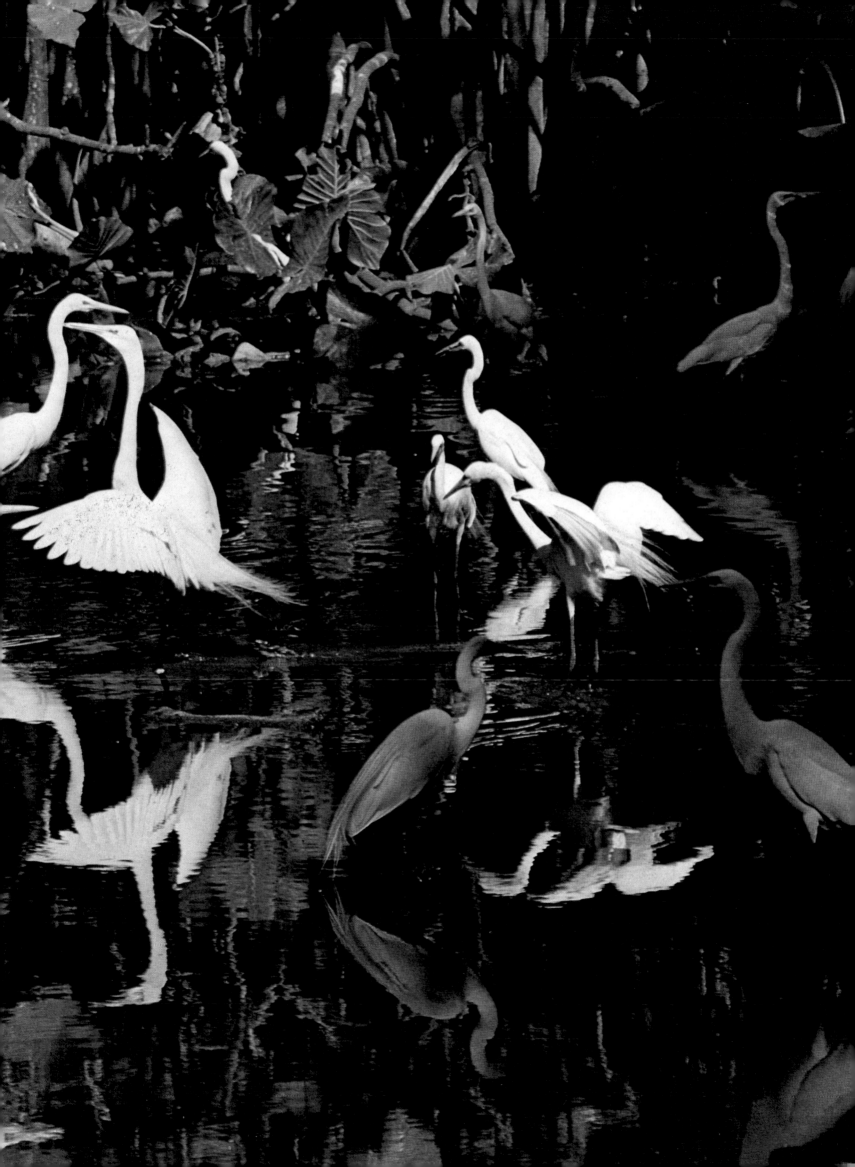

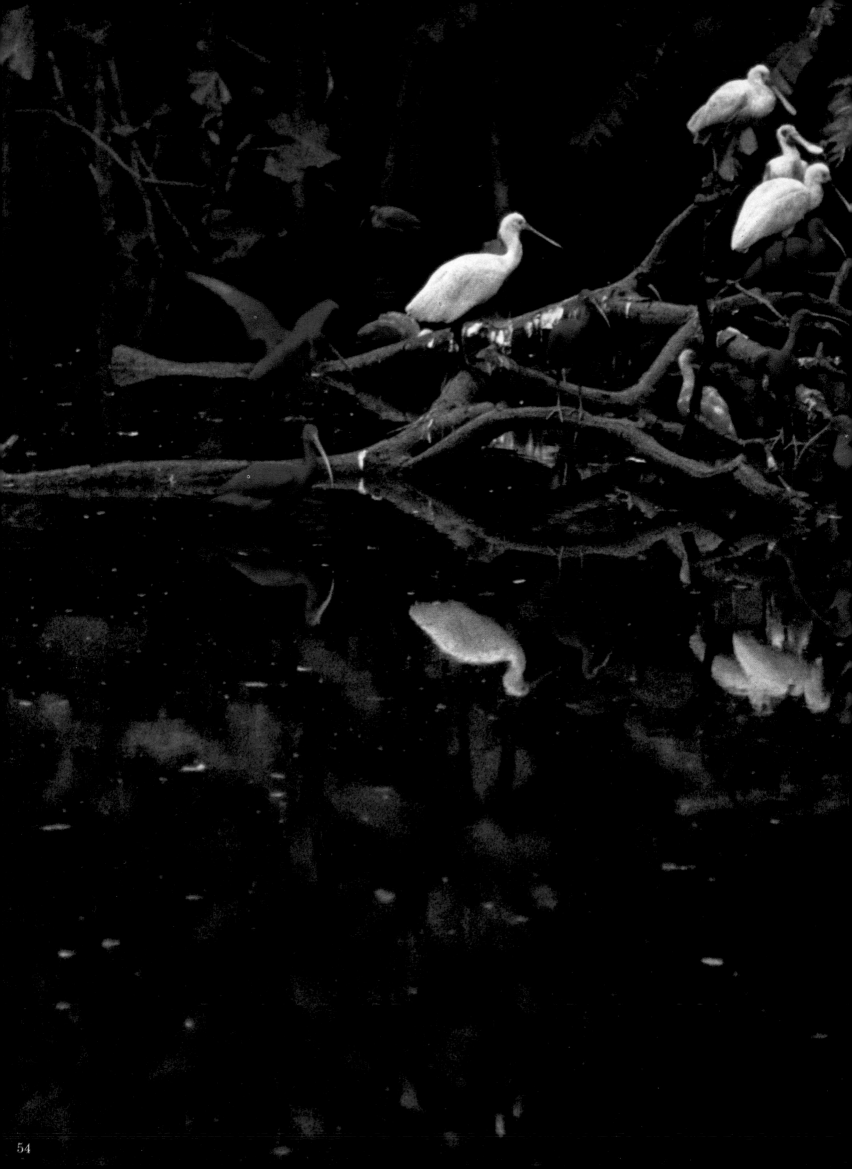

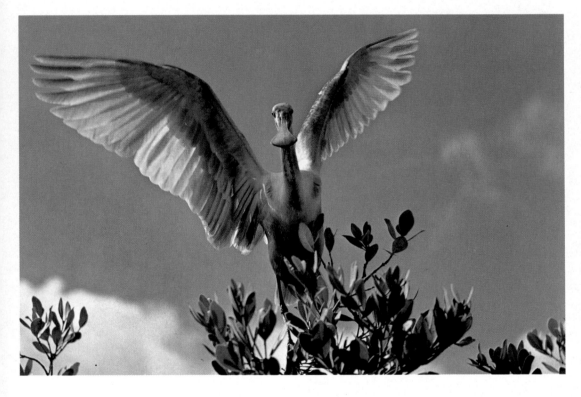

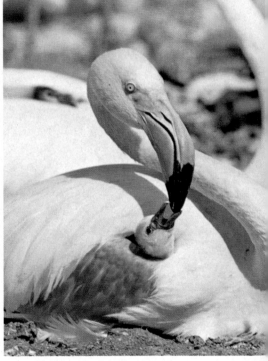

56 *left. Landing in a mangrove in Florida's Everglades National Park, a roseate spoonbill* (Ajaia ajaja) *flaps its pink wings for balance. Spoonbills feed by swinging their half-open bills through shallow water as they wade along, gathering up fish, amphibians, insects, shrimp.*
56 *right. Brooded under the wing of a parent greater flamingo* (Phoenicopterus ruber), *a three-day-old chick is fed a regurgitated fluid that is blood-red in color and, indeed, contains about one percent of red blood cells. In another day or two the chick will leave its nest mound, on Kenya's Lake Elmenteita, and hop off to herd with other chicks of similar age.*

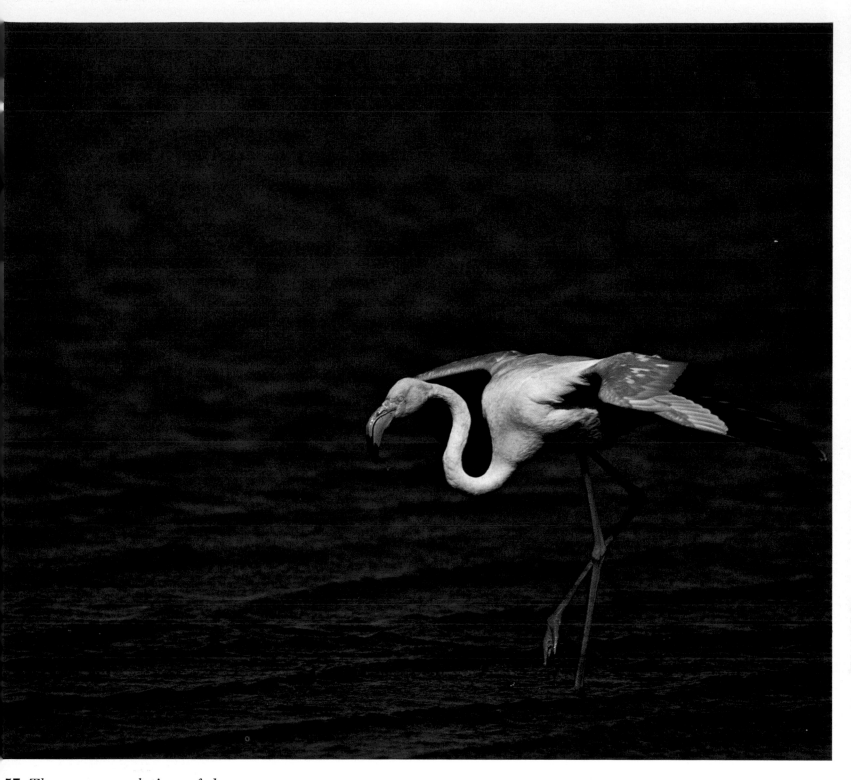

57. *There are populations of the greater flamingo in both the Old World and New World. The Eurasian birds are whitish with pink wings, but flamingos breeding in the Caribbean and on the Galápagos Islands are bright pink overall. The flight feathers are always black.*
58 *overleaf. Adult greater flamingos engage in a head-flagging display—a courtship ritual in which they stretch upright and turn their heads back and forth in metronomic rhythm.*

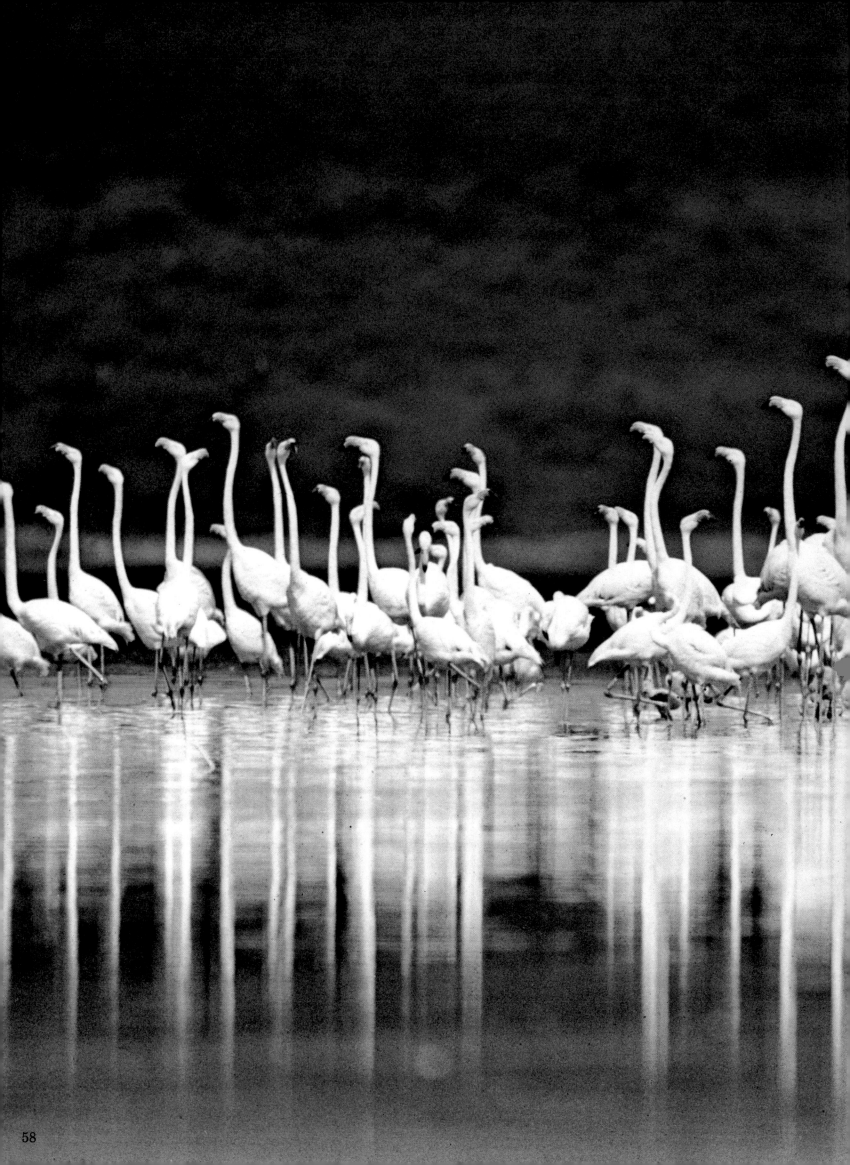

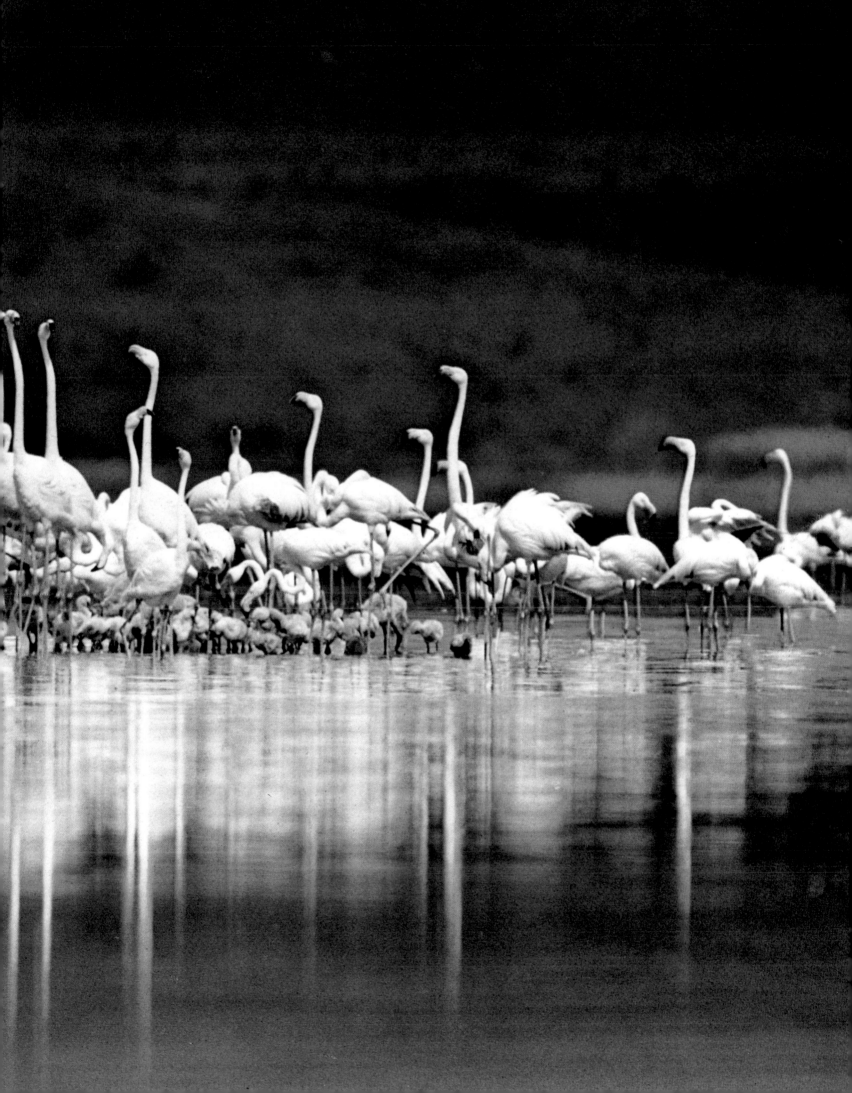

Stalkers in Secret

The bittern stands in shallow water flanking the
reeds of an Iowa marsh, a dull-colored bird with a long
beak and piercing eyes. A stealthy noise nearby
galvanizes the bird. It elongates its entire body and
thrusts up its beak vertically. In a moment the bird
becomes an integral part of the background reeds. Its
eyes swivel in their sockets so that they look downward.
As a final touch, the bittern moves its neck slightly
to conform to the faint movement of the reeds behind
it stirred by a soft wind.
Most waterbirds of the world have chosen to live in
open environments where there is little concealment.
They must stand fast and visible and see the approach
of their enemies at long range. But another group of
waterbirds, which has also chosen to hunt in a similar
world, uses quite different techniques to survive.
These are birds with shortish legs but strangely large
feet and splayed-out toes: the skulkers. They
mingle with their backgrounds. They freeze. They are
heard but not so frequently seen. They prowl the
undergrowth along the edges of ponds, estuaries,
lakes and seashores. They are supremely specialized.
Their flight is poor. But they are beautifully
adapted to their limited world, mainly through their
feet which, with four extremely long toes spread
wide, can take many of them like brown ghosts across
a pond of floating leaves with scarcely a tremble of
a leaf or a ripple of water left behind them. Many can
use their feet like hands and pick up vegetable
food and chew it with conical beaks, like the black-
tailed waterhen. Or they may swim with the facility

of a duck, like the purple gallinule. Some have developed webbed flanges to their extraordinarily large toes, as in the horned coot.

They would be easier to describe if anything more than their peculiar feet unified them. But some have long pointed beaks, others short beaks. Some have heavy beaks, like the New Zealand takahe. Some are dun colored and unobtrusive, while still others have bright red and blue and greenish tints in their plumages. The takahe, which is a rail, is typical of the secrecy of these skulking marsh birds everywhere. It was thought to be extinct for more than half a century in New Zealand until it was rediscovered in 1948 in the southern part of the South Island.

The birds in this group include rails and crakes, coots and gallinules. The bitterns are actually herons which, more commonly, are wading birds of the open. The yellow bittern, which occurs in Australia, India and China and is about the size of a blue jay, is related to the goliath heron of Africa, which stands nearly eight feet tall. The skulkers are bound by their environment, not by any family ties.

Skulkers occupy many different wetland worlds. They fit precisely into that zone where the dry land gives way to water, often a narrow band of territory running along the edges of an estuary or a salt marsh, or the fringes of a pond or lake, or an oxbow near a river. It is dangerous territory, well prowled by skunks, mink, raccoons, foxes and egg-eating snakes. To have any chance of survival, the skulking birds must be in complete harmony in this world. They must steal among the bulrushes or the burreeds, hide themselves among the cattails and sedges when they hear the sound of a fox's footstep. Yet they must also not venture too far toward the dry land where the thick growth of shoreline plants gradually opens up among pussy willows and thence into the trees of the forest.

In the tidal marshes they are doubly vulnerable, since the withdrawal of the tide leaves the salt meadow cordgrass and other shoreline plant territories open to the hunting of all the dry land animals. There, very special adaptations are necessary for survival. The clapper rail exemplifies this. It is only about twelve inches high, and its brown-gray body blends into all the saltmarsh backgrounds. It exploits the twice-daily march of the tides by hunting for its main food,

scuds or amphipods, digging for clams and catching crabs, worms and insects. Its loud "hah-hah" cries mark its position, but it is rarely seen by any of its enemies, so well does it skulk among the vegetation. It takes great care to conceal its nest by weaving a canopy of grasses to completely hide its eggs from view. But even this is not enough defense. The female rail will stand fast when the nest is attacked by mink, skunks, raccoons, opossums and even hawks.

The skulkers have evolved secrecy and camouflage, and for this they have sacrificed strength and the capacity to fly well. Some of them are poised midway between two worlds, half skulkers, half swimming birds, like the great families of waterfowl. The European coot has spread its toes so that it will have at least partial paddle feet when it is swimming like a duck. But on foot it retains its stealthy speed through the reeds, enjoying at least part of the advantages of both worlds. The rails swim and fly poorly, but their bodies are so narrow that they can slip between stems of vegetation where no other creature their size can follow. The jaçanas, which are actually in the great shorebird group, have evolved toes that are longer, proportionate to their bodies, than those of any other bird and enable them to scamper across floating leaves at high speed.

Such specific evolution suggests that the skulking waterbird has sacrificed many other qualities. The poor flight of all these birds implies their ranges must be limited. Yet, oddly, many of these birds are extremely widely distributed around the world. Few landbirds range more than 1000 miles in both width and depth of their habitats. Yet the common gallinule, or moorhen, has colonized most of the Americas, except the far north and the West Indies. It is spread through Africa and Madagascar, Europe and Asia. Weak wings have not stopped it from reaching both the Hawaiian islands and the Galápagos.

Such distribution is the result, at least in part, of a long evolutionary history. The rails reached their present specialized form about 40 to 50 million years ago. So, while climates changed, and seas advanced and retreated, cooled and warmed, the water worlds of the skulking birds remained quite unchanged. This enabled the birds to fit themselves superbly into their environments.

Their voices seem to speak of a primal world long occupied. A strange mixture of gulps, croaks and booms rings out across the marshlands day and night. The cries resemble those of no other birds. The bitterns have the most characteristic voices, usually heard around dark. The birds stretch up their necks, fill their gullets with air and, with great effort, expel blasts from the resonating chamber of the gullet. The marsh booms with the cries.

Night is the final refuge of these creatures. Despite their weak wings, many make surprisingly long migrations, always at night and in short stages. The fox and the raccoon, the mink and the coyote, may also hunt at night, but not with the same stealth and adjustment to a territory of reeds and sedges, water and weed.

But such precise adjustment is also a part of their vulnerability. Fire sweeping along the shores of a prairie marsh, or a Saskatchewan slough, wipes out all the cover of these creatures. They are left naked, in a world made open. In western American marshes, where spring is often set back by wintry spells, the coots are particularly vulnerable. They may be mingling with the first migrating ducks. When snow blasts across the freezing waters, the ducks may escape on their strong wings, but the coots are often trapped in their marsh, their wings frozen to the ice. Then the foxes can catch them. Mink kill them and drag their bodies away to their holes. Even skunks join in the feast.

The wind touches the reeds and a whisper of water runs among matted roots. Red-winged blackbirds call noisily in the day marsh. Hovering hawks prowl the salt marsh. The visible forms of life appear dominant. But this is the illusion of the skulking birds of the reeds. They are everywhere, but nowhere. Their bright eyes stare out from a tangle of undergrowth. With a boom, a choke and a gulp, they disappear into the thickets of their secret world.

65. *With its remarkably long and webless toes, the purple gallinule (Porphyrula martinica) can stride over floating plants even in the deepest parts of the marsh as it hunts for frogs, snails, insects and seeds. It also readily climbs about in shrubs near the water and has been known to steal eggs from the nests of egrets. Although many of its relatives among New World marsh birds are both cryptically colored and secretive in their habits, the purple gallinule is a fearless extrovert, walking about in plain view of human observers. Yet how could a bird so wildly colored be otherwise? Not surprisingly, its call suggests a shrill laugh; in flight, with its yellow legs dangling, it cackles like a hen.*

66 *overleaf. Although a weak flier that will barely flutter away if flushed from the cattails, the sora (Porzana carolina) may cover a distance of 3000 miles on migration. The most abundant species of rail in North America, soras will evacuate a vast marsh overnight when the first frost strikes.*

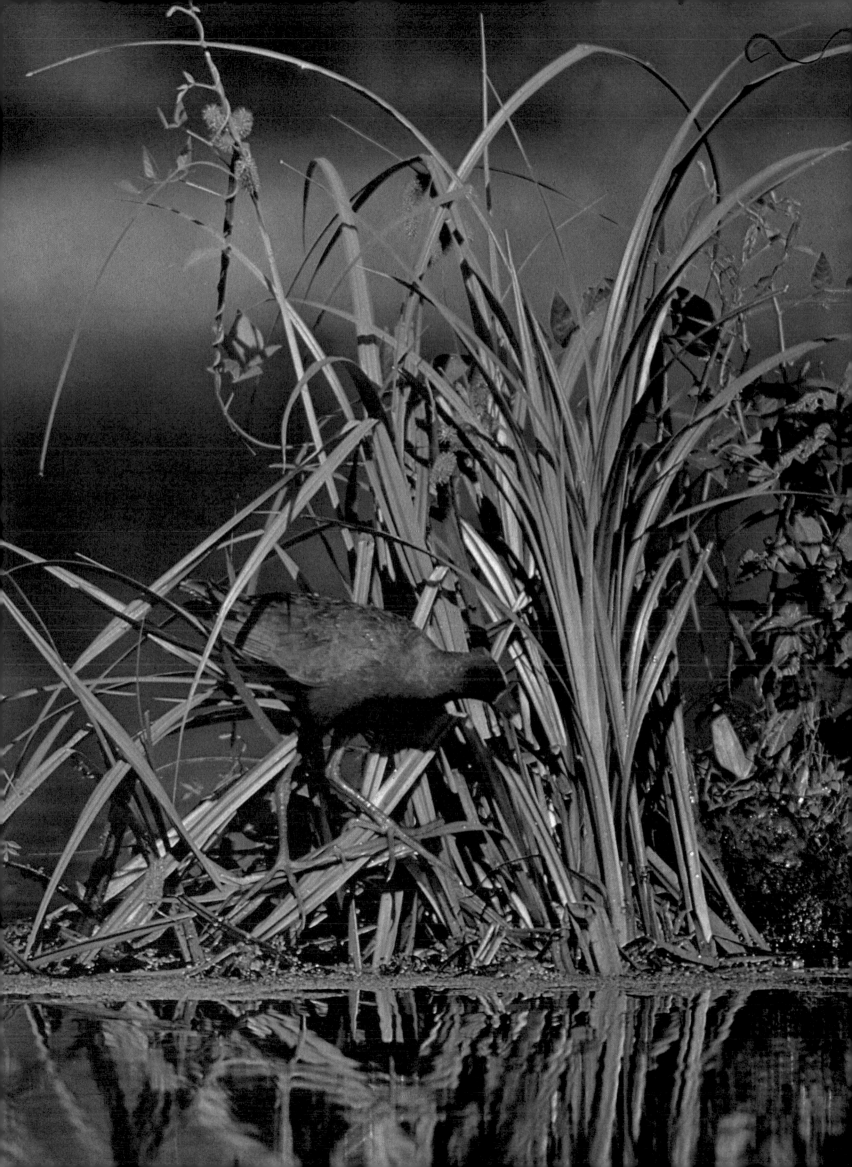

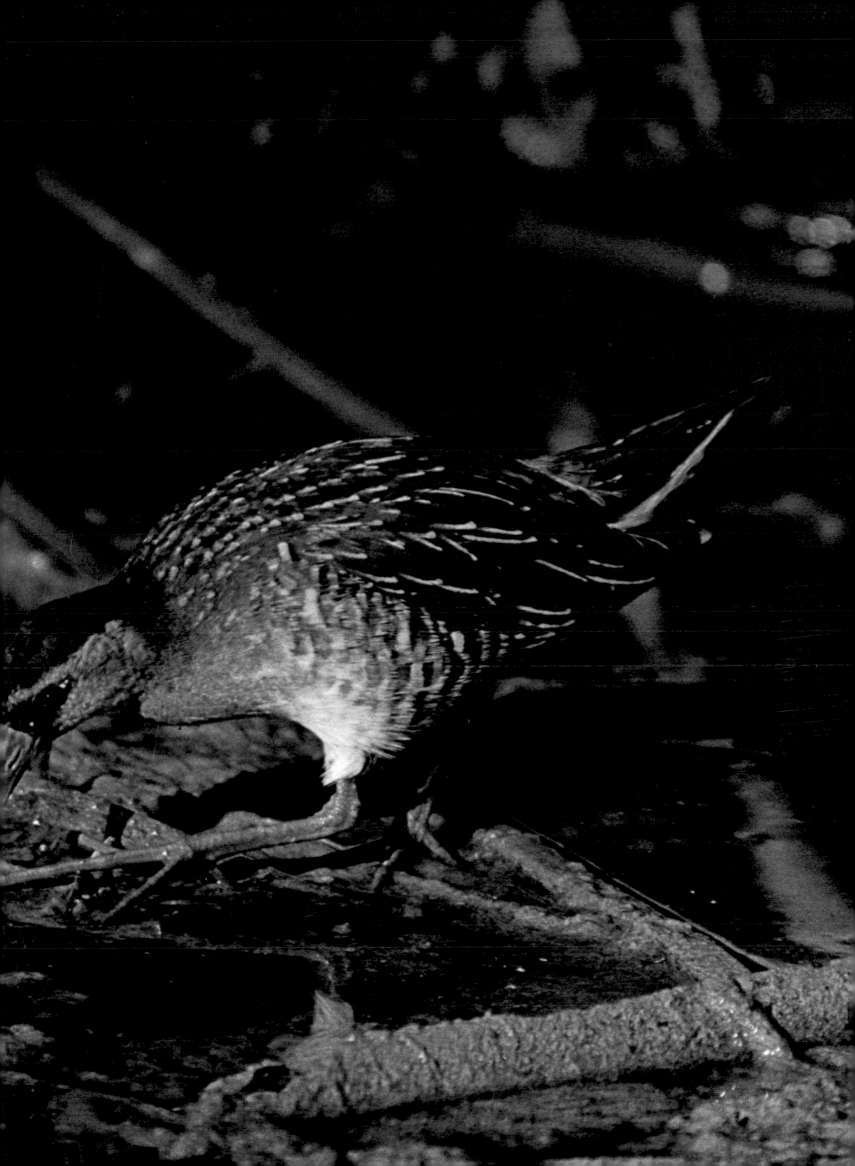

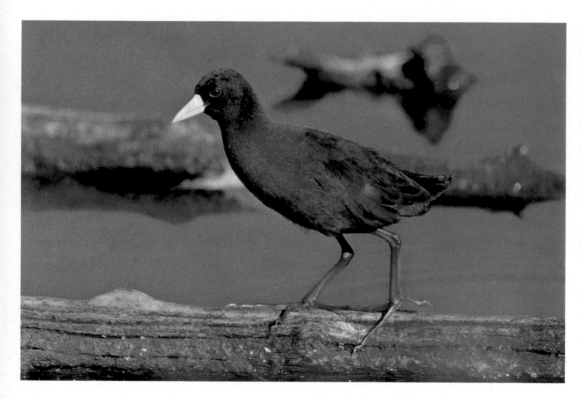

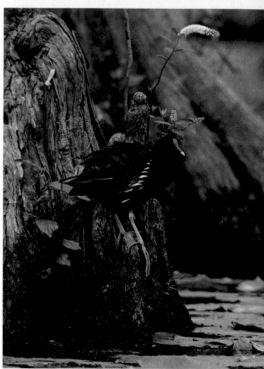

68 *left. Crake is an Old World name for the rails, and the African black crake* (Limnocorax flavirostra) *clearly shows the narrow, compressed body that is the rails' adaptation for scampering through dense vegetation. From these birds comes that old expression, "thin as a rail."*

68 *above. Scientists say that the African jaçana* (Actophilornis africanus) *is more closely related to plovers, but like the purple gallinule it has enormous feet that allow it to trot about on water-lily leaves.*

68 *below. Found in freshwater wetlands throughout much of the world, the common gallinule or moorhen* (Gallinula chloropus) *often swims like a duck, diving or dunking its head to feed on submerged plants.*

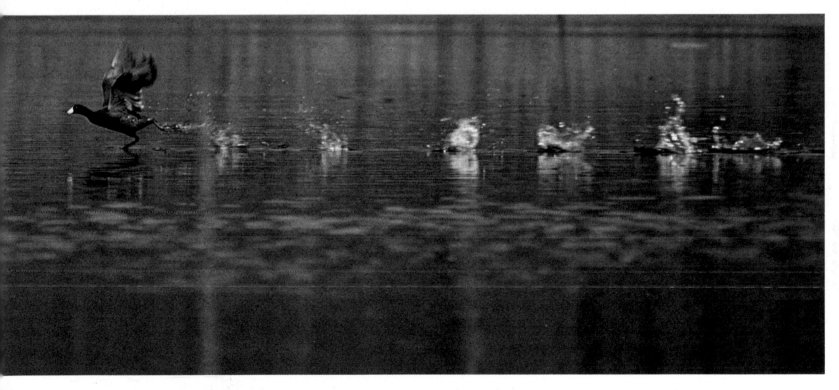

69. *Pattering along the surface of a lake, headed into the wind, an American coot* (Fulica americana) *tries to become airborne. Provided by evolution with toe flaps to help them swim, coots spend as much time afloat as do ducks. Vast numbers of coots congregate in winter on coastal bays, producing an indescribable babble of cackles and croaks.*

71 *right. Only a foot tall, the least bittern* (Ixobrychus exilis) *is a secretive bird whose nest is hidden away in dense cattails or other marsh vegetation, a flimsy structure built a foot or so above the water out of both dead and living plants. Although it has concealing coloration, in flight the least bittern displays bold markings of chestnut and greenish black.*

70. *Frozen motionless against the reeds, bill thrust skyward, an American bittern* (Botaurus lentiginosus) *is difficult for man or natural enemy to spot. Indeed, the bittern may be heard more often than seen, for in spring its guttural, ventriloquial mating call is audible half a mile away, a booming croak that has led to such nicknames as "stake-driver" and "thunder-pumper." Although it belongs to the heron family, this short-legged skulker shares the freshwater marshes with gallinules and rails.*

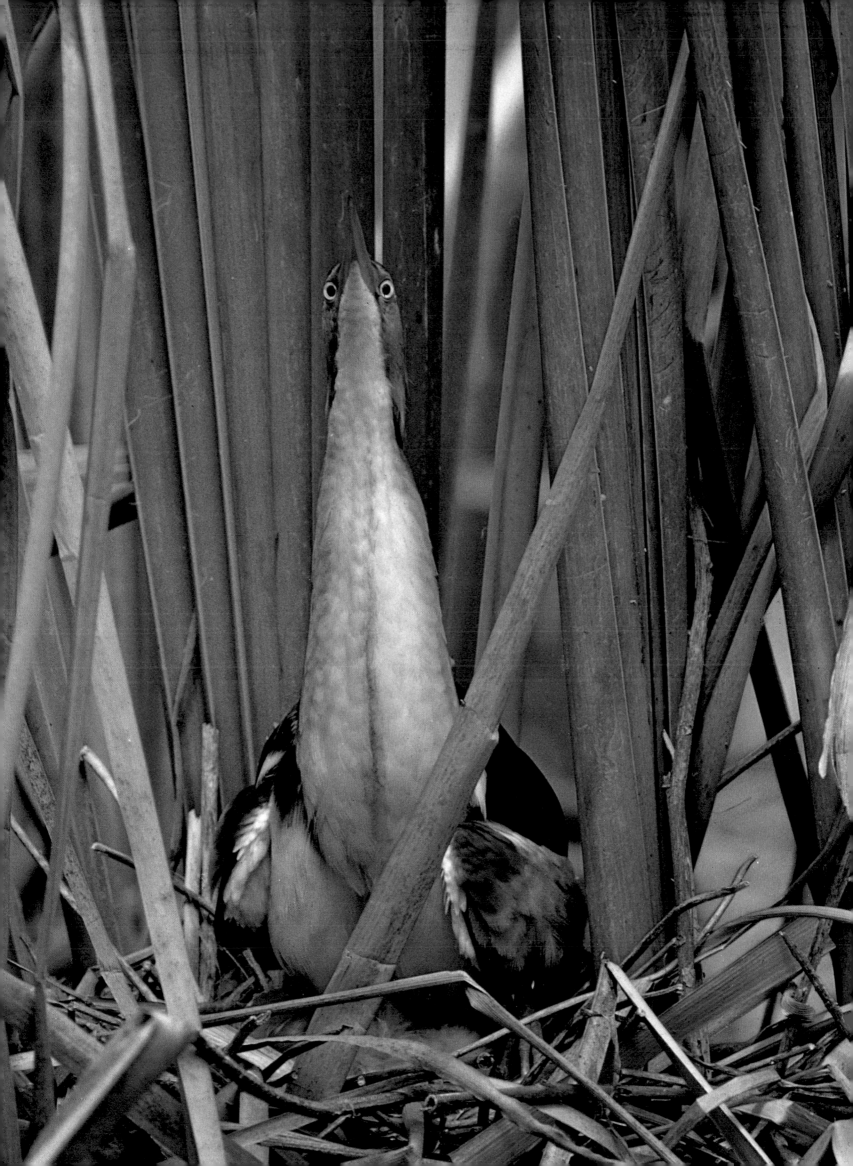

Photographic credits for the preceding illustrations:

Fishers in All Waters

The blue Caribbean waters are smooth, decorated only
by a solitary, graceful white bird with a streamer-
like plumed tail that sails into a faint breeze. Suddenly
three flyingfish break the surface, and in one deft turn
of its body the bird drops and seizes one of the fish in its
beak, then rebounds from the water into flight.
The tropicbirds, which hunt the oceanic currents of
both shores of the American continent, are fishers, one
of a specialized group of birds that has perfected the dive
as the method of securing food. With their graceful
swallow-like form and lightness of flight, they are one
manifestation of this grouping of birds—those that dive,
in many different ways, in fresh water and salt, to get
their prey. And the dive takes many forms. Only its aim
is uniform. It may consist of a heart-stopping fall from
a great height, as with gannets and boobies, the
streamlined arrow-shaped form of the bird knifing into
the sea. It may be the kingfisher's dive, deft,
pinpoint accurate, so quickly performed that the eye
has trouble following it. It may be the startlingly swift
swoop of the frigatebird, which can snap a flyingfish
out of midair in a fraction of a second. It might be the
crashing tumble of the brown pelican, which looks
like an accident. Or it may be the deep submarine
dives of the cormorants, one of the few birds with
equal mastery of both air and water travel.
The divers are united only in their purpose, not in
their species or families. They exemplify the power of
evolution to reach identical results along varied
highways of development. They personify the wonder
of the bird in all its forms.

The most dramatic divers are the gannets and
the boobies. This highly successful family of birds has
spread its numbers through tropic, temperate and
subarctic seas, and has perfected the pure dive as a
weapon of the hunt.

Gannets may be seen in their spectacular
diving displays almost anywhere around the coasts of
Newfoundland and in the Gulf of St. Lawrence. The
boobies are more wide ranging, being found throughout
the Caribbean, much of the Pacific and through the
Indian Ocean. They swarm on the Peruvian guano
islands and dive into the Humboldt Current to secure
their share of the swarming anchovettas.

Frequently they create perfect vignettes that speak of
the unity between the natural world and the creatures
that live in it, wherein man appears to be apart, and
forever only an observer. One place to watch the
diving birds is from the southern coastline cliffs of
Newfoundland, where the watcher may literally be at
eye level with the birds. There they appear silhouetted
against white clouds clustered along the coast. The
gannets circle, dark crosses against the overcast.
Abruptly the birds begin diving, although you see
nothing of their prey in the tumbling dark waters beneath.
It is like a series of death dives, the birds
dropping nearly vertically into the water, sending up
explosions of spray. The diving appears heedless. Bird
upon bird falls into the spouts of water thrown up by
those ahead of them. Yet, somehow, they avoid under-
water collision. Actually, the birds are diving quite
deep, turning under water, beneath their prey, and
attacking them in upward thrusts.

The dive appears to require a special type of body, but
this is quickly contradicted by the brown pelican, an
American species that can dive efficiently despite its
apparent ungainliness and its massive pouch for
storing caught fish. It is a master stroke of adaptation
because the pelican, although it flies quite lightly on
wide, broad wings, is not really built for the stunning
impacts with water that the gannets and boobies
survive so easily. Instead, the pelican, sighting its
prey, flips over on its back and falls so that its body
enters the water on a backward angle. Perhaps this
maneuver is designed to protect its pouch and its
more vulnerable chest. But the visual effect is
untidy, even ludicrous. But each time you think
you have witnessed a mistake, the pelican rises,

squirting water out of the pouch, flipping the fish into the air and catching and swallowing it deftly.

The diving of the brown pelican is surprising because the pelicans of the rest of the world prefer to cooperate in their hunting, working in lines or groups, beating their wings against the water to drive fish into shallow areas where then can be scooped up.

Among the diving and fishing birds, cormorants also cooperate in the hunt, and do not attempt to make the pelicans' aerial dive. They are perhaps the most deft of all underwater creatures. They, too, stage great fishing drives and form lines, particularly in bays and estuaries leading to shallow water, and drive their prey ahead of them.

They work the sea so thoroughly that no gull, or any other seabird, may find fish without the cormorants being instantly aware. And they join the hunt immediately. Their fishing skills are great, and they can satisfy their appetites faster than any other fishing bird. Often a hunting cormorant can fill its belly in only thirty minutes of hunting a day. This is perhaps the reason cormorants are so visible during the day, drying and sunning their wings, preening, displaying and playing.

When there is a real abundance of food, the cormorants show how efficient they have made their fishing. They are among the guano birds of South America, where rising currents bring up phosphates from the deeps to fertilize the surface waters and create immense populations of plankton and fish that eat the plankton. The cormorants, many millions strong, and countless other seabirds, gather to feast on this oceanic bounty, preying mainly on the anchovettas. The fishing is so effective, the numbers of cormorants so huge, that their guano, deposited on offshore islands, is dug by man by the millions of tons to fertilize crops around the world.

The cormorant has given man an object lesson in the art of fishing. In the Far East the cormorant has long been tamed and taught to fish for man's benefit. The cormorant is adaptable, which is perhaps one reason it has spread to most of the world.

Man exploits the cormorant. The incredibly agile frigatebirds, which resemble the tropicbirds in configuration, exploit other fishing birds. They range widely across the ocean without being true ocean wanderers, concentrating their powers of flight in

robbing the boobies. The victim is followed by one or two frigatebirds simultaneously, which force the attack until the fish is disgorged and dropped. The robber birds are so swift to change their course that the fish is caught in midair every time.

Actually the main food of frigatebirds are flyingfish, which are usually taken at six to twenty feet above the surface; this diet is relieved when they chase gannets and boobies. They also pirate food scraps from the ground by diving and grabbing the food in full flight without touching the surface, a technique they use for snatching up nestling birds from the ground.

This is highly specialized hunting but perhaps not as well developed as that of the anhinga, also known as the water turkey. These birds occur along eastern North America, through Central America, over much of South America, through the southern half of Africa, and in India down to Australia. These rather extraordinary birds, which live on freshwater fish and other aquatic animals, swim slowly underwater with their wings partially open. When a fish, alarmed by the dark shadow passing overhead, attempts to dart away, the anhinga unleashes a special hinge and muscle arrangement in its cervical vertebrae to thrust its head down and stab its victim with a dagger-like beak.

The anhinga's plumage, like that of the cormorant, is permeable, which reduces its buoyancy and allows the birds to submerge almost without a ripple so that the creatures they are hunting have no warning that they are coming.

All these birds are members of the great pelican tribe. Thus they are by far the most diverse group of related birds to be united by a common habit. The dive has given them greatly improved chances of exploiting the oceanic world, and this is visible in their huge concentrations of numbers off the coast of South America and in the North Atlantic. Their habits find a quiet counterpart in the life of one unrelated bird. Many kingfishers use the dive to hunt, but resemble the diving seabirds in no other way. The American belted kingfisher darts down a winding stream, gives its rattling call, then pulls up short to hover on quick-beating wings. In one movement it drops into the water and comes up with a small fish. It is a small act, on a small stage, but an essential part of the worldwide drama of the diving bird.

77. Two nestling American white pelicans (Pelecanus erythrorhynchos) crowd their heads into a parent's pouch in anticipation of a meal of regurgitated, partially digested fish. Contrary to appearance, the adult pelican's pouch does not hold the dinner ready. Instead, a nestling must rub its own bill along the base of the parent bird's bill to stimulate regurgitation directly into the chick's craw. Pelican chicks emerge blind and naked from the egg and must be shaded from the sun until they are down-covered.

78 overleaf. Pelicans like the company of their own kind, whether foraging or merely loafing like this flock of Old World white pelicans (Pelecanus onocrotalis) on the shore of Lake Edward in Zaire. There are many misbeliefs about pelicans. They do not, for instance, keep captured fish in the pouch. It is used as a dip net, and fish are swallowed as soon as the water drains away.

80 second overleaf. Gliding in on a wingspan of nine feet, white pelicans form up for a cooperative fishing expedition on a lake in Botswana. Once arranged in a crescent-shaped line, they will thrash the water with wings and feet, driving a school of fish into the shallows as they close the arc.

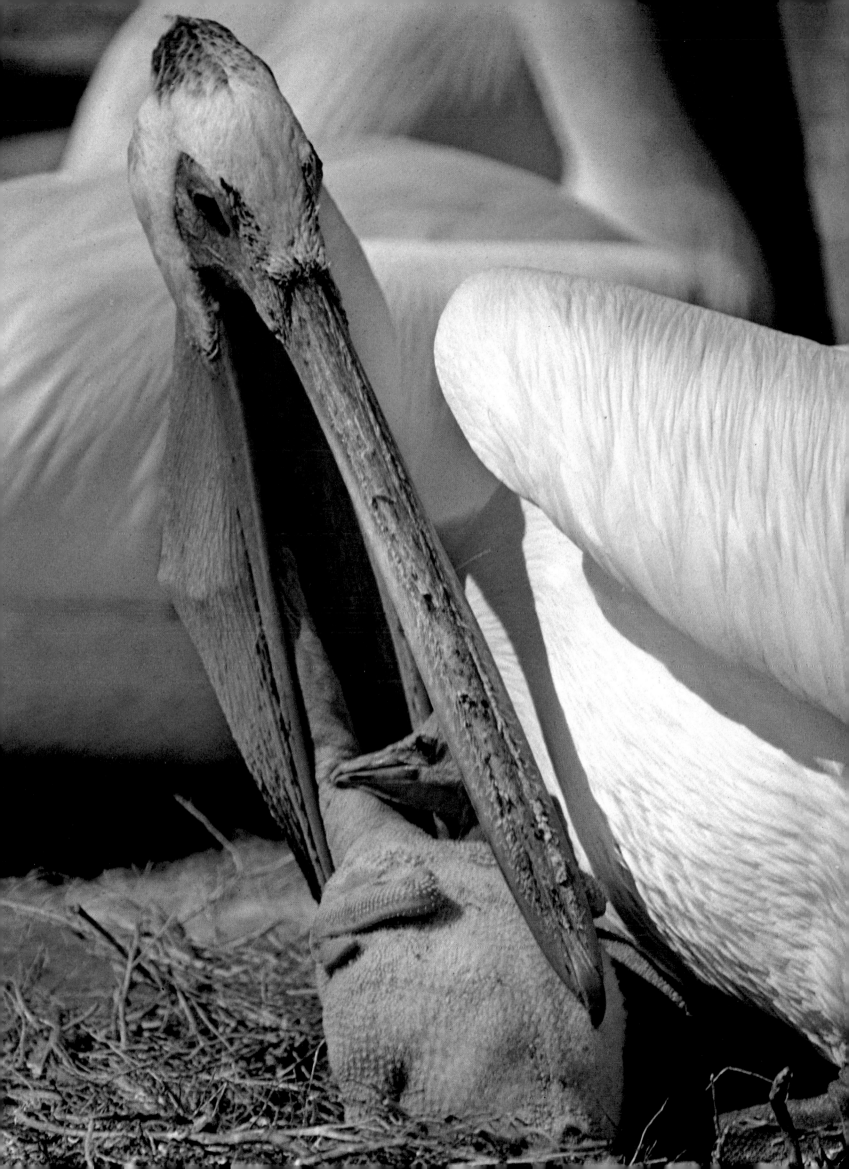

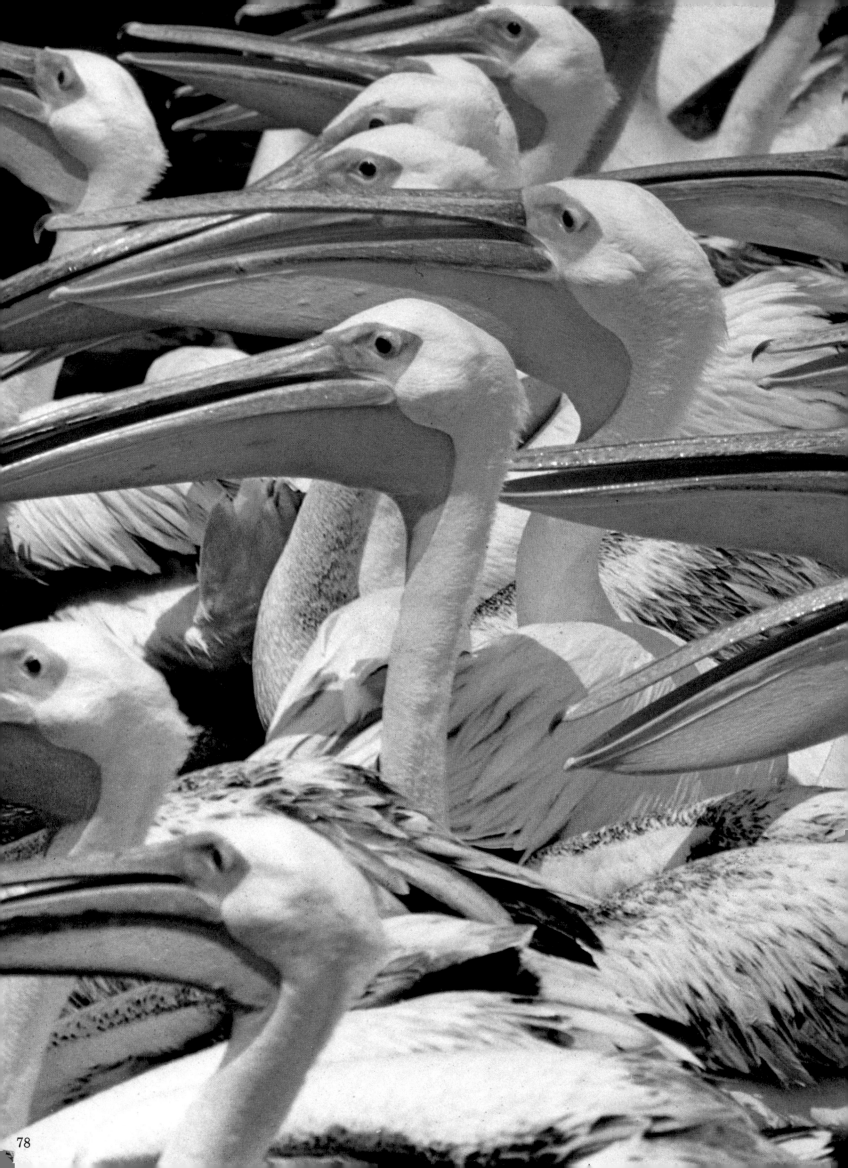

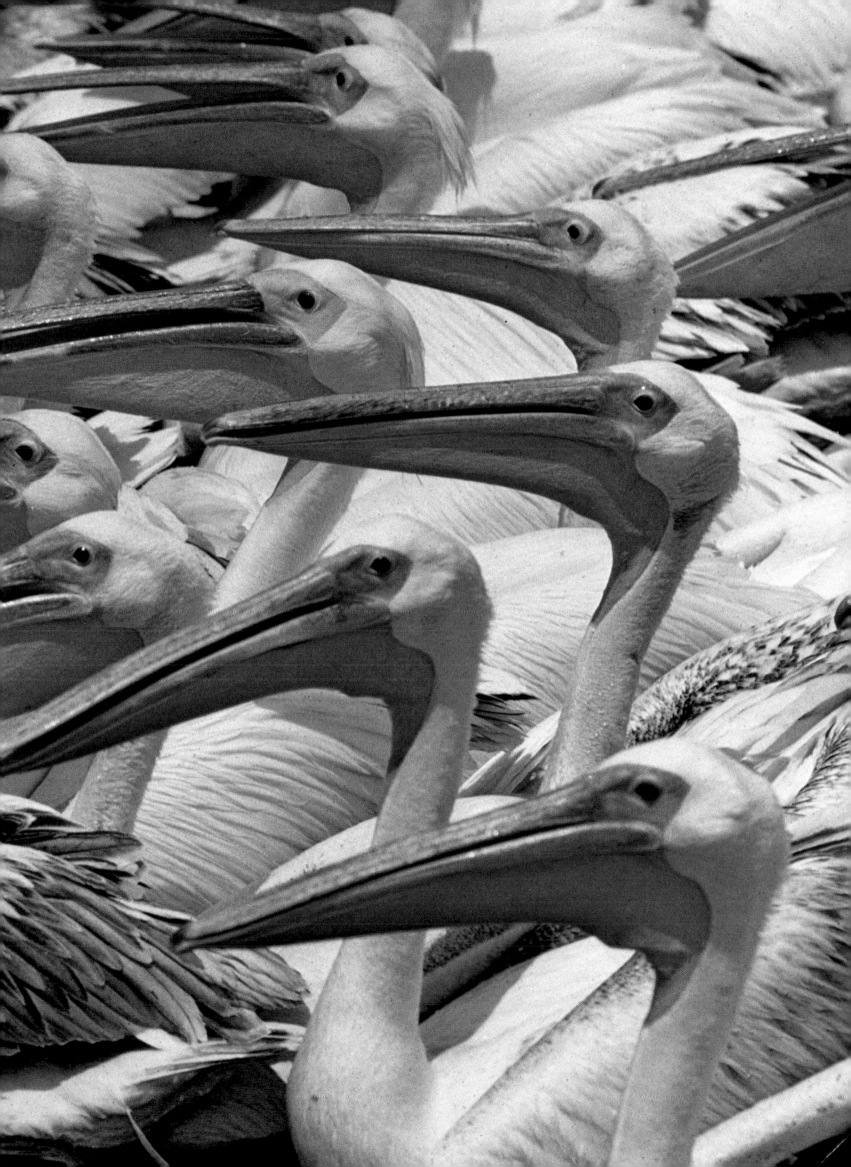

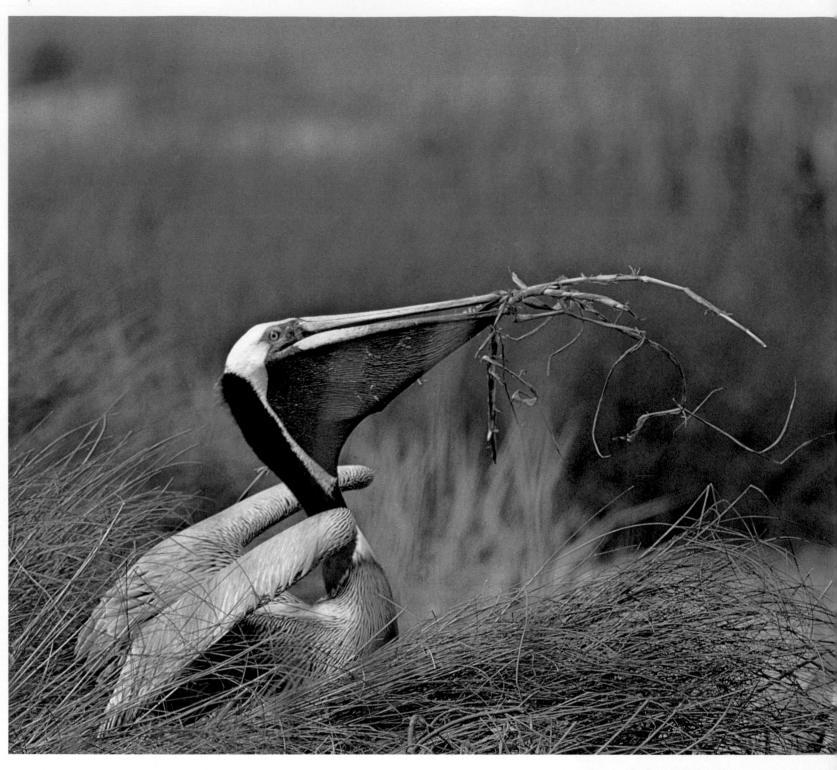

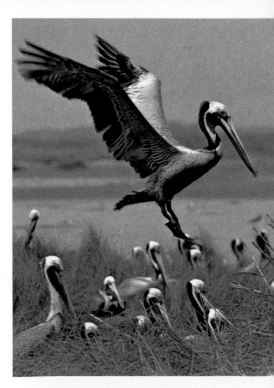

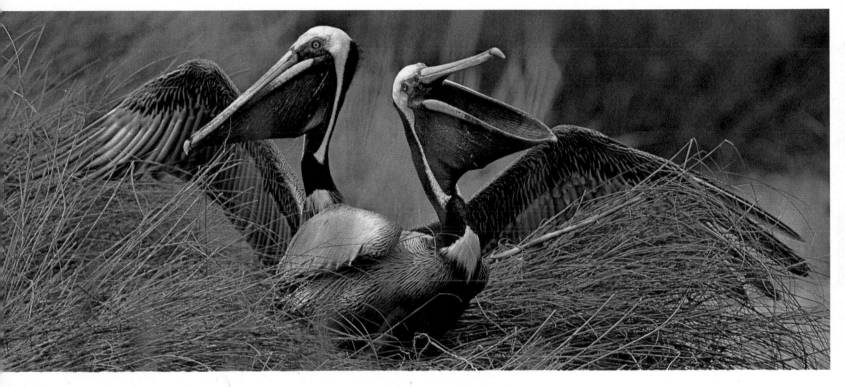

82-83. *In the low, grass-covered sand dunes of a barrier island on the coast of South Carolina, the nesting season is well underway for a colony of 1200 pairs of brown pelicans* (Pelecanus occidentalis). *Most of the birds are still incubating eggs, but a few chicks have hatched, and the island—a National Audubon Society sanctuary—is a hive of activity. A pelican bringing food for its chick glides into the wind and then, once over its nest, sinks down like a heavy helicopter. A male bird arrives with a bill-load of sticks, which are presented to his mate in an elaborate ceremony, then added to the nest. Neighboring pelicans bicker over an unseen territorial line between two adjacent nests. Brown pelican populations along the Gulf of Mexico and on the Pacific shore have been decimated by pesticides, primarily DDT, which contaminate the fish they eat and cause the birds to lay eggs with soft shells. Only in Florida and on the Atlantic coast have pelican numbers remained stable.*

84. *It takes the male great frigate-bird* (Fregata minor) *twenty minutes to inflate his gular pouch, a melon-size scarlet balloon that he displays for hours to attract one of the white-throated females flying overhead. In the nest they have built in an opuntia cactus on Tower Island in the Galápagos archipelago a single egg will be laid. For fifty-five days both parents share the incubation. Each takes three long turns, losing one-fifth of its body weight each time it sits on the nest. Frigate-birds are marvelous fliers; with bodies weighing no more than four pounds, supported by wings that span seven feet, they soar on oceanic air currents, reaching a height of 4000 feet and traveling as far as 1000 miles from landfall.*

85. *Like snapshots from a family album, these pictures from a Galápagos nest of the magnificent frigatebird (Fregata magnificens) show a blind and naked chick emerging from its egg, and the young bird at the ages of one week and three weeks. As suggested by their familiar nickname "man-o'-war bird," frigatebirds are feathered pirates. They will torment passing pelicans, boobies, cormorants, even ospreys, pecking at them or grabbing a tail or wing tip until the victim of the assault disgorges the content of its crop or drops its catch. The falling loot is then seized in midair. When buried eggs of sea turtles are hatching, frigatebirds patrol the beach, snatching the baby reptiles as they scamper over the sand toward the* safety of the surf. Colonies of other nesting seabirds are regularly raided by frigatebirds, who are not above grabbing a neighbor's unattended chick. But they are also skilled fishermen, plucking flying fish that leap ahead of dolphin or albacore. The frigatebird cannot land on water, however, for unlike other seabirds its feathers are not waterproof.

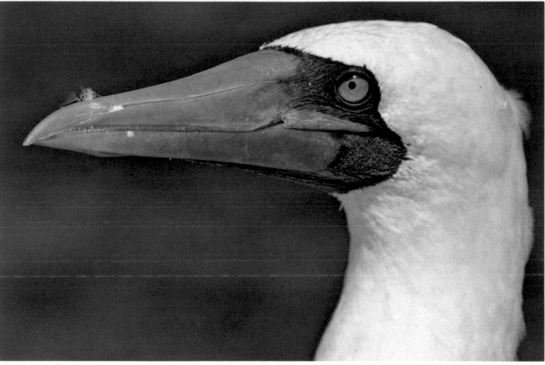

86 *left. At their nest on the seacliffs of Bonaventure Island, in the Gulf of St. Lawrence, a pair of gannets* (Morus bassanus) *engage in a ritual that helps preserve their "marriage" bond. Facing each other, standing on tiptoe, stretching their necks, they tap their beaks together with rapid, saber-like motions, then engage in mutual preening.*

87 *above. There are two color phases —brown and white—of the red-footed booby* (Sula sula), *which un-like most other boobies and gannets nests in trees on tropical islands. Red-footed boobies forage far at sea, feeding on flying fish, and the bird sitting on the nest waits an average of sixty hours—and some-times as long as six days— to be relieved by its mate.*

87 *below. The nesting of the masked booby* (Sula dactylatra) *is remark-able for the regular occurrence of sibling murder. The female usually lays two eggs, five days apart, and the first chick to hatch will evict the second one, which perishes of starvation. This fratricidal instinct ensures that the survivor will reach maturity.*

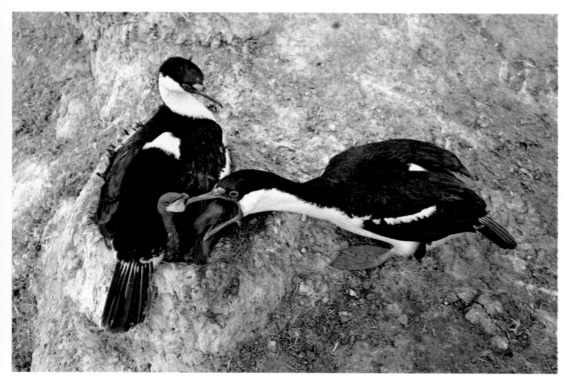

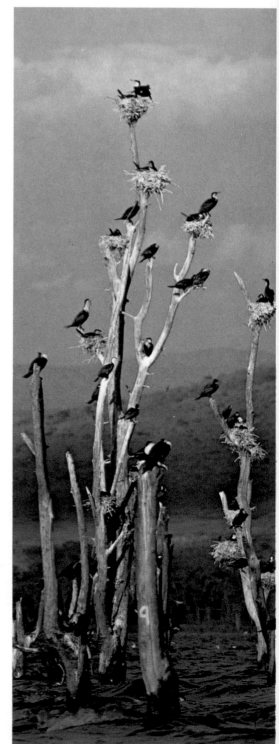

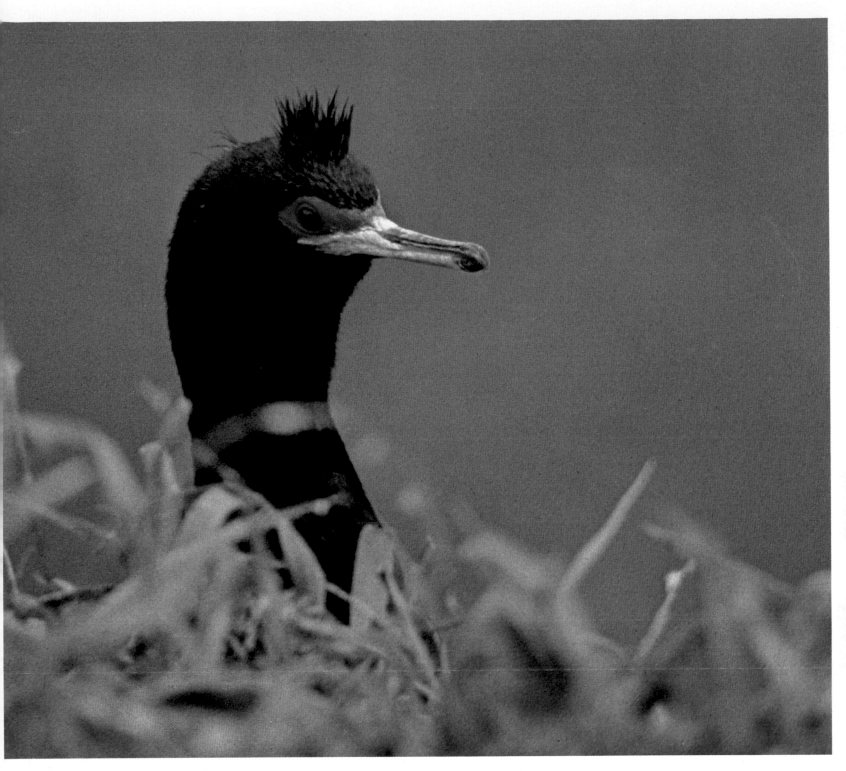

88 *left. While his mate continues to brood them, a male blue-eyed shag* (Phalacrocorax atriceps) *feeds their two chicks by regurgitation. This is one of only fourteen species of birds that have been found breeding on the continent of Antarctica. For a nest, the shags construct a mound of seaweed, feathers and bones glued together with their own droppings.*

88 *right. The skeletons of dead trees in Kenya's Lake Nakuru support a colony of white-necked cormorants, the African race of the great cormorant* (Phalacrocorax carbo). *The largest of all cormorants, nesting from Nova Scotia and Greenland across Eurasia to New Zealand, this species was once used by Oriental fishermen who kept the*

birds on tethers and filled their baskets with the cormorants' catches.

89 *above. A birdwatcher peering cautiously over the edge of a high cliff on the Pribilof Islands in the Bering Sea may find himself face-to-face with a red-faced cormorant* (Phalacrocorax urile), *with its bright blue pouch and erect crest. The name "cormorant" is a corruption of* corvus marinus, *the Latin term for "sea crow."*

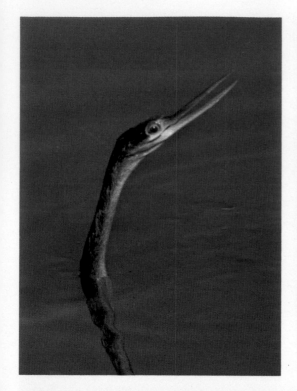

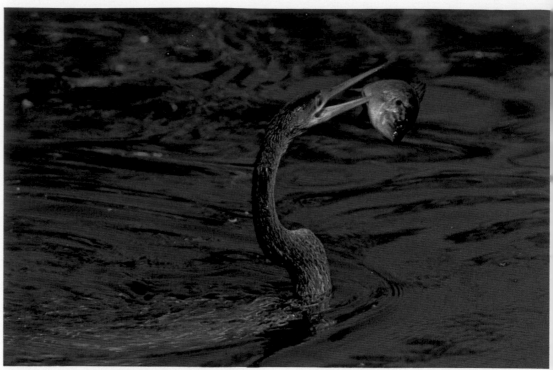

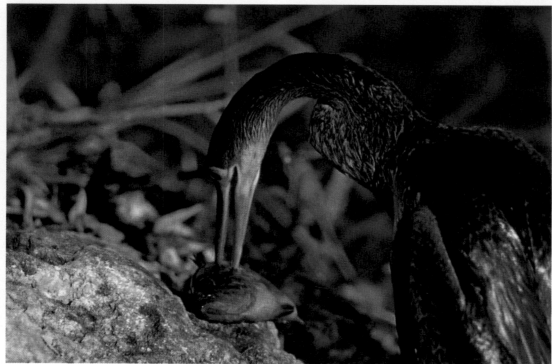

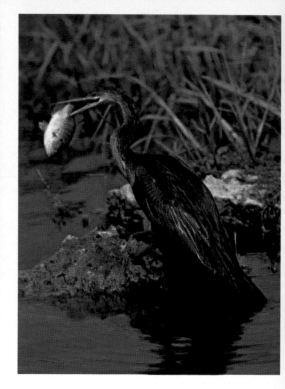

90-91. *Birds of many names, the anhingas are variously known as water turkeys, snakebirds and in the Old World as darters. The scientific name of the genus, and the official common name for the species* (Anhinga anhinga) *that nests from the southeastern United States to Argentina, comes from the language of the Amazonian Indians. Its tail feathers, when fanned, suggest those of a wild turkey. Its head and neck, which certainly are snakelike, are kept coiled as the anhinga uses its powerful feet to pursue a fish underwater where it darts out its rapier beak to spear its prey. Because the anhinga's wings are not waterproof and thus must be spread to dry in the sun, it enters the water only to feed or to flee*

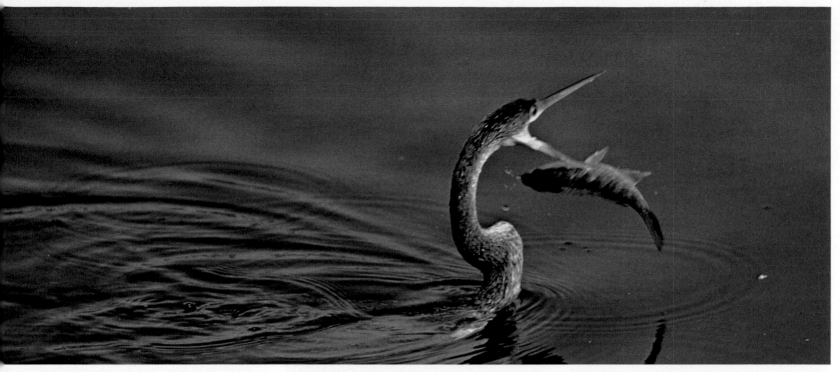

danger. It swims about with only head and neck above the surface, and once the bird has speared a fish it faces the problem of positioning the catch to be swallowed head-first. If tossing the fish into the air does not work, the anhinga takes the fish ashore, pounds it into submission against a rock, then consumes it whole.

93 *right.* **Kingfishers range in size from a minuscule four inches in length to eighteen inches. Among the smallest of its kind is the azure kingfisher** (Ceyx azurea) *that haunts jungle pools in tropical Australia.*
94 *overleaf.* **The length of its body doubled by a pair of streaming white feathers, a red-billed tropicbird** (Phaethon aethereus) *flutters over the rolling Pacific beneath its nesting cliff in the Galápagos Islands. Named for the son of Helios, Phaëthon, who fell into the sea from the sky, tropicbirds will plummet—sometimes in a spiral—from a height of fifty or more feet to capture squid and fish.*

92. *Pelicans, frigatebirds, gannets and boobies, anhingas, tropicbirds— these large, fish-eating aquatic birds are closely related members of the same order, Pelecaniformes. Much further up the avian evolutionary tree are the kingfishers—a world-wide family of brightly colored land birds whose more than eighty species include both skilled fishers and forest-dwellers that feed on insects, snakes, earthworms, small birds and mammals. A fishing king-fisher will hover over the water, or perch motionless on an overhang, then—like this sacred kingfisher* (Halcyon sancta) *of Australia and New Zealand—plunge and seize a minnow with a narrow, sharp-pointed bill resembling that of a gannet or tropicbird.*

Photographic credits for the preceding illustrations:

Wings near the Shore

The Arctic terns gather in noisy congregations, swooping upward in brief, almost hesitant flights, then settling back into the tundra grasses where they have nested during summer. They are ready to leave, their juveniles among them. But the journey ahead is daunting.

At dawn one day they depart, flying rapidly over lake and pond, over tundra river and estuary until they reach the shores of Labrador. They cut down the coast toward Newfoundland, or cross the sea to Greenland. Their passage south is quick and sure. They will not stop until they have crossed the Atlantic, flanked the shores of Africa and sped south beyond the Cape of Good Hope.

The grace and style of the terns is typical of a group of seabirds that make their living in a narrow band of territory, neither in the deep ocean nor on the shore-lines of seas and lakes. These are the gulls and terns, related but separate in development, and including some of the most attractive and interesting birds to be seen anywhere: the powerful royal terns, the pretty roseate terns, the hardy glaucous gull of the north and the predatory black-backed gull.

They are represented by jaegers, piratical killer gulls, that range the Northern Hemisphere in pursuit of almost any other gull, its chicks, its eggs. Jaegers hunt shorebirds, ducks, even owls. Compared with the jaegers is the delicate kittiwake, one of the smallest of the gulls, which ranges even more widely and is the most thoroughly widespread seabird breeding in the North Atlantic. It is by far the most oceanic of gulls.

All these birds are consummate fliers, not with the directness and brute power of waterfowl nor with the soaring grace of wading birds, but with a capacity to equally master both dead calm and howling gale. The artistry of the flight of the terns, so dashingly and visibly paraded at all times, may seem to depreciate the real skill of the gulls, which are among the most expert fliers anywhere. With some exceptions, gulls are truly creatures of the immediate offshore area. Some of the dark-headed gulls have gone far inland to breed. There they have turned their hunting to worms, insects and small invertebrates. All of the gulls, except the oceanic wandering kittiwakes, the ivory gulls and the Ross' and Sabine's gulls of the Arctic, depend on the land to supply them with food. They plunder berry crops as well as the grain and seed crops of man. The dainty ivory gull of the Arctic lives on the droppings of bears, walrus and seals, supplementing this diet with shellfish, insects and crustaceans. Its northern range is set in such hostile country, so far north, that its southern movement during winter takes it only into areas where other Arctic birds summer, around the mainland shores of the polar basin. It is, without doubt, the hardiest gull on earth.

All of the northern gulls are elusive in their movements and habits, but the Ross' gull was for long the North's greatest mystery. Very few of these birds had been collected as late as 1900. Just before the turn of the century, Fridtjof Nansen, noted Scandinavian explorer of the Arctic, shot eight of them from his ship, the *Fram*, when he was frozen for ten months in an icepack. In the summer of 1905 its breeding place was discovered in the delta of the Kolyma River, which flows into the polar basin in eastern Siberia. From this came the knowledge that Ross' gull comes south to breed in summer, then migrates north in winter to resume ranging around the Arctic.

The motif of the gulls is diversity. Sabine's gull is a good contrast with the Ross'; it is just about as beautiful, with its rich dark gray "hood," its pale gray mantle, its forked tail and its black primaries. It breeds in the high Arctic, but unlike the Ross' gull, its movement is north and south and it appears to winter off the coasts of South America and the Bay of Biscay. Gulls are the true free spirits of earth. They have reached almost all corners of it. Bonaparte's gull

occupies only the far north of Canada reaching up to the Arctic circle. The black-headed gull occupies most of Europe and all of the Soviet Union, right to the Pacific shores. Saunder's gull occurs only in northern China. The white-eyed gull is tropical, hunting the hot Red Sea and part of the eastern shores of Africa. The brown-hooded gull occupies only the far southern reaches of South America.

The close relatives of the gulls, the terns, are no less adaptable. The main difference between gulls and terns is that gulls are chiefly northern birds and the terns are fundamentally tropical. The Pacific hosts thirty species, and twenty-five occupy the Atlantic and the Mediterranean. Nineteen species of terns have made their home around the Indian Ocean. They have colonized most of the borders of the North Atlantic with seventeen species. The Arctic tern has crossed the Arctic Circle in the north during its breeding "summer." It "winters" near the Antarctic Circle.

The terns are spread widely, creatures also of the marshes, of the rivers, of many swamps. Six species breed inland in North America; several in Africa, Australia and South America; five in India; and nine are inland breeders on the Eurasian landmass.

The terns show their relationship to gulls in their gull-like habits, or perhaps it is the other way around. But the terns have longer wings. Their tails are much longer and are usually forked. This gives them a particularly distinctive appearance. In flight they are like thistledown: buoyant, light, as though they were floating.

The gulls, in the main, are predatory, sometimes cannibalistic, determined, and solidly emplaced in their worlds. The terns are nervous, frequently capricious, often abandoning an entire breeding site and moving away several miles. They are extremely sociable and appear to depend on having large colonies, with the nests very close to each other, for their breeding successes. They have extremely mixed relations with the gulls. They have been known to settle without warning in the middle of a gull colony and, by their aggressive and hostile activity, drive away the gulls. But herring gulls often move into a colony of terns and drive them off.

The terns are the butterflies, or the swallows, of this grouping of seabirds. Despite their graceful aspect, they have no hesitation in attacking marauding

skunks and raccoons—which are usually able to ignore them—and they successfully drive off dogs, cats, rats and even large animals like sheep and men.

Their close relationship to gulls may be divined in their flight and general appearance. They can swim, but do not like it and do not do it well. If incapacitated on the ocean surface, they soon drown. A gull, on the other hand, may swim indefinitely. A herring gull with a broken wing once swam across the Atlantic, according to reports of Newfoundland fishermen.

The tern has specialized the hunting process so well that it can make an accurate strike from a height of fifteen feet on a quick-moving fish several inches below the water. It can strike the surface, penetrate it and seize the fish in its long bill, all in one smooth motion that looks as though the tern has been drawn down to its target on a string. One of the terns, the noddy, has perfected this to the point where it can catch minnows as they leap clear from the surface.

Marsh terns not only hunt small freshwater fish but also tadpoles and beetles, spiders and other insects. They hawk for insects, like swallows and other flycatchers. Forster's tern, of the New World marshes, is a scavenger when it arrives on its thawing breeding grounds. It picks up all kinds of dead fish, insects and amphibia released by melting ice.

At the far end of the evolutionary scale is the highly specialized black skimmer. It is actually a black-backed red-footed tern and feeds at dusk by plowing the surface of estuarine waters with its extremely long lower beak. This stirs up phosphorescence which attracts small fish, enabling the skimmer to come back over the disturbed area again to snatch and scoop up shrimp and small fish.

The skimmer is so specialized that it has none of the personality of the rest of the terns. On its breeding grounds it is rather clumsy. It appears to be stupid in relationship to the terns all around it. When nesting near or with the extremely fast-flying and powerful royal terns, the skimmers have a hard time of it. The royal terns often persecute them, hack out a colony of their own inside the center of the black skimmer group and kick sand over their eggs. The skimmers look on and do not attempt to defend themselves. The specialist pays a high price for his skills.

101. Soft light penetrating the tropical foliage of Cousin Island, one of the Seychelles group in the Indian Ocean, outlines the lovely form of a fairy tern (Gygis alba), which has just caught a tiny fish. Barely the size of an American robin, the fairy tern is truly one of the most beautiful birds in the world: it is pure white except for black bill and legs and a patch of black feathers surrounding the eyes. Found on isolated islands throughout the tropical seas, the fairy tern is also noted for its curious nesting habits. It lays a single egg in the most precarious places—in a slight depression in the bark of a mangrove branch, on the midrib of a palm frond, on a minute rock ledge— from which it could be ejected by any mismove of the parent birds as they alternate incubation duties. When the chick hatches it will hang on by its claws for several days, even dangling upside down.

102 overleaf. In their food habits, gulls are opportunistic. They scavenge man's wastes at garbage dumps and fish canneries. They scour shorelines for shellfish. They tag behind farmers' plows to glean worms and grubs turned up by the blades. They are also rapacious hunters, raiding the nests of other colonial species, and pursuing small mammals and birds. But the closely related jaegers of the Arctic tundra have made piracy and predation their specialty. While wandering the oceans in winter they harass other seabirds, forcing them to give up their catches. In summer, on their breeding grounds, they feast on songbirds and shorebirds, on eggs and nestlings of larger species—even owls!—and particularly on lemmings. Indeed, these mouselike animals are the staple diet of the long-tailed jaeger (Stercorarius longicaudus), which can hover like a falcon or soar like a frigatebird, its central tail feathers projecting an extra six to ten inches, its shrill cry ripping across the barrens.

104 *left. Phantoms of the polar pack ice, a pair of ivory gulls (*Pagophila eburnea*) land on frozen Seymour Island, a three-square-mile jumble of rock high in the Canadian Arctic that is the last breeding place of this circumpolar species in North America. The only gull with pure white plumage, this is also one of the rarest of all gulls. Its nesting sites are among the most remote and inhospitable places on earth, and it will even colonize rock-covered floating ice islands. Ivory gulls feed on lemmings, insects, crustaceans and mollusks, and they will follow both Eskimo hunters and polar bears, cleaning up any remains of kills and eating blood-soaked snow. While natives in northern Greenland kill some ivory gulls for food, the bird's* worst enemy is the arctic fox. If ice conditions allow a single marauding fox across to an ivory gull colony, it can wipe out every nest in a few days.

105 *above. A herring gull (*Larus argentatus*) floats in to land on a branch of a dead spruce. More than fifty thousand of its kind colonize Kent Island, in Canada's Bay of Fundy. To outwit the egg-gatherers and feather-hunters of earlier years the gulls took to roosting and even to nesting in trees.*

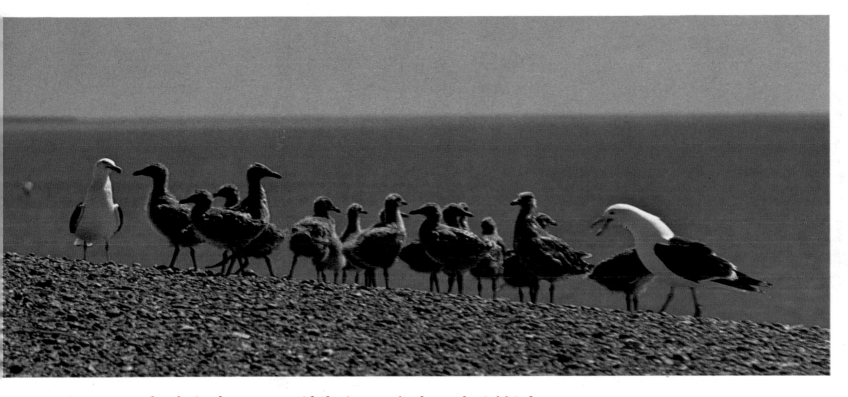

106 *left above. Found only in the Galápagos Islands, the swallow-tailed gull* (Creagrus furcatus) *is not only one of the most attractive gulls but also the most extraordinary. It feeds at sea after nightfall, when squid and small fish come to the surface. Scientists have noted several adaptations that may aid this nocturnal activity: an unusually large eye that reflects rather than absorbs light, a clicking call that may help in finding a cliffside nest by echo-location, and white markings on the bill that make it easier for a chick to feed from its parent in the darkness.*

106 *left below. A pair of dolphin gulls* (Larus scoresbii) *copulate on a beach in the Falkland Islands. These aggressive predators continually raid the nests of other colonial birds, and are brazen enough to snatch an egg virtually from under the feet of a much larger kelp gull.*

107 *above. A creche of young kelp gulls* (Larus dominicanus) *is watched over by two adults on the shore of Tierra del Fuego. Gull chicks can walk soon after they hatch, but they stick tight to their nest until well grown. Straying chicks risk being eaten by a neighboring gull.*

108 *below left. Golden stonecrop on an island off Maine provides a perfect setting for the lovely Arctic tern* (Sterna paradisaea), *whose annual migration far into the Southern Hemisphere and back may cover twenty thousand miles.*
108 *below right. A common tern* (Sterna hirundo) *drops to its nest on a sandy beach along the North Atlantic shore. Before bird protection laws were enacted, terns often were mounted whole on the hats of fashionable women.*

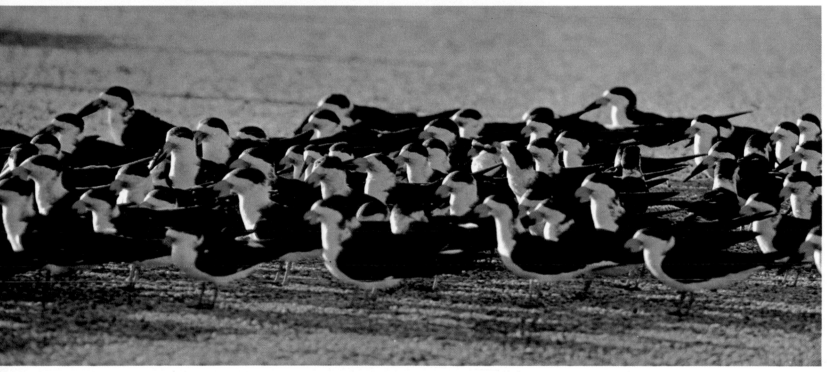

109 *above. Caspian terns* (Hydro-progne caspia) *tend their chicks on a New Zealand beach. Largest of all terns, with a wingspan of fifty-three inches, this tern is gull-like in many of its habits, soaring to great heights, riding on the waves, and even raiding nests of eggs and chicks and robbing other seabirds of their catches.*

109 *below. Heads pointed in one direction, their remarkable bills aglow in the late afternoon sunlight, a closely packed flock of black skimmers* (Rynchops niger) *rests on a Florida sandbank. The mandible, or lower bill, of a skimmer is four inches long and considerably over-laps the maxilla, or upper bill. When the bird feeds, it plows the water at a speed of twenty feet a second with the knifelike mandible immersed nearly to the mouth. When the bill strikes a fish, the maxilla snaps closed. The bone structure of the skimmer's skull and its neck muscles are strengthened to absorb the sudden impact.*

110 *overleaf. A close relative of gulls and terns, the black skimmer flies with fast, powerful strokes of its long wings. The skimmer's eyes are as unique as its bill. It is the only bird with a vertically split pupil, which enables it to be active in both the glaring light of day and the dim light of twilight and night.*

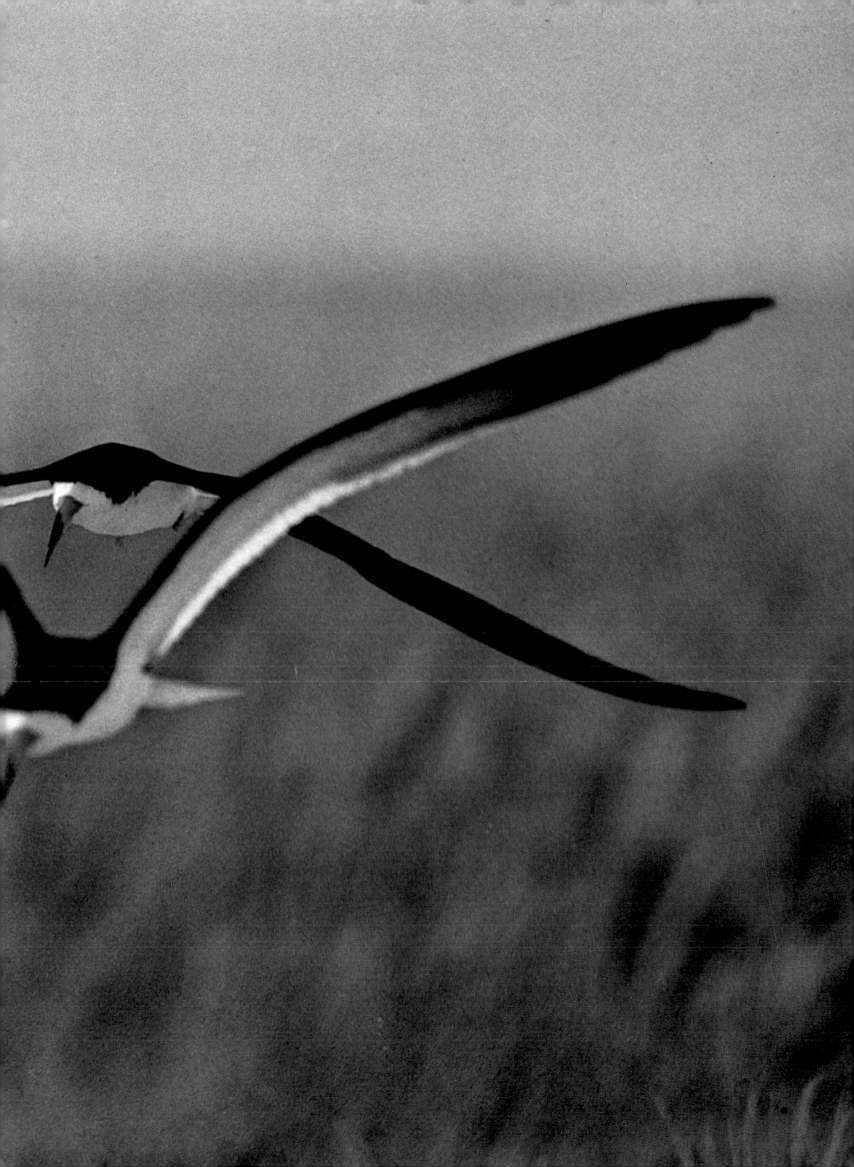

Photographic credits for the preceding illustrations:

Shorebirds in Migration

They come down the shoreline in great rushing engines
of movement, compacted so well they look like
single instruments of flight. These are sandpipers, in
migration flight from their tundra breeding grounds
in the subarctic. They are shorebirds, a misleading
term because many other birds, such as gulls and terns
and others, also spend much of their time along
shorelines. The sandpipers are united to the shorebird
group by their specialist capacity to glean food in the
wake of retreating oceanic waves along most American
and Eurasian beaches.

All shorebirds are highly specialized in getting their
living from that territory where sea meets shore,
although many are just as capable of hunting far inland.
The oystercatchers, with their peculiar bills that can
seize and twist shellfish bodies out of their shells with
one deft motion, exemplify a typical differential common
throughout the shorebird group. The long-billed curlew
is equally well fitted into its world, with a bill that can
probe into mud and sand to find hidden worms and
shellfish buried well below the reach of any other
shorebird.

But for the human watcher, the magic of the shorebird
is in the backgrounds against which they are usually
seen—crashing breakers, gray-blue expanses of marsh
and dune, sweeping vistas of estuary and rock-bound
coasts. The shorebirds pause to be seen, then hasten on
to destinations on the other side of the earth. They
leave behind memorable impressions of their forms.
The statuesquely graceful black-necked stilts stalk the
shore on long red legs and feed with delicately tapered,

slender bills. The avocets also have peculiar bills, upturned, and fully half as long as their bodies, sprouting from beautiful orange-pink heads surmounting black-and-white striped wings. The golden plover, a master of long-range flight, stands boldly on a rocky outcrop of the Newfoundland shore, short-legged, short-billed, but built like a powerful machine for its long flights. The other plovers, too, are short-legged, stocky, more like sandpipers, and camouflaged with stripes and dark wings to blend against the rocky backgrounds, the seaweed-strewn shores. They often disappear the moment they land.

The long-billed curlews give elegant touches to the shorebird world, with long downturned bills, tall necks, longish legs and stocky bodies, pairs of them often seen mirrored against tundra ponds. Shorebirds are at once oddly beautiful and utilitarian, whether they be godwits, killdeers or yellowlegs.

As the sandpipers come rushing down the eastern American shores in the late summer, they show the three qualities shared by all shorebirds. Their flight is fast—there are no *slow* shorebirds anywhere—and they have great endurance. Some plovers may fly more than 2000 miles nonstop on the longest stages of their migrations.

The great ranging movements of shorebirds, their quickness of arrival and departure, the difficulties of observing them at all times, has created much mystery about parts of their behavior. Some migrating plovers, which customarily eat bladder snails, have been found with the snails placed in their plumage. Certainly they travel far across territory where there are no suitable feeding grounds. But whether they do in fact carry food reserves in this form is a puzzle that may never be solved.

Shorebird migration suggests that the birds are locked into innate and unchangeable behavior. It is more likely, however, that external pressure has forced this evolutionary response to make such vast journeys. One presumed cause is the advance and retreat of the glaciers of the Wisconsin ice age, which forced large populations of shorebirds, and others, to move southward, perhaps beyond territories suitable for them to survive. Thus it is theorized that they had to wing far south to find "wintering" grounds to prepare themselves for the northern breeding. But quite a number of shorebirds have given up migration

altogether. Some of the willets, avocets, oystercatchers and Wilson's plovers, killdeer, snowy plovers and rock sandpipers all give up their migration flights when the conditions are suitable for them to remain in place. So shorebird flights are neither innate nor unchangeable. But for those which do migrate, they provide compelling spectacles of creatures gathering all around the earth in a series of mass movements toward the Arctic Circle. A migrant sanderling, moving up the shores of the United States and Canada, may be heading directly toward another sanderling coming up to nest in the Russian Arctic. Although most shorebirds go high up into the tundra country to breed, as a group they are various in their behavior there too. Some, like the long-billed curlews, the marbled godwits and some of the sandpipers, prefer prairies or grasslands for their breeding. Marshes are favorite places for some plover, snipe and the spotted sandpipers. The woodcock go into forests, as do the lesser yellowlegs, the solitary sandpiper and the short-billed dowitcher. The remainder, more than half of all the shorebirds in species, go into the tundra.

Why should such a vast army of birds fly so far north, at such cost in danger, energy and accident? One answer is that the tundra offers an unlimited temporary resource of insects, flies, beetles, mosquitoes, midges and spiders. The shorebirds never lack for food in the brief time they spend in the subarctic. It is a cornucopia of life, and they are there to exploit it. The tundra summer is so short that the shorebirds must arrive to breed almost on the day that the spring thaw starts. Their young must be born, raised and on the wing in a little more than sixty days. So their arrivals are timed precisely. The excitement of the tundra meeting is infectious, almost overpowering. There is frantic purpose and competition for the best breeding sights, for the choosing of females and for the construction of nests, if any, and the laying of eggs. Few naturalists who have seen this spectacle ever forget it, for it carries such a feeling of joy and abandon that it picks up and carries the human watcher with it. The air dances with hovering, fluttering, darting birds. It rings with the music of their cries. On the ground, willets strut about while many of the shorebirds are flipping their wings in display, or bowing to each other, as do the avocets, while

dowitchers sing to each other. The pectoral sandpiper inflates a sac in his throat and flies overhead booming strange cries as he drops down toward his mate. The excitement grows. The ruffs, which have reached the North American tundra grounds from their Eurasian territories but have never bred in America, are among the most beautiful of all the shorebirds and unique in that they establish dancing grounds that they use year after year. Here they dance and pivot and fight with other males, and exhibit their beautiful ruffs to secure the attentions of the reeves, their females. All during the rest of the year, the ruffs and reeves tend to live separately. No matter how hard the ruffs run back and forth and display, it is only handsome appearance, apparently, that counts for the reeve. Frequently she chooses the vanquished because he, not the victor, preserved his ruff from being crumpled in the fighting. The roles are reversed with the phalaropes. The hen displays, defends the territory, courts and chases the apparently reluctant male. Sometimes males hide themselves in vegetation, as if to escape these incessant attentions. The males of at least two species, the Wilson's and the northern, both guard the nest and rear the young without the assistance of the hen. The reversal is complete in that they are duller colored and smaller than the females, which may be of help in their nestling-raising duties. All too soon the brief subarctic tundra summer is over. The young shorebirds are all on the wing. Although 80 percent of them did not survive from egg to feather, hundreds of thousands are now on the wing and ready for the great voyages to the south. The tundra country is withering as the weather cools. The mosses, lichens, sphagnum and dwarf willow will all soon be yellow and become dormant with the arrival of the first frosts. The great swarms of flies, midges, mosquitoes and spiders will return to the earth to survive the next ten months of freeze. The endless light that made breeding possible is being replaced with twilight and night. The energy of the insect swarms has been transferred to the shorebirds. Impatiently, they wait for the sign. One day, in masses, in small flocks, as individuals, they start south. The great migration of the shorebird millions continues on its endless course.

117. *The tide is receding in this Virginia estuary as a pectoral sandpiper* (Calidris melanotos) *in winter plumage probes the mud with its straight bill in search of worms, mollusks or crustaceans. It is early October and the bird is en route from Arctic nesting grounds to South America. Never a common species, most pectoral sandpipers migrate overland in small flocks, pausing to rest and refuel in wet meadows, marshy places, even pasturelands—a habit that earned it the nickname "grass snipe" in days when shorebirds were heavily hunted. Displaying males inflate their neck and breast, puff out a bib (their pectorals), and drift over their chosen territory, hooting a musical song that suggests a child blowing across the mouth of an empty soft-drink bottle.*

118 *overleaf. The low late afternoon sun casts a long shadow on an Atlantic beach as a dunlin* (Calidris alpina) *rests in a typical sandpiper pose: standing on one leg, bill tucked under a wing. In summer the dunlin is distinctively colored, with a rusty back and black belly, but this bird shows the typically cryptic winter plumage that causes endless anguish for birdwatchers trying to tell one sandpiper from another. Nesting in the Arctic around the pole, dunlins—unlike many other shorebirds—remain in the Northern Hemisphere in winter and can be seen along seashores in dense flocks.*

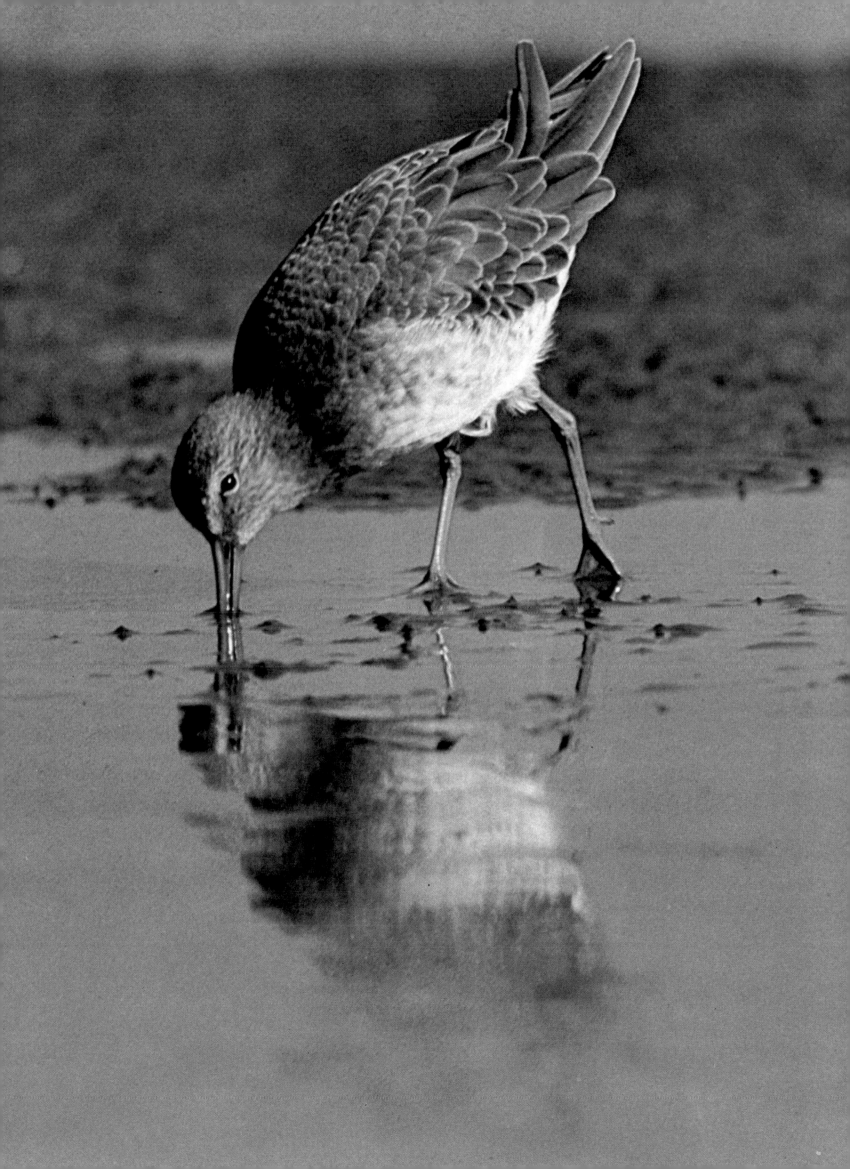

120-121. *Grouselike in its courtship behavior, the ruff (Philomachus pugnax) is unique among shorebirds. Although in winter both sexes look like plain large sandpipers, in spring the males undergo an incredible transformation. Now they sport the lavish adornment of a feathery collar that flares out around the neck and head, plus two showy tufts atop the head and colorful wattles on the face. Moreover, no two males look alike as they gather on communal arenas—called leks—across northern Eurasia to vie for the attention of the unornamented females, or reeves. The color of that feathery mane may be black, white, purple, orange, yellow or any shade in between; the ruff may contrast in hue with the tufts; and the pattern may be spotted, speckled or solid.*

122 *overleaf. Most shorebirds find their food by wading about in shallow water or scurrying across mudflats and beaches. Not so the phalaropes, which have adapted to an almost ducklike life. Having evolved semi-webbed feet, they bob about the water like corks, spinning in circles to stir up small organisms that are then picked off the surface. One observer counted a phalarope making 247 consecutive spins. Morever, these widely distributed birds have reversed the sex roles. This female northern phalarope (Lobipes lobatus) is much more brightly colored than her mate, whom she will leave in charge of incubating and rearing their young.*

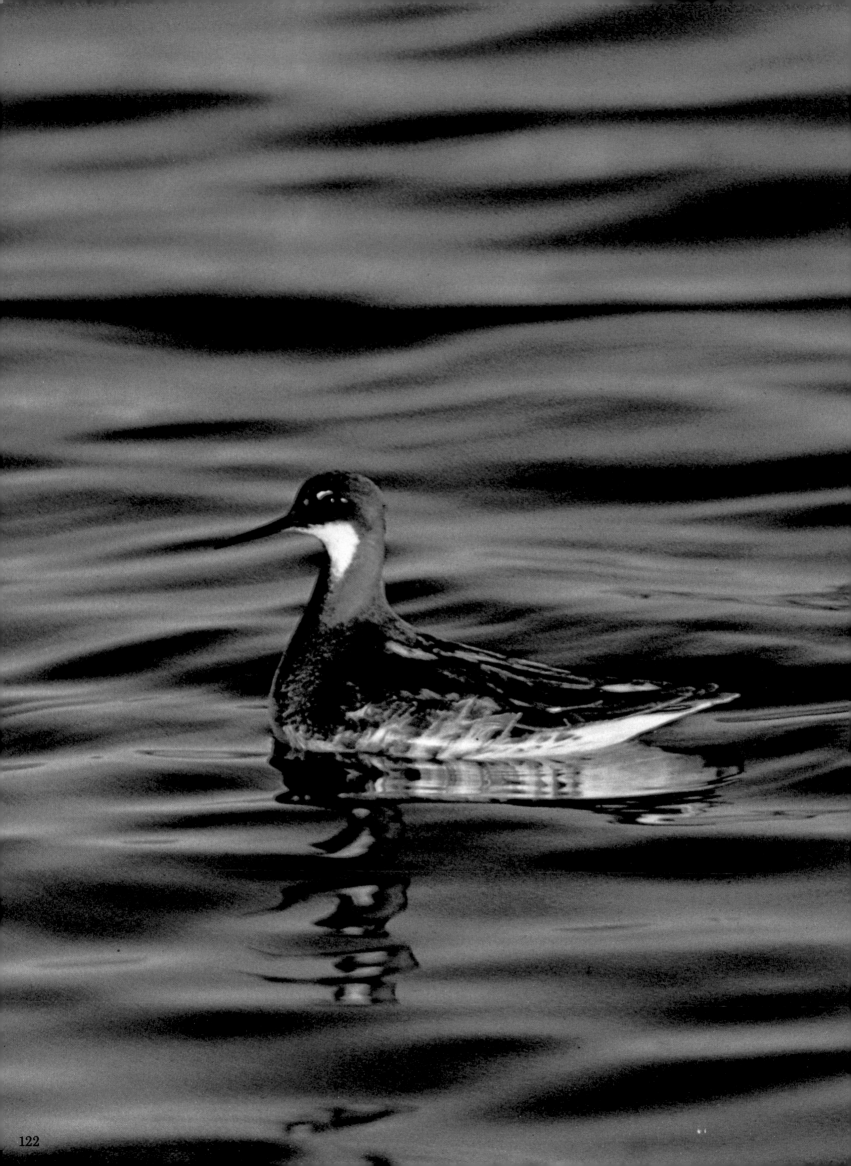

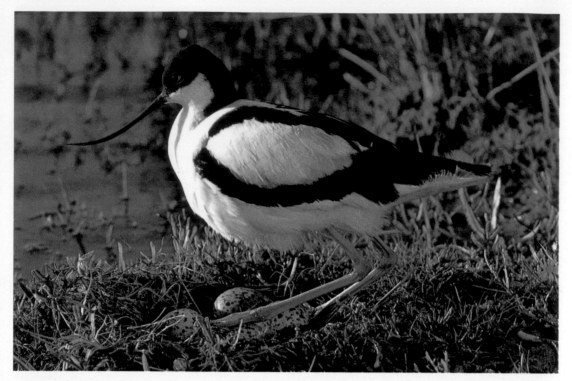

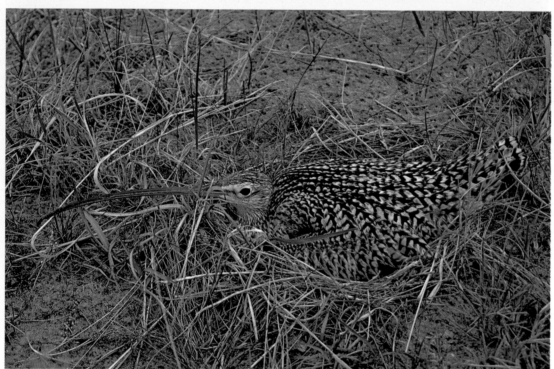

125 *right. An American avocet* (Recurvirostra americana) *cocks its cinnamon-colored head to follow the path of a marsh hawk circling over a prairie pond in Nebraska. Several feeding avocets may form a rank, moving in concert across a pond, perhaps driving their small prey like beaters pushing game. Or, equipped with webbed feet, they ma* swim in deeper water and tip for food like ducks.*

124 *above. Elegantly marked in black and white, an avocet* (Recurvirostra avosetta) *settles gently on its four eggs, cradled in a scrape on a hummock in a Netherlands marsh. To capture a wide variety of aquatic life, an avocet swings its upturned bill back and forth in the water like a scythe.*

124 *below. Before shorebirds were protected by international treaties, the long-billed curlew* (Numenius americanus) *of North American prairies was easily slaughtered by hunters because curlews would always return to a crippled member of the flock. With that incredible bill—up to nine inches in length— it deftly catches grasshoppers and crabs, plucks berries and probes muddy marsh bottoms for worms.*

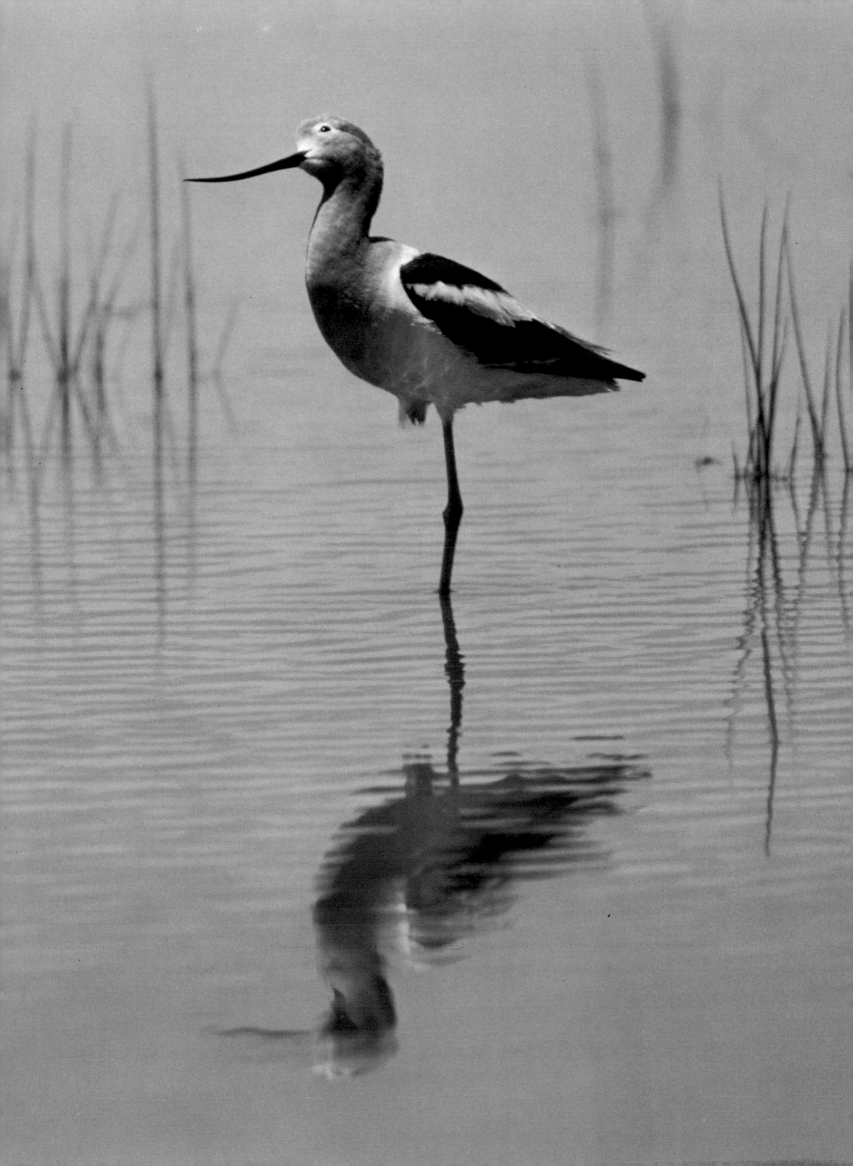

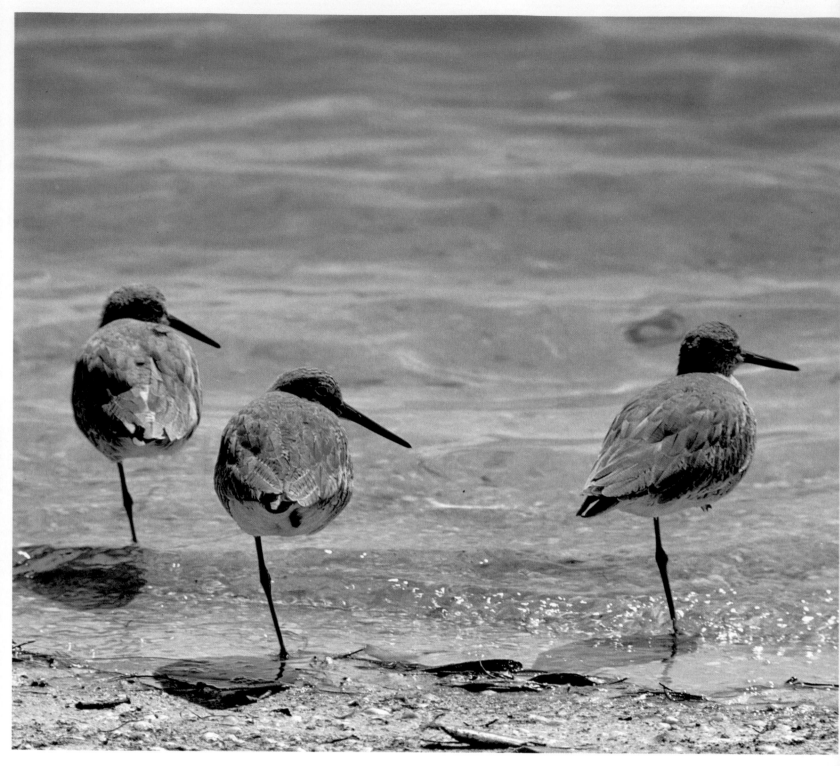

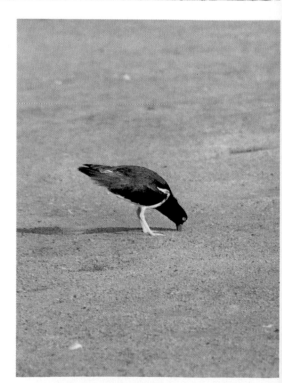

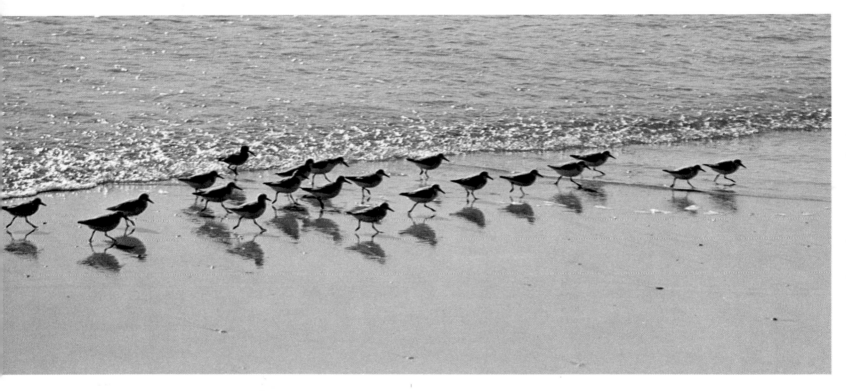

126 *left above. A rather nondescript bird when poised on a Florida beach, the willet* (Catoptrophorus semipalmatus) *flashes a distinctive black-and-white wing pattern in flight and loudly calls its name.*

126 *left below. With its powerful bill—long, blunt and flattened laterally—the American oyster-catcher* (Haematopus palliatus) *can open the shells of mollusks, pry limpets off surf-washed rocks or dig deep into mud for worms.*

127 *above. On almost any ocean beach in the world a flock of sander-lings* (Calidris alba) *is scurrying along like clockwork toys, pursuing the retreating waves, punching holes in the sand in search of tiny crustaceans and mollusks.*

128 *overleaf. A flock of sanderlings erupts in the pale early morning light. The way vast numbers of sandpipers wheel and turn in flight in perfect synchronization, yet have no leader and no special formation, still puzzles ornithologists.*

130 *second overleaf. The quiet of sunrise on a coastal marsh on Panama's Gulf of San Blas is interrupted only by the gentle movements of a trio of short-billed dowitchers* (Limnodromus griseus).

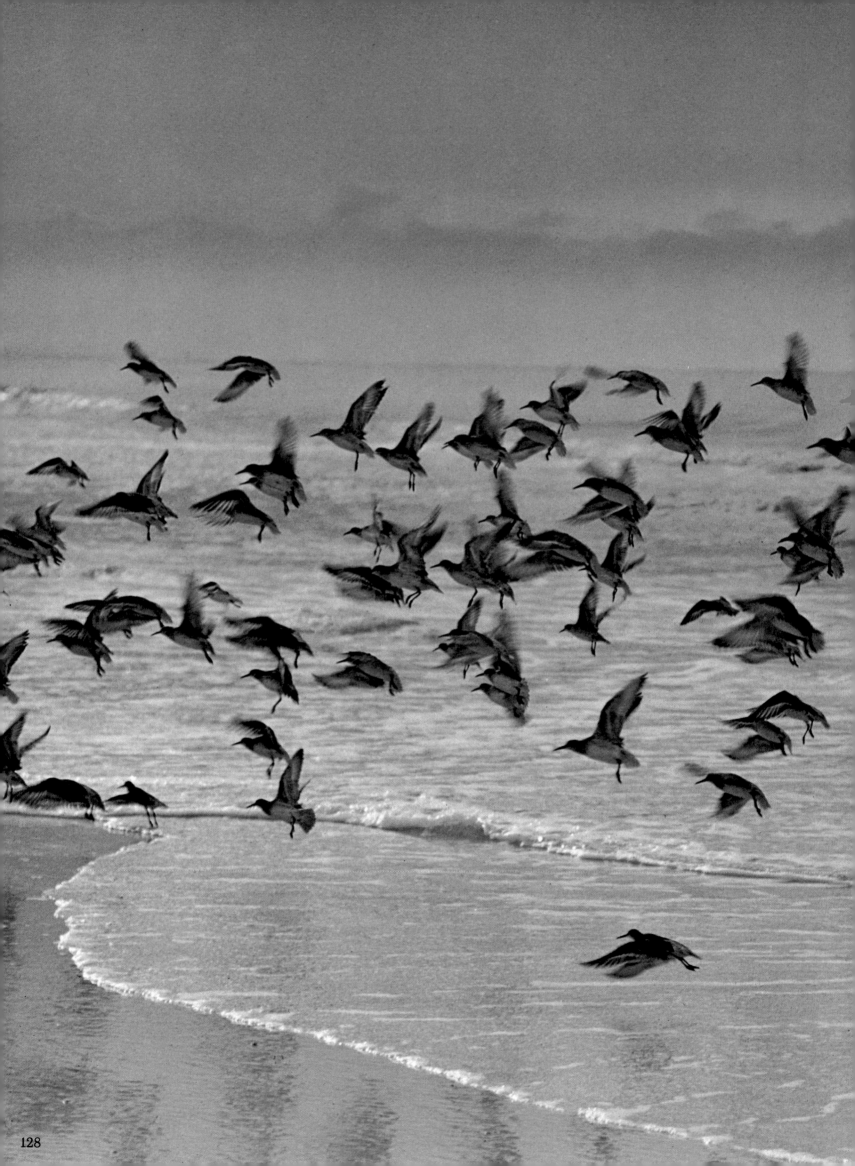

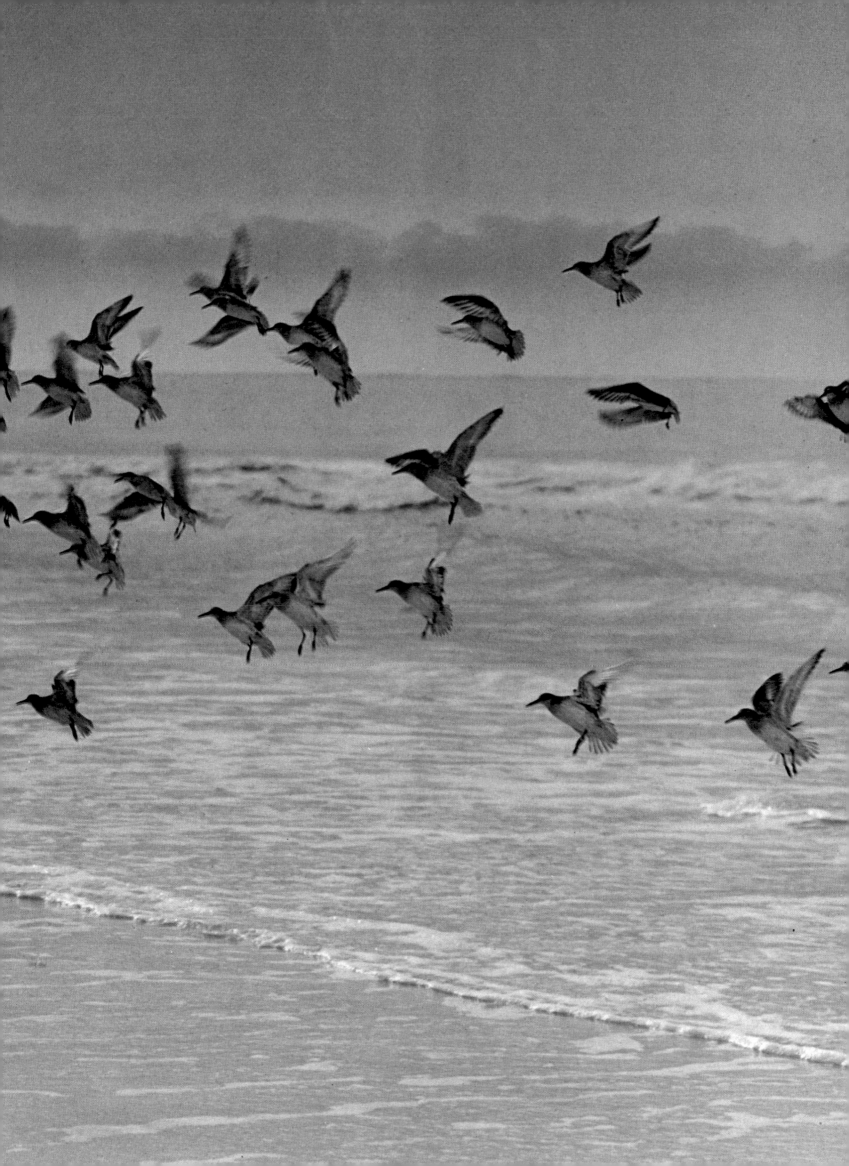

Photographic credits for the preceding illustrations:

Les Line 117, 118, 127
Arthur Christiansen 120, 121 both
Thase Daniel 122, 126 below
Cyril Laubscher/Bruce Coleman, Inc. 124 above
Mary Tremaine 124 below, 125
Bullaty Lomeo Photographers 126 above
James H. Carmichael, Jr. 128
Carl Kurtz 130

Wanderers at Sea

When the wandering albatross turns at the peak of its
climb and begins its race downwind toward the
tossing southern ocean, it may by flying at forty miles
an hour. By the time it has dropped into the
trough of a wave, its fourteen-foot wings are cutting
through the air at nearly ninety miles an hour.
Here is a true glider, a creature so reluctant to flap
its long slender wings that it appears to possess
some mystic inner energy that propels it invisibly. It is
the largest flying creature left on earth, sometimes
eighteen feet in wingspan, and it may fly halfway
around the earth in a month of its zigzag
wandering.
The albatross makes most of its life totally at sea. It
may not see land for months or even years. In its inde-
pendence of land it is a member of a peculiar
conglomeration of birds: wandering seabirds that
have achieved many separate masteries of oceanic life.
They include the millions of chunky-bodied auks
(murres, puffins, guillemots, dovekies) which, with
their short wings, their clumsy flight, at first
appear oddly ill-fitted for life at sea. Among them are
the petrels, the millions of swallow-like prions
of the Antarctic waters, the bloodthirsty giant petrels
of the Southern Hemisphere, the wide-ranging
shearwaters of almost every ocean. The oddest members
of this group of wanderers are the penguins, which
in their evolution have gone in the opposite direction
to the albatross: they have all become
flightless.
The sea, covering five-sevenths of the earth, is both a

hostile and a natural home for birds. Adapting to this world has required special qualities, chief of which has probably been toughness. Only 3 percent of the world's species of birds, about 260 species in a dozen families, have made the sea their home. Not all of these are real oceanic wanderers; the gulls and terns, cormorants and frigatebirds, pelicans and others never truly reach far from land in their travels. There are fewer than 150 species of truly oceanic, wandering birds.

The birds that have adjusted to this vast world may thrive in great populations. The Wilson's petrel, about the size of a swallow, which breeds at the edge of the Antarctic and comes to the North Atlantic every summer to "winter," is judged by some to be the world's most abundant bird, its numbers perhaps in the many scores of millions. Slender-billed shear-waters sometimes collect in huge congregations. A flock once seen in Bass Strait, Australia, was estimated to hold more than 150 million birds. The fulmar, which looks like a gull but is actually a petrel, is spread in its many millions across wide areas of the sea.

At least 5 million Adélie penguins breed on one island in the Antarctic. Colonies of murres in the Northern Hemisphere numbering many hundreds of thousands, and even more than a million, are common enough.

The Manx shearwaters scatter widely across the North Sea but also hunt the coasts of Brazil. The great shearwater breeds at Tristan da Cunha, halfway between Cape Horn and the Cape of Good Hope, and reaches as far north as Greenland, in travels that take it through an endless summer, thousands of miles from its birthplace.

The dovekies, pigeon-size auks, wander thousands of miles in their off-breeding seasons and nest in millions in remote Greenland fiordlands. They move south to winter off the shores of Newfoundland. The murres range across much of the North Atlantic, almost always in great flocks and collected in huge breeding bazaars, some of which, notably that at Akpatok Island, off the northern coast of Labrador, holds several million creatures.

Puffins, their near relatives, are almost equally ubiquitous in the northern waters, but instead of nesting on bare rocks and on or near vertical cliffs,

they excavate deep burrows on island soil to tunnel their way to breeding success.

The auks, although masters of their oceanic world, are neither so wide ranging nor as independent of shelter and land as the tube-nosed birds, which include the petrels, albatrosses, shearwaters, storm-petrels and the diving petrels, all of which drink sea-water and get rid of its saltiness through their large nasal glands.

Despite the toughness of the world in which they live, the oceanic wanderers do not rear large families. Most lay only one egg. The majority are long-lived. Only occasionally are they cut down by the elements.

The oceanic wanderers exploit the sea at all its levels. The tube-nosed birds mostly feed on the surface, although some dive and so are particularly common in the Antarctic waters, where the greatest plankton growths occur. The bigger albatrosses are also killers of larger game. They not only eat great quantities of squid, which they apparently hunt at night, but also feed freely on the millions of prions, the small petrels of Antarctica, and themselves tubenoses. They even chase and kill small penguins, and have also been known to attack men helpless in the water after shipwrecks.

All of the auks are true divers. They all "fly" underwater, using both legs and wings to propel them-selves rapidly in pursuit of small fish. And because they invariably hunt in large packs with sometimes thousands of birds being underwater simultaneously— they create underwater confusion among schools of fish, which panic as they are attacked from all sides at once.

Skillful as they are underwater, the auks are no match for the Southern Hemisphere's penguins. Underwater the penguin is transformed. The streamlined body elongates as the bird swims forward, its feet kicking at the back of its body, like propellers, to give both thrust and control of direction, its triangular tail an efficient rudder. The shortened, flattened bones of the wings are rigidly connected by ligaments so that the wings become, in effect, flippers, in the manner of seals. The thick breast muscles drive the wings with powerful beats, and the penguin disappears like a miniature torpedo

into the gloomy but life-rich waters of the Antarctic.

The penguins have fitted themselves into every conceivable niche of life in the southern waters, as oceanic ranging birds exploiting the squid and plankton-producing waters of the Antarctic convergence, as breeders on many islands and on Antarctica itself. The emperor penguins are the exemplars of the conquest of the southern waters. They breed in winter on Antarctica. These four-feet-high birds are the best of all underwater swimmers in the penguin ranks, nearer to being fish than fowl in their hunting. They can dive down hundreds of feet and can work in pitch darkness in pursuit of their favorite prey, the squid. They can escape the deep-diving, fast-moving leopard seals and avoid the many killer whales that prowl the southern waters.

The emperors are the ultimate form of a line of evolution. They walk inland to breed in the worst weather in the world. Hurricanes blow. The temperature drops to 60° or 70° below zero. The penguins cannot eat for the ninety-odd days they are brooding their eggs. Other penguins, including the gentoos, rockhoppers and the most numerous, the Adélies, breed conventionally in the brief summer.

When the emperor penguins return to the Antarctic Ocean in the spring they linger along the melting ice shores for a while, then slip away into the sea. It is not known how far they travel, or where they fish or what their mode of life is during the months they spend at sea. And this is also true for most of the other great oceanic wanderers. They can be seen, like shearwaters, whisking along in the trough of a wave in a great gale 1000 miles from anywhere. They can be watched, like petrels, darting along on their way from Newfoundland to Portugal, from southern Africa to South America. They have made the oceans their own.

And, in a last view of this great skill, the wandering albatross can be seen turning into the wind and using its force to climb. The bird's downward glide is effortless, a perfect example of how the elemental power of the sea can be deftly turned to the advantage of the oceanic wanderer.

137. *On the cliffs of Alaska's St. Paul Island, thick-billed murres (Uria lomvia) congregate on a lichen-painted ledge that juts over the surging Bering Sea. Remote cliffs in the North Pacific and North Atlantic may be occupied by thousands of breeding murres, and banding studies have proved that individual birds return to the same spot year after year to lay their single egg. In a remarkable adaptation to the murre's precarious habitat, that egg is pear-shaped so that, if dislodged, it will turn in an arc rather than tumble over the edge. Propelled by their wings, murres can "fly" underwater to depths of 200 feet or more in pursuit of fish, squid and other marine life.*

138 *overleaf. The spring arrival of common puffins (Fratercula arctica) at their remote nesting islands in the North Atlantic is an exciting event rarely witnessed except by light-house keepers. Rafts of hundreds of puffins begin to appear offshore, their numbers building over several days as courtship and pair-forming get underway. After perhaps a week the puffins launch reconnaissance flights, circling round and round the breeding grounds they left seven months before. One morning the puffins flutter to the rocks a few at a time until most have landed. They stand nervously for a couple of hours then return to the sea. It may be several days before they come back to the land in earnest and begin clearing out their old burrows.*

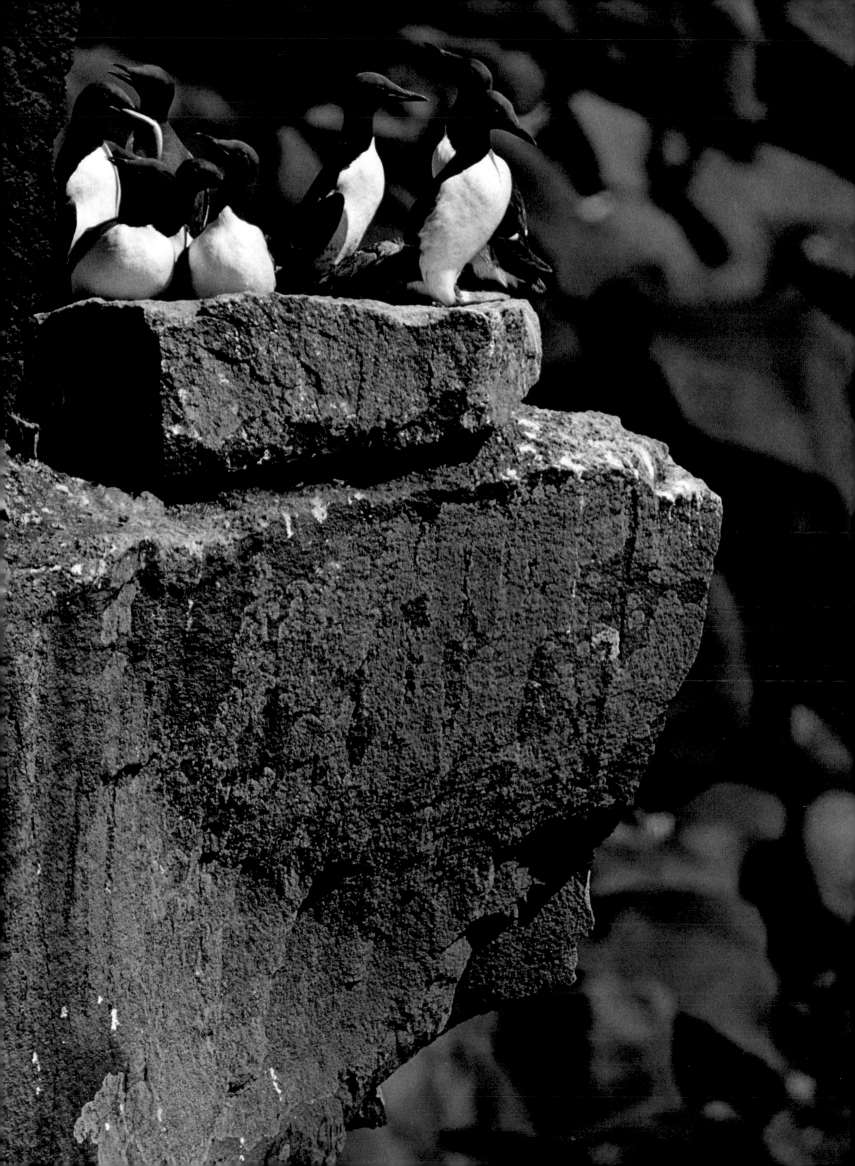

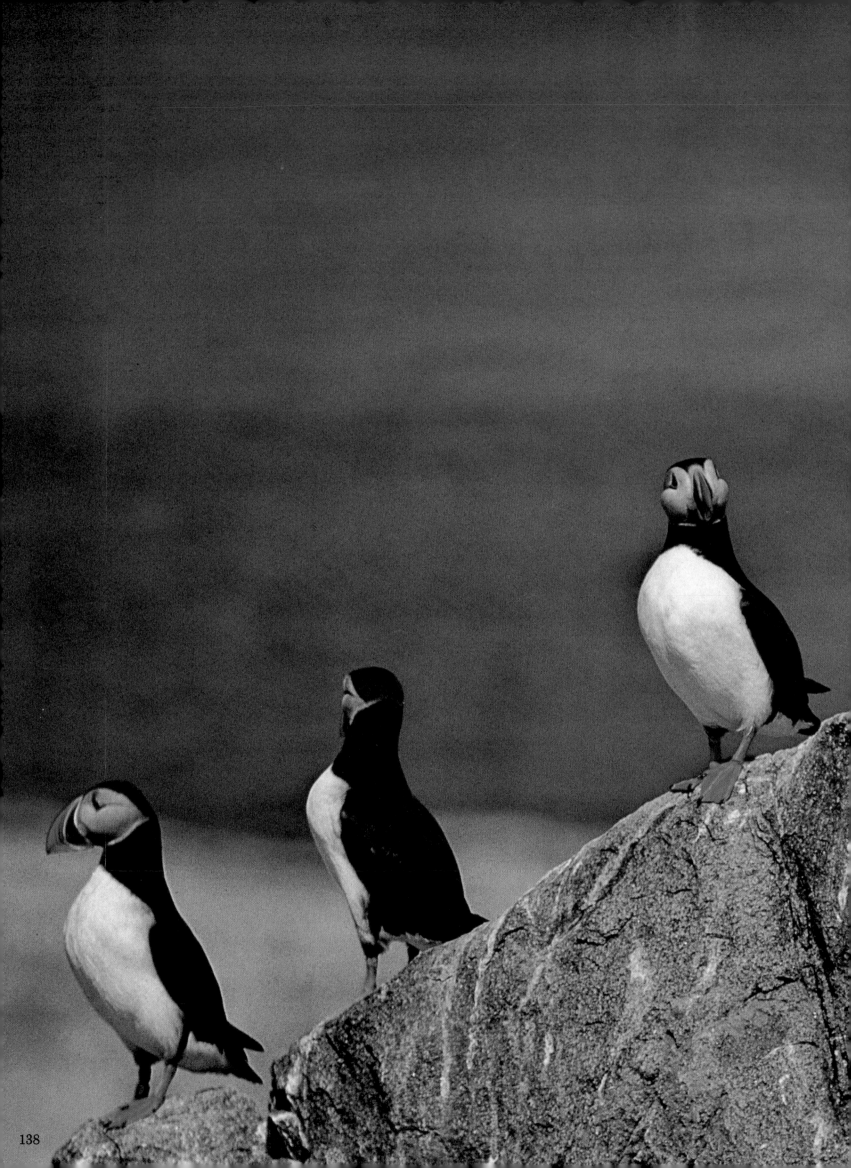

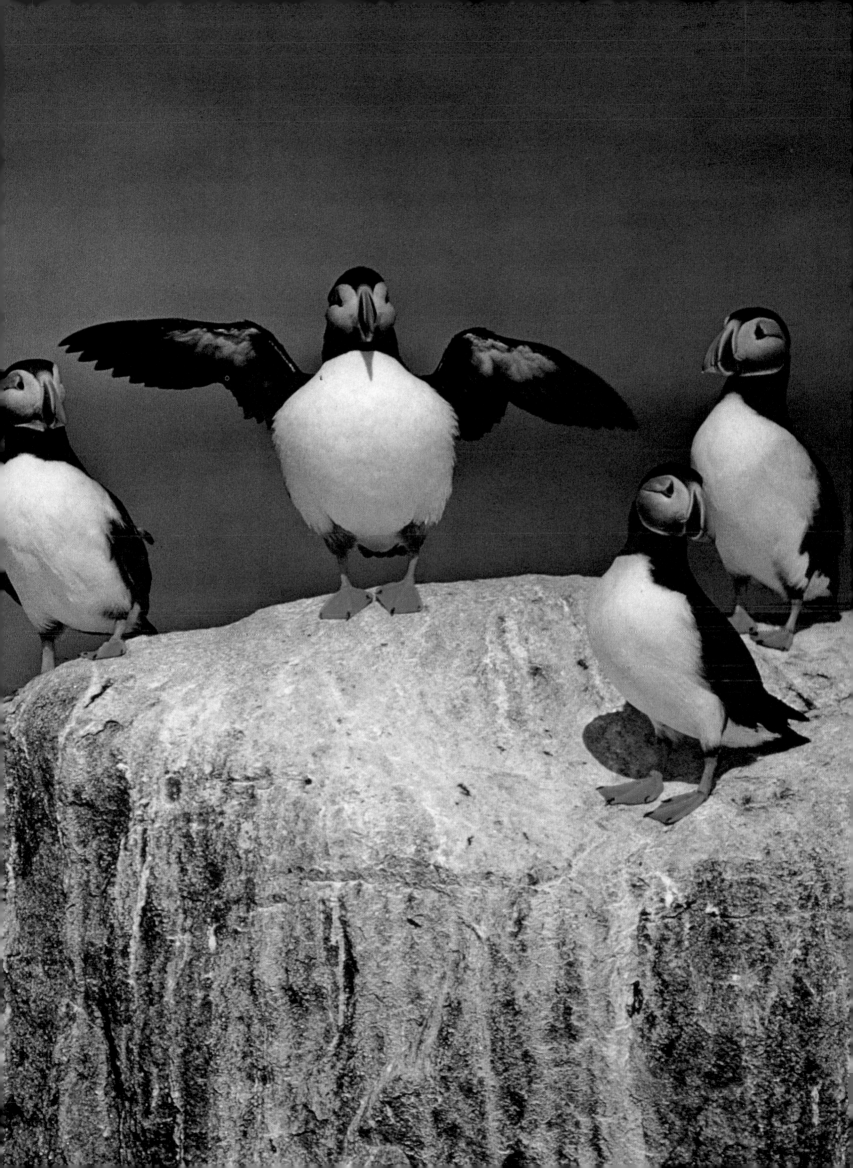

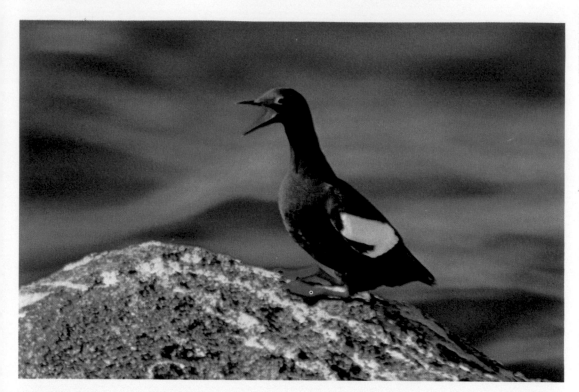

140 *left. Rocky coasts from the Bering Sea south to Japan and California are the year-round habitat of the pigeon guillemot (Cepphus columba), which lays two eggs in a crevice or burrow in a cliff facing the sea.*

140 *below. The handsome razorbill (Alca torda) lays a single egg on North Atlantic seacliffs. Though its wings are unfeathered, the young bird takes to the sea at the age of two weeks, plunging unharmed from heights as great as 600 feet.*

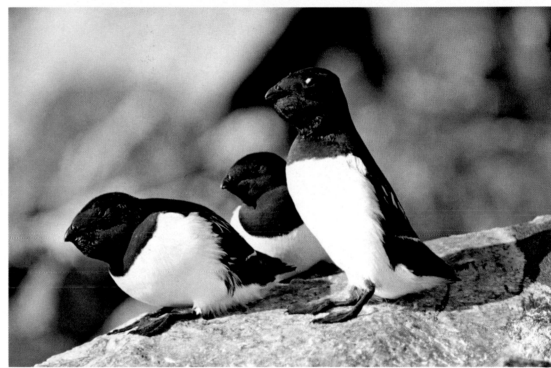

141 *above left, right. Common puffin parents feed their chick about 2000 small fish over a six-week period before they desert it. One night a week later the starved fledgling will leave its burrow and flutter to the ocean.*

141 *below left. In breeding season, long forward-curling plumes and orange wattles covering the bill add bizarre decoration to the crested auklet* (Aethia cristatella) *of Bering Sea islands.*

141 *below right. Millions of dovekies* (Alle alle) *nest in the high Arctic, from Greenland to Novaya Zemlya, where natives gather their eggs, feast on their flesh and make coats of their tiny skins. Because dovekies winter far at sea, they are rarely seen unless blown ashore by storms.*

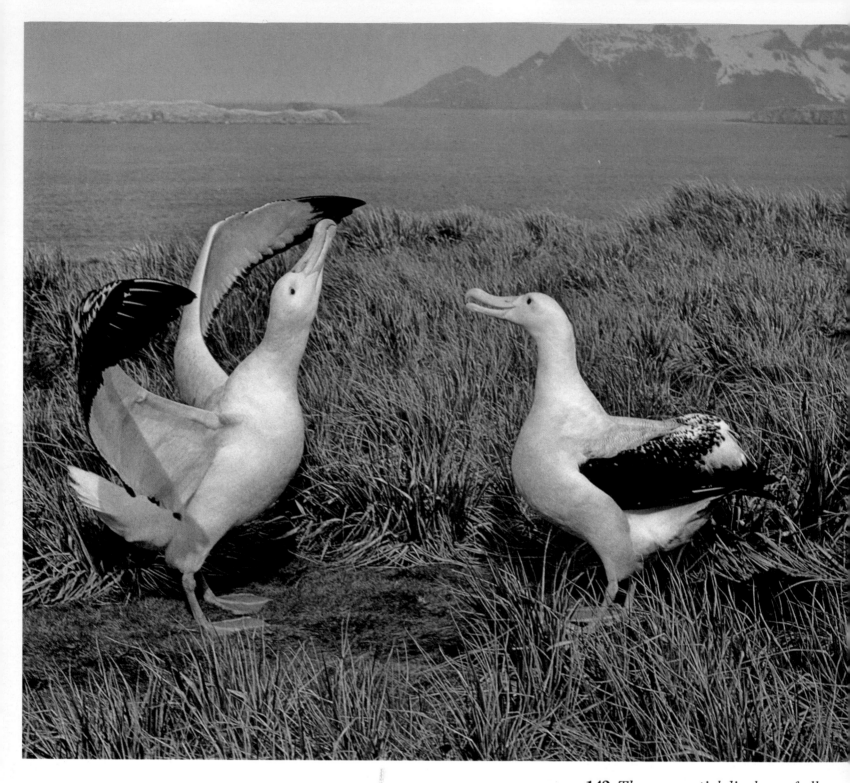

142. *The prenuptial displays of albatrosses are elaborate, complex and to human eyes grotesque. With tails fanned, heads outstretched, and wings opened, the birds snap and rattle their bills, groan and gurgle and bray, bow to each other, touch bills and prance about. In some species the males are the first to reach the breeding grounds, and they will converge in communal dances about the earliest females to arrive. This pair of wandering albatrosses (Diomedea exulans) on subantarctic South Georgia Island faces a full year of caring for their single chick before it fledges. They may fly 2500 miles from their nest before returning for the intermittent feedings.*

143 *right. The world's entire population of the waved albatross* (Diomedea irrorata), *perhaps 3000 pairs, nests on Hood Island in the Galápagos. In years when unusually heavy rains trigger plagues of mosquitoes, nearly every nest is abandoned.*

143 *below. The nest of a pair of black-browed albatrosses* (Diomedea melanophris) *is a volcano-shaped dome built of turf. In the era of sailing ships, meat-starved mariners caught albatrosses on baited hooks and raided their colonies.*

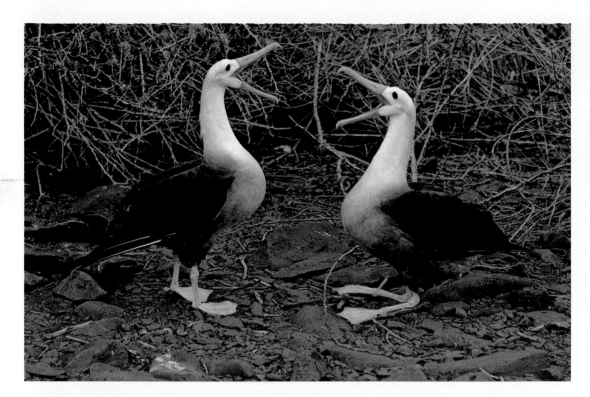

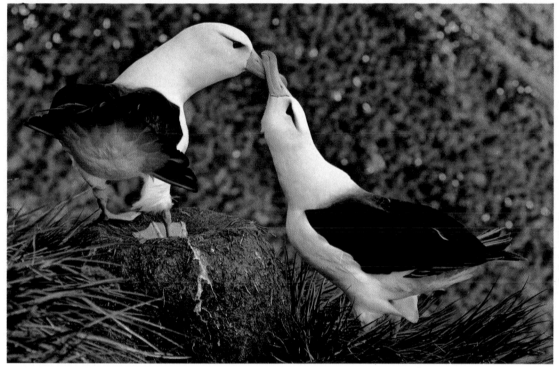

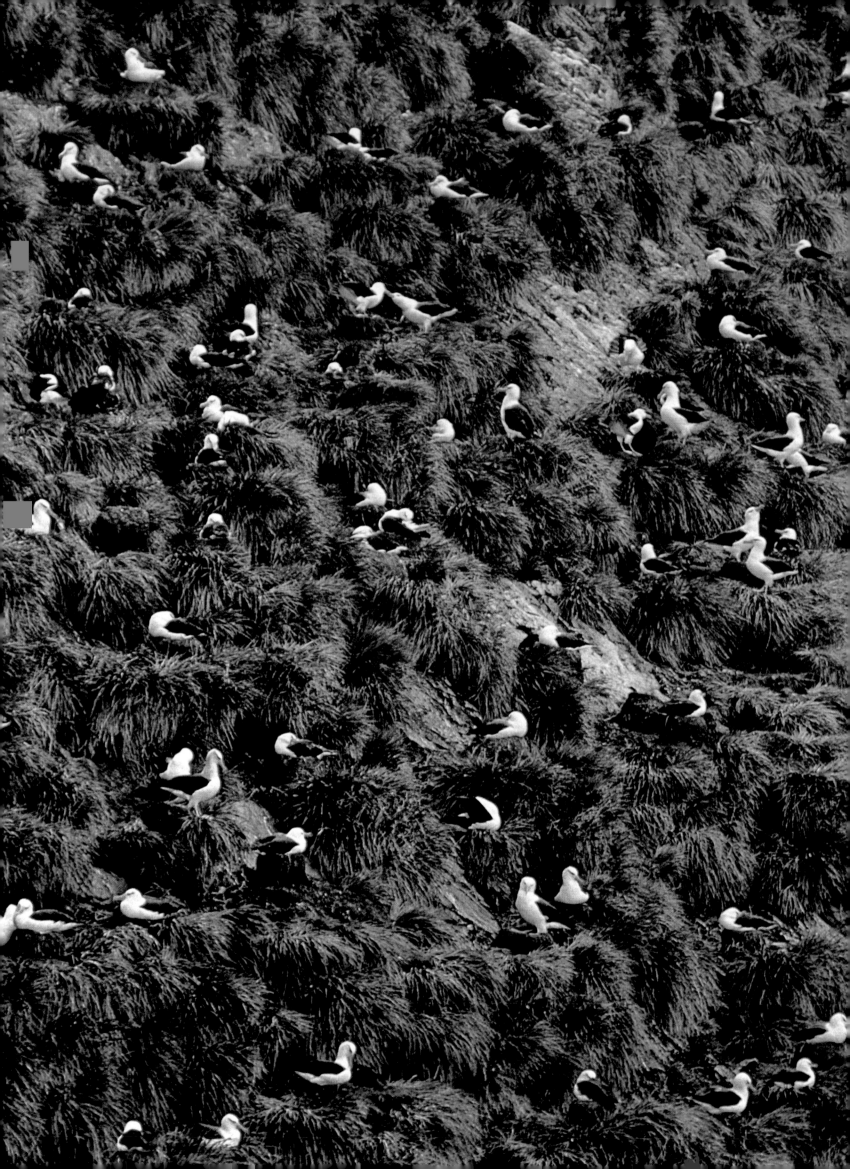

144 *left. Like tenants of an apartment building, black-browed albatrosses occupy every level of a tussock-covered cliff on South Georgia Island. The most abundant and widespread species of albatross, the black-brow often strays from the southern oceans into the high latitudes of the North Atlantic. Some birds have remained there, arousing hope that a breeding population might one day be established.*

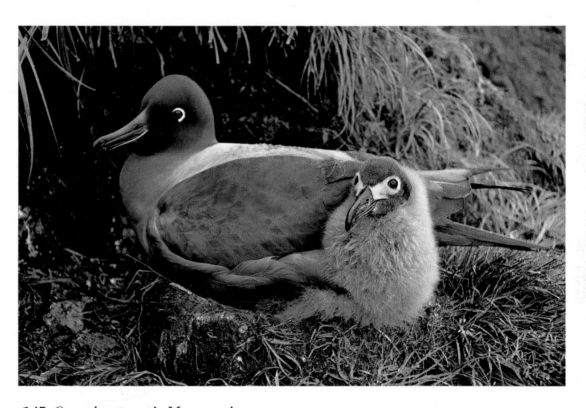

145. *On subantarctic Macquarie Island, a light-mantled sooty alba-tross* (Phoebetria palpebrata) *shelters its chick from the morning drizzle. Only a white half-moon behind the eye marks the delicate pastel shadings of this loveliest of all albatrosses which, despite its great size, flies on long, slender wings with the deftness of a swallow.*
146 *overleaf. To launch itself from the sea, the royal albatross* (Diomedea epomorphora) *must pedal hard over the surface on its large webbed feet. One of the two great albatrosses, the royal has a wingspread of nine feet on which it may circle and sweep and tilt over the waves for hours without flapping its wings except to maneuver.*

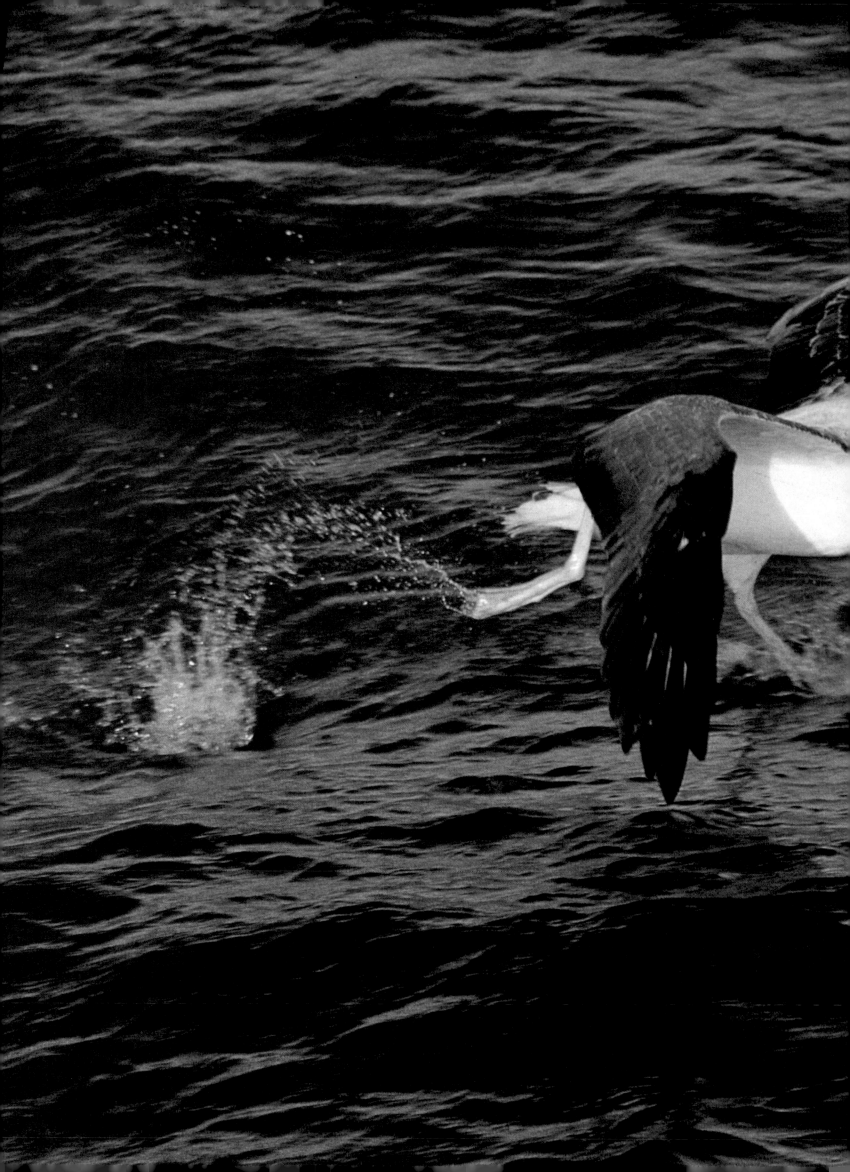

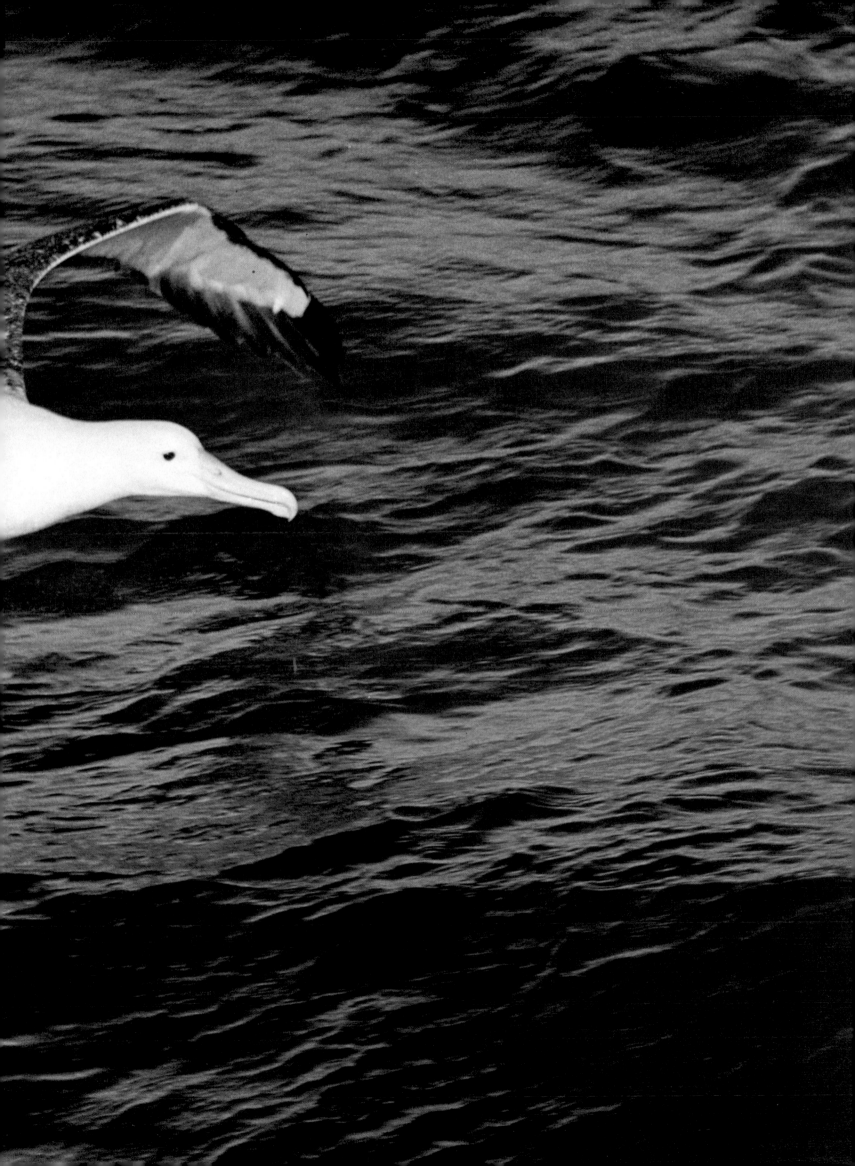

149 *right. Macquarie Island south of Australia is the natal home of every royal penguin* (Eudyptes schegeli) *in the world. Two to three million of their kind crowd the beaches and lower valleys at the peak of the breeding season, and many penguins must toddle along the beds of shallow streams to reach large colonies a quarter-mile from the sea.*

148. *Three feet tall and strikingly patterned, the king penguin* (Aptenodytes patagonica) *nests in large colonies on several subantarctic islands, each bird claiming a territory three feet wide. The single egg is carried on the feet of the male, protected from the cold by a warm fold of belly skin and feathers where the temperature is kept between 99° and 101° F.*

150 *overleaf. An ice floe is stained pink by the excreta of chinstrap penguins* (Pygoscelis antarctica) *that have been feasting on shoals of krill— shrimplike animals that also sustain the lives of the great baleen whales. Scientists found 960 of these crustaceans, which in turn graze on diatoms, in the stomach of one penguin.*

Photographic credits for the preceding illustrations:

Killers on the Wing

The flight of killer birds displays a terrible and
memorable beauty. All of them—hawk, falcon, eagle,
vulture—are inspiration in flight. The marsh hawk dives
and loops-the-loop during its courtship. The small falcons
hover like butterflies, waiting to stoop into the
long meadow grasses. The golden eagle flutters, almost
out of sight of the ground, then closes its wings to
make one long dive to its aerie. Kites fall on half-
closed wings during mating, then grasp their talons
together with their partners and flutter for long
seconds, face-to-face, before spinning away in
exhilarating falls. The drop of vultures at the sight of
carrion prey is the falling of black stones, transformed
quickly to life when they pull out of their dives close to
the ground and the air roars across their wings.
In pursuit of meat, birds of prey have become more
closely united in form than any other group of birds.
Almost all of them have the powerful hooked beak, the
strong talons and wings. In varying degrees they are
daring or ferocious, or both. The largest eagles may
cut down victims much larger than themselves,
even small deer. The small American kestrel attacks
young wood rats, ferocious opponents for a bird
smaller than the energetic, sharp-toothed rats. The
osprey falls feet-first into the water, sometimes
driving its large victims deep into the water before
emerging with gripped talons around its prey.
The graceful, lethal birds of prey are a cross section
in the diversity of life itself. The tiny pygmy
falcons of Indonesia and Malaya are smaller than
many songbirds, in contrast with the great monkey-

killing eagles that terrorize the treetops of South America and Central America. Eagles dive into rivers to snag salmon, and other birds of prey plunge into holes and burrows in pursuit of their victims. Fearless, it seems, they drop among family groups of mongooses on the African plains and seize a victim.

There is hardly a bird on earth that is not chased by these killer birds. Few rodents are safe from them. They catch almost everything from moths to large and venomous snakes. One extinct form, a giant South Pacific sea eagle, may even have preyed on the world's largest bird, the New Zealand moa, several times the size of the modern ostrich. The killer birds may have originated early in the general development of the bird, traced roughly from about 180 million years ago during the Jurassic, when *Archaeopteryx* clumsily flew. By 85 million years ago the birds of prey were well developed, and by 30 million years ago they had evolved into the familiar forms that we know today, including great eagles and buteo hawks. Mostly they became solitary birds, at least in the kill, although the lesser kestrel of Palestine, which moves between tropical Africa and southern Europe, not only nests in colonies but hunts in large groups and terrorizes flocks of small birds.

The technique of the killers differs widely. The peregrine makes its great stooping fall from a height, striking its victim in midair in a cloud of feathers, either crippling or killing the bird in flight. One of its favorite hunting grounds is among the large seabird bazaars of the far north, where more than a million creatures may be gathered.

The lanner falcon of Africa cuts down its prey by sheer speed, or strikes them on the ground. The goshawk and other accipiters wait silently, unmoving, their eyes probing the undergrowth for that one moment of unwariness of a victim that will send them swooping down on their short, rounded wings, cutting through the branches, to clutch a sparrow or warbler before the victim knows the killer is present.

One of the most skillful of these hunters is the Cooper's hawk of North America, which works in thick undergrowth or in heavy woodlands. At one moment a songbird is sitting on a branch, unaware that it has been perceived. Then in a movement that is too fast for the human eye to follow, the songbird is gone, dead in the talons of the hawk.

Each of the hunting birds tends to be restricted to its own territory. When birds of prey share hunting territory, it is usually stratified, with hovering hawks occupying the higher altitudes and watching for victims in open spaces, while the smaller hawks work among the undergrowth and trees. Falcons and eagles may uneasily share territory, but usually only in transit, so one bird of prey may move through the other's territory as long as it flies at the correct altitude. African vultures, which may cluster in scores over a large carcass, feed in strict order, one species after another, each species a specialist in exploiting the meat harvest in its own way.

The falcons, with their long pointed wings and high speeds, must work in the open spaces where there is distance to build up speed, room to maneuver, space to perceive. They work across the rivers of the taiga forests of the north. They patrol seashores. They relish those rare moments when ground birds unwisely make longish flights in open country, and they are especially dangerous to waterfowl.

They cannot hunt without being extremely visible, a quality they share with the eagles, particularly the golden and the bald. So they are vulnerable to the attentions of men, who persistently misinterpret the functions of the falcon or the eagle, and see them as threats to their own affairs rather than as complementary additions to the work of weeding out the unfit and the sick.

The work of killing is highly specialized. Each of the hunting birds shows its adaptation, and its vulnerability, through its predilection for certain kinds of food. In the great Alaska Range the gyrfalcon hunts ground squirrels almost exclusively during the spring and summer, and uneasily shares this hunting country with visiting peregrine falcons that hunt birds. When winter comes the gyrfalcon easily switches to hunting ptarmigans. The peregrines migrate along with the birds they have been hunting.

Territory among these lethal birds is so specifically delineated that their victims have learned that the falcons and eagles, and many other kinds of prey, will not hunt near their own nests. Thus thrashers and vireos breed closely to the nests of Cooper's hawks and are safe. Jack rabbits, one of the favorite victims of golden eagles, raise their

families directly beneath the nests of the great hunting birds. Cliff swallows breed as close as possible to the nests of the prairie falcon. The jackal buzzard ignores the swarms of African weavers building their colonial nests around its nest, but will kill them the moment they venture too far from the nest area. The rules of the hunt, although strict, can be broken. One of the races of the peregrine, the Peale's falcon, is spread along the coasts of British Columbia, where the hunting consists mainly of sandpipers and ducks. But in one area, large colonies of ancient murrelets, Cassin's auklets and Leach's petrel are clustered along the shores. There the Peale's falcons have also gathered in thirteen aeries close together in response to such bountiful hunting. Determination and adaptability characterize the bird of prey. The lammergeier smashes turtles on rocks. The Egyptian vulture picks up stones to break ostrich eggs. Golden eagles attempt to kill porcupines. Red-tailed hawks tackle diamond-back rattlesnakes. The harrier eagles are heavily armored with leg scales to help them subdue poisonous snakes. The honey buzzard of the Old World has a scaled face mask so it can raid the nests of stinging bees. The stink of skunk spray does not deter the red-tailed hawk. The fishing hawks and the eagles, and others that hunt in water, all possess a visual correction that enables them to adjust for the double image caused by the refraction of light from the water. The hunter thus knows exactly where the fish is really located in the water.

The killer birds are at the apex of avian evolution and so are both inspiration and excitement to the human watcher. Personifying this, in its most lethal and naked form, is one of the largest eagles on earth, the Australian wedgetail. Despite its size and the fact that it is mainly a hunter of mammals, it hunts birds with the speed, abandon and bravado of the fastest of the Northern Hemisphere falcons. The speed of its fall from a great height is awe-inspiring. Its airborne collision with its flying victims is a brittle explosion of death. This great bird of prey, persecuted by man, poisoned in thousands, screams defiance and pleasure, and speeds upward thousands of feet. There, for this moment, no work of man or nature can reach it.

157. *Before he carries this sea trout, caught in the shallows of Florida Bay, to his waiting mate and young, the male osprey (Pandion haliaetus) will devour the head as his own reward. Transfer of the catch at the nest atop a mangrove will not be easy; the female must forcefully pull the fish out of the male's powerful grip. Then she will use her strong beak like scissors to snip off pieces of flesh, and after the nestlings have been fed she will eat what is left.*

158 *overleaf. The great wings of the bald eagle (Haliaeetus leucocephalus), which span seven feet, and its powerful and deeply curved talons are clearly evident as the bird back-pedals to keep its balance upon landing on a favorite but fragile perch. Like the osprey, with which it shares many fishing grounds, the bald eagle—national emblem of the United States—has suffered severe reproduction and population declines because of pesticide contamination of its food chain. But a ban on the use of the most toxic chemicals holds hope for the future of both species.*

160 *second overleaf. Facing into a strong wind, a golden eagle (Aquila chrysaetos) is about to launch itself off a cliff in the Idaho wilderness. The golden eagle also has suffered grievously at the hands of man, although in a different fashion. Wrongly blamed by sheep ranchers for slaughtering lambs, they have been hunted down from planes and helicopters and blasted out of the sky. Countless other eagles have died from eating poisoned baits set out to kill coyotes and other predators, or have been electrocuted when landing on poorly designed power transmission lines.*

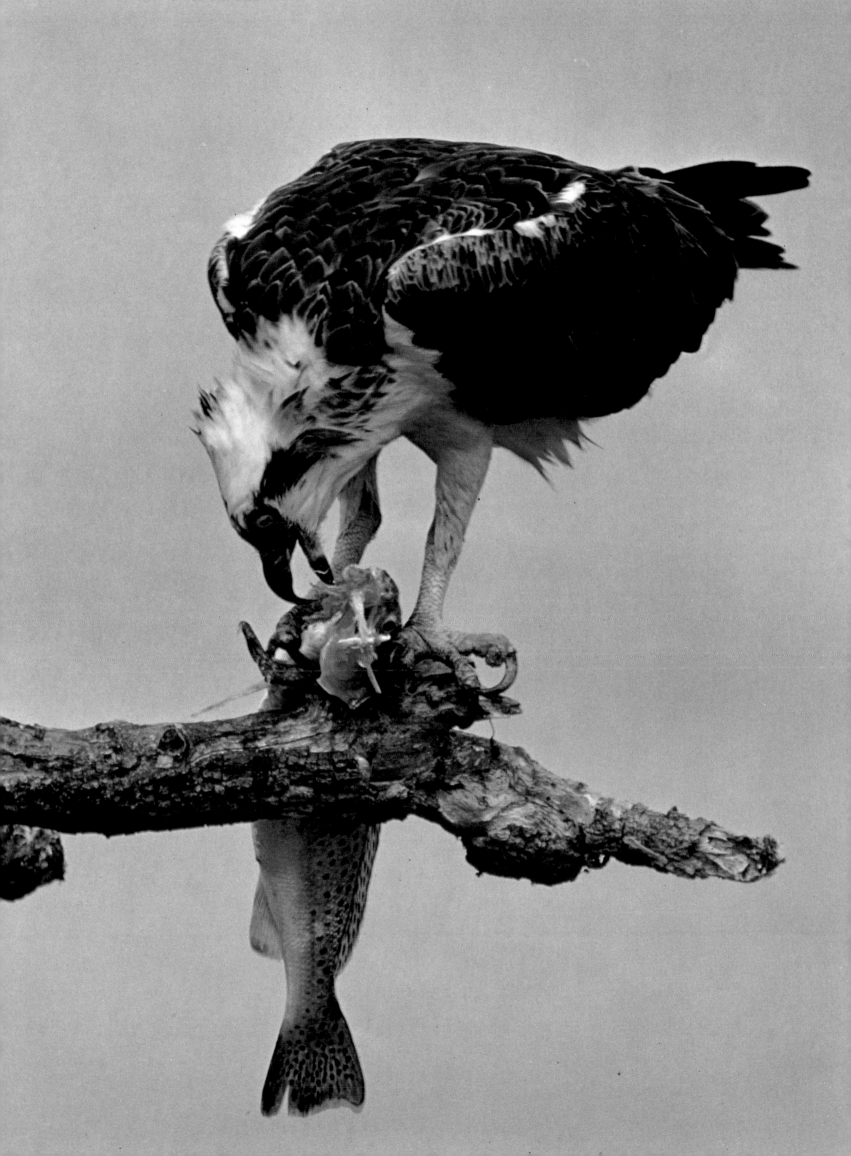

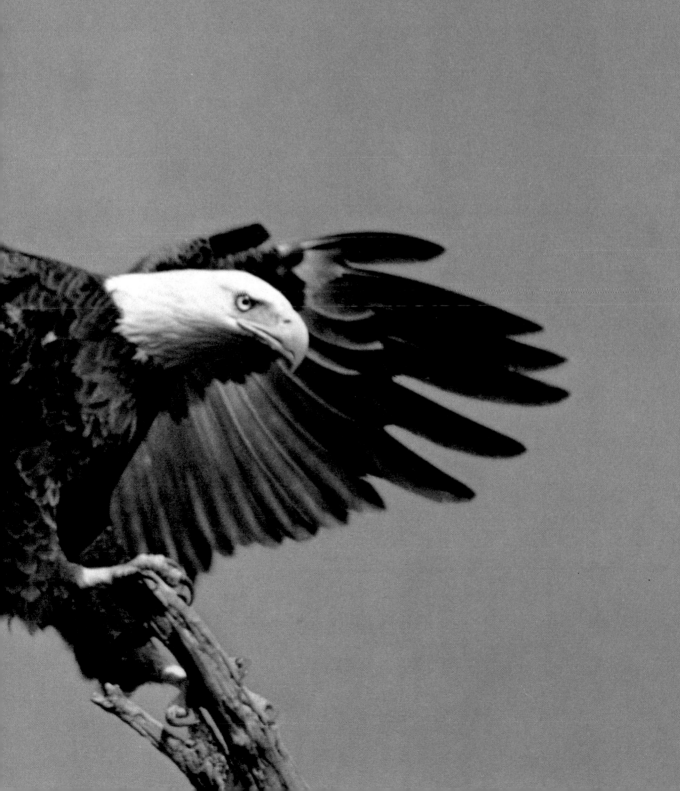

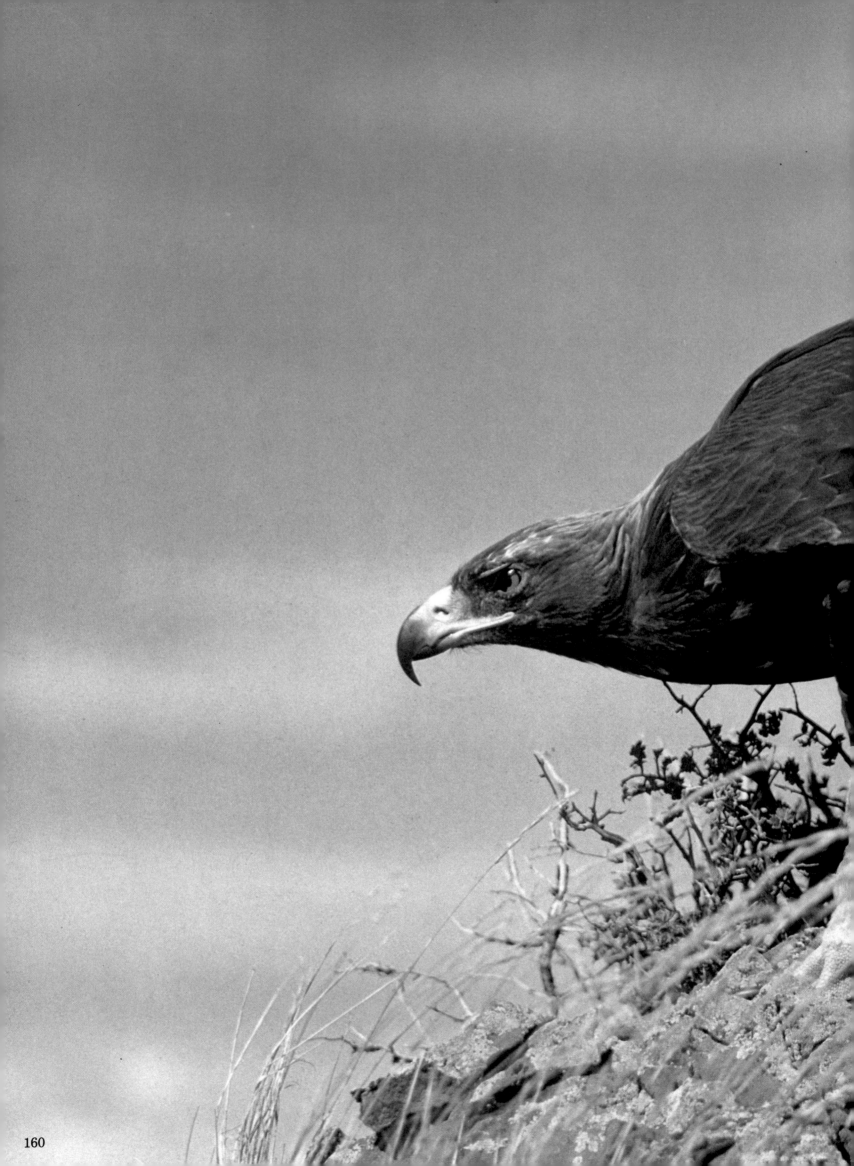

163 *right. A peregrine falcon* (Falco peregrinus) *rips into a wild pigeon it has just struck to the ground. In North America and Europe the peregrine also has been decimated by pesticide poisoning, but imaginative efforts are underway to restore, through captive propagation, this magnificent aerial hunter to long unoccupied eyries.*

162. *The raptor seen most often on the Great Plains of North America, a ferruginous hawk* (Buteo regalis), *brings a ground squirrel to its nest on a rocky outcropping. This hawk benefits man, for it preys mainly on small rodents that destroy crops.*
164 *overleaf. At a cliffside eyrie high in the Canadian Arctic, a female gyrfalcon* (Falco rusticolus) *feeds her chicks from the hindquarters of a twelve-pound Arctic hare that was killed and butchered by her mate.*
166 *second overleaf. One of the New World caracaras, a chimango* (Milvago chimango) *has built its nest in an Argentine swamp. It is so bold that it will attack sick lambs, peck at the saddle sores of horses or try to rob much larger hawks.*

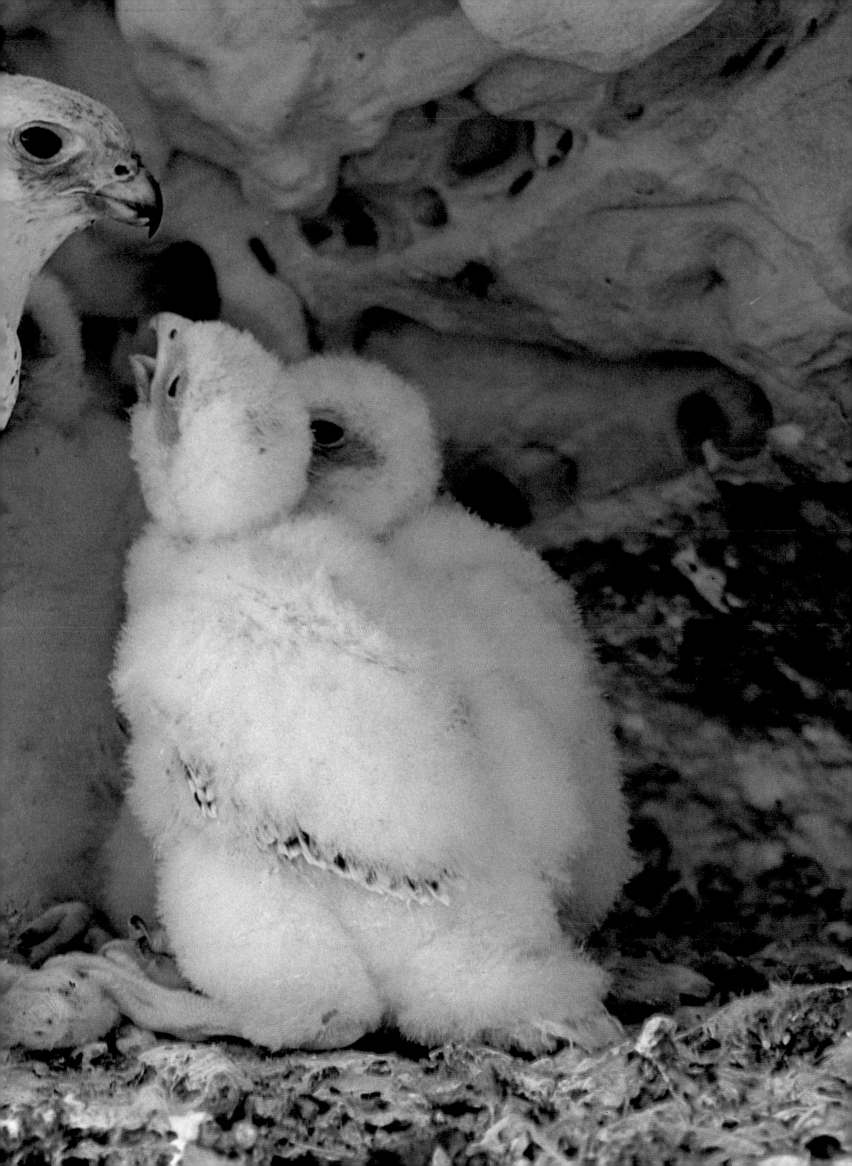

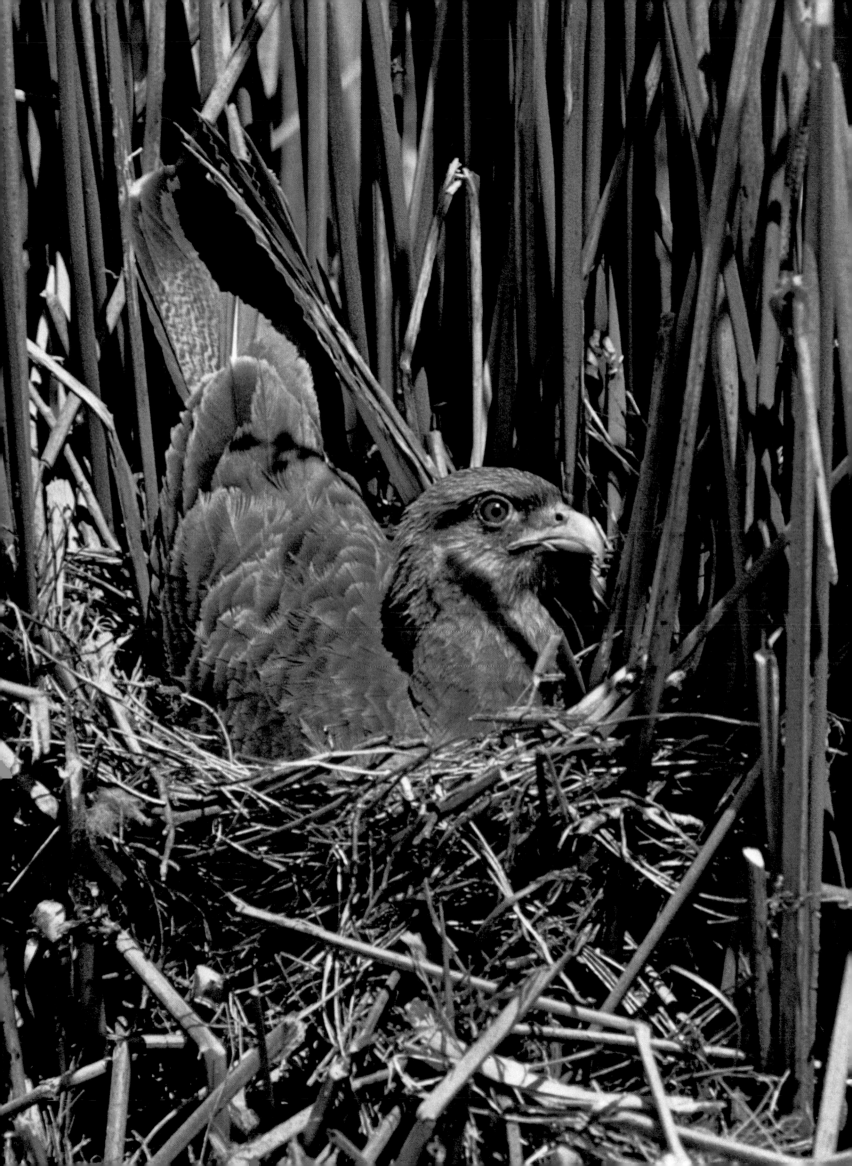

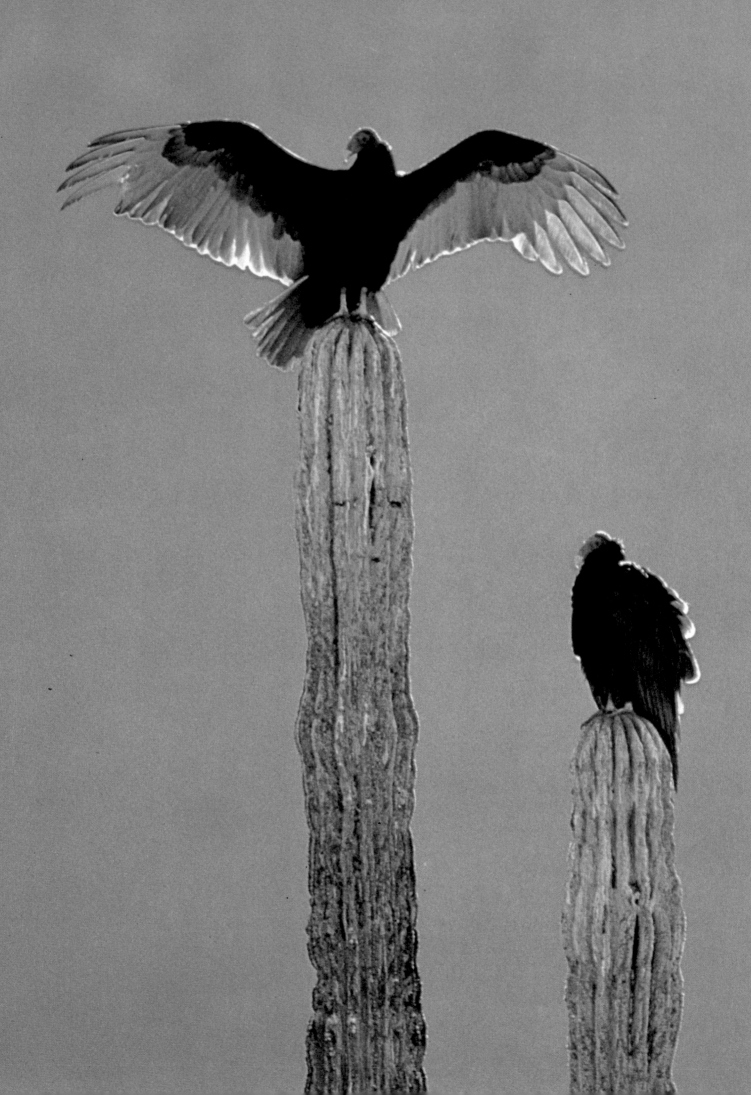

168 *left. In the desert of Mexico's Baja California, turkey vultures* (Cathartes aura) *wait atop the towering columns of cardon cactus for the morning updrafts that will carry them in search of carrion, which they find by both sight and their enhanced sense of smell.*

169. *One of the rarest and largest birds in the world, a California condor* (Gymnogyps californianus) *rides the hot thermals over the coastal mountains of southern California on wings that stretch ten feet from tip to tip. Although it was once fairly common on the Pacific coast, its slow reproductive rate could not keep pace with the toll claimed by guns and poisons. Today scarcely fifty survive.*
170 *overleaf. In a cloud of dust and a cacophony of harsh croaks, a horde of white-backed vultures* (Pseudogyps africanus) *tear at the carcass of a wart hog killed by a lion on the East African plains. Their featherless heads are an evolutionary response to their carrion-eating habits.*

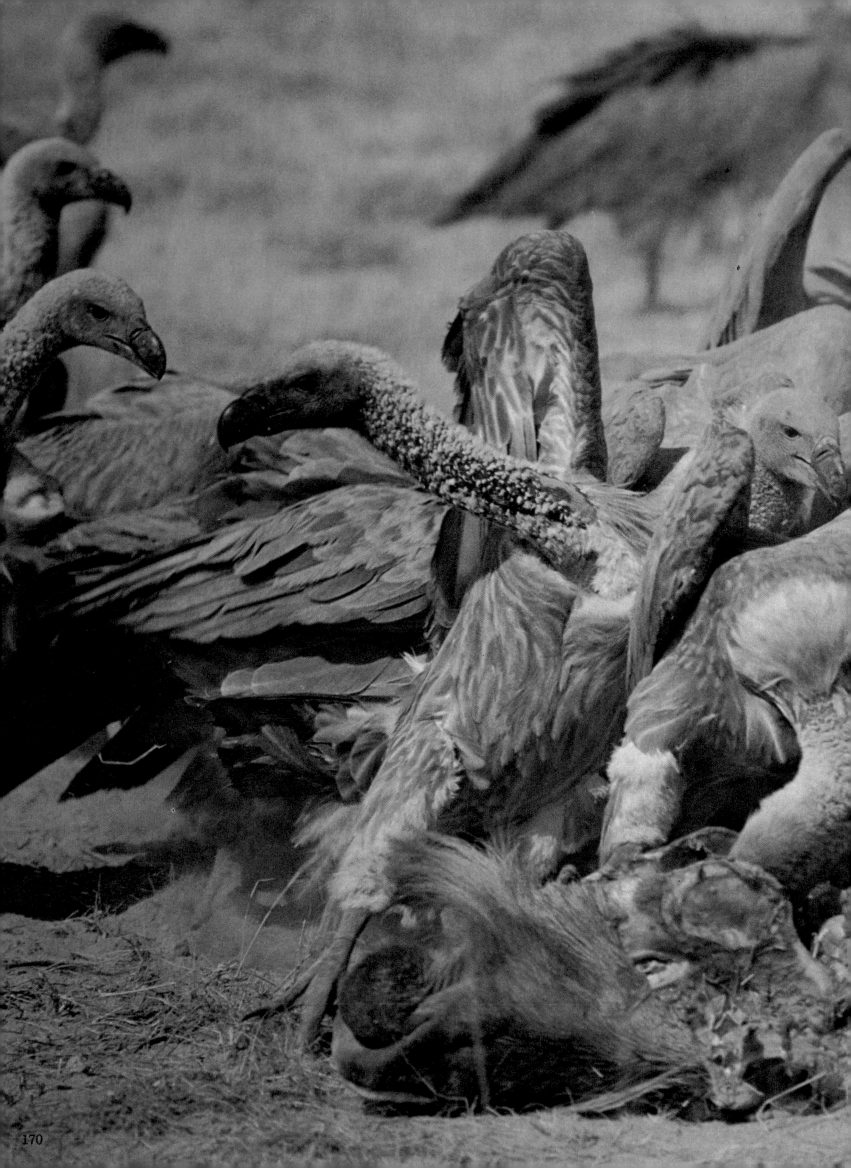

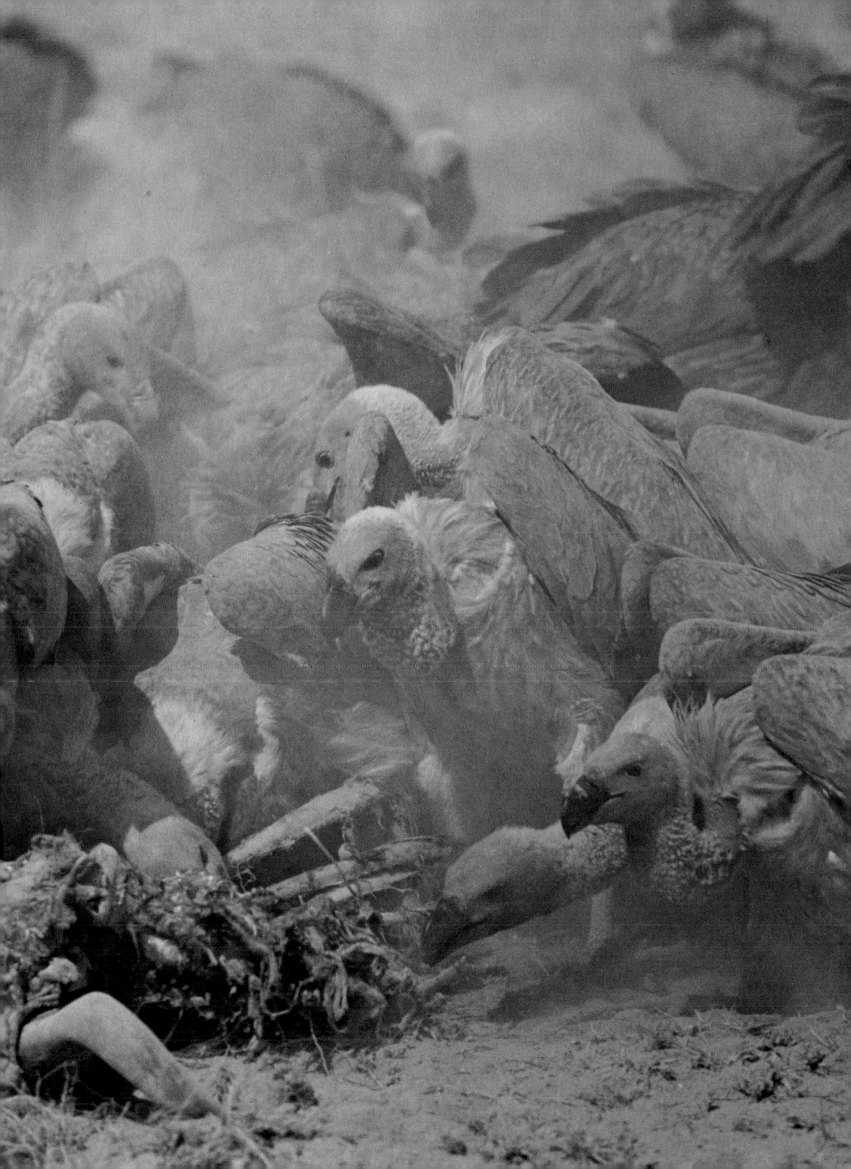

Hunters in the Night

The somber yellow eyes perceive the victim, a snake,
in the dim light. The great horned owl launches
itself, tail raised, feet clenched to its belly. The owl
is silent on outspread pinions and is aimed
accurately, its body tilted backward as it approaches
the snake, the pantalooned legs swinging forward
in a perfect arc. The snake, rearing up in alarm, faces
two sets of outspread, armored talons. It strikes
but hits only reptile-like scales. In the next instant it
is gripped by the talons. Desperately, the snake
thrashes, coils its body around the owl's legs. The owl
responds by fluffing out its feathers so greatly
that the venomous fangs of the snake strike
uselessly again and again at the feathers. Eventually
the owl changes its grip, seizes the head of the
snake and crushes it. The fight is over.
In the eye of any owl, the image of its victim is
greatly enlarged. A million cells around the
retina are sensitive to the faintest light. Starlight gives
the owl enough vision to hunt easily. The light
of a candle 1200 feet distant is enough illumination to
guide the owl to its target.
Not all night hunters are owls. Some are nightjars,
which include the well known nighthawks and
whippoorwills of North America. In South America,
the oilbirds, which are totally nocturnal, provide
another aspect to the night hunt. They eat nothing
but fruit.
To hunt at night is a theoretical ideal. The night
hunter should have the advantage over many helpless
day creatures. It is surprising, therefore, that

there are so few night birds. Only about 130 species of owls have evolved around the world, and not all of them are totally nocturnal. Nearly one-third of them hunt in daylight, and many species hunt only in the early evening as dusk is falling. However, within their night world the owls have exploited most of the available prospects open to them. Some are insect hunters that catch moths on the wing. But these few species are far outskilled by the efficient nightjars, which, with their silent flight, may be very distantly related to the owls. A few species of owls catch fish, and others have become skilled at catching crabs.

All the night hunters are united in the exceptional acuity of their eyes. The eyes of owls have a high number of rods, light-sensitive cells that give acute night vision. They also have a high proportion of cones that give sharp vision in bright sunlight. Their extraordinary eyesight is coupled to an almost radar-like precision of hearing. The ears of owls are quite different from those of all mammals and all birds of the day. They apparently have some capacity to analyze the separate combinations of sound vibrations, and because their heads are so large and wide, the ear openings so far apart, they seem able to get an extremely accurate auditory fix on the position of their prey. Thus some owls, notably the barn owl, can attack in total darkness where they are as good as blind.

In the dark there is no point in bright colors, or in differences between the sexes, so owls are almost uniformly grayish-brown, and muted in all their markings. It is their voice that distinguishes them, ranging from the soft hoot of small American owls to the horrendous scream of the Australian great owl. Between these two extremes lie some of the most wonderful sounds made by any animals—wails, shrieks, growls and grunts—all of which mark territory and identify individuals.

Owls have colonized large territories of the earth. They are common in the lowland forests of eastern North America and also in the open country of the West. They have gone high into the Himalayas. They have colonized most of the world's great deserts, wherever there are oases or piles of rocks to give them shelter. Owls have gone into the Saharan mountains, into the valleys of the Andes up to

10,000 feet, into the trees of forests almost everywhere. They nest in hollow trees, in riverbank holes, in barns; in the grasslands they have become ground nesters and even dig holes or commandeer the burrows of other animals.

The fish-hunting owls work wide areas of the world but are particularly common in the tropics where there are sluggish streams and rivers winding back and forth through the jungles, or where there are mangrove swamps and flooded rice fields. Some of the tropical fish hunters have even taken to the mountains and hunt streams at 5000 and 6000 feet.

This kind of hunting suggests supersensory skills. A number of creatures make their own sounds, which bounce off prospective victims and return to the hunter's ears. By this method the hunter gets a precise fix on the victim and may make the kill without ever seeing its prey.

This is an obvious enough technique for a meat-hunting creature as represented by the nightjars with their great appetites for moths and other insects. But the most contradictory creature in the night-hunting group is neither meat-eater nor related to any of the owls or the nightjars. This is the oilbird, or guacharo, a crow-size South American bird that eats only fruit. Not only is it nocturnal, but it retreats into the deepest and darkest caverns it can find for shelter during the daylight, refuges of such difficult access that the oilbirds must use some system of sonar navigation to find their way in the absolute pitch blackness. Their voices are the clue, a series of clattering and croaking noises, sharply enunciated, and undoubtedly their method of locating themselves in the darkness of the caverns.

The nightjars, or the goatsuckers as they were called for so long in Europe because of their presumed habit of stealing meals of milk from lactating farm animals, have come very close to the owls in their evolution. However, they are not related. They have large eyes (but not as large as those of any of the owls), identically soft plumage for the silent night flight and extremely large mouths which, opened wide and fringed with bristles, engulf night insects in high-speed flight.

In North America the familiar nighthawk differs from the other nightjars in that it is not totally

nocturnal but is often seen during the day and migrates south during daylight hours. Its loud cry—"peent"— echoing from the darkness of much of the North American continent is its characteristic identification. This is coupled with its courtship habit of diving almost vertically to earth and pulling out at the last moment with a loud booming noise of air rushing through its plumage.

The night is a time of mystery for all day creatures, particularly man. But some creatures are equally at ease in either day or night. The snowy owls of the Arctic must hunt in daylight during the northern summers when there is no night. Indeed, their main prey is the lemming, which is a day animal. But when the lemming populations fail, after periodic population explosions, the snowy owls are led south by their hunger, sometimes as far as the Caribbean. Owls are such strong creatures of territory it is unusual for them to move such distances away from their familiar hunting grounds. Each owl has its territory very strictly outlined. The great horned owl, which is a close relative of the eagle owls of Eurasia and Africa, may need up to six square miles of forest to satisfy its great appetite. The tiny screech owls of the high mountains of the southwestern United States live in about three acres. The pygmy owls of Mexico may manage in even smaller areas.

The territory of most owls is fiercely preserved. There is even a kind of "no-owl" territory between the home bases of great horned owls, the territory claimed by their loud voices. However, the owls of the open spaces, and those that hunt in daylight, cannot use their voices to mark out their territory and so must wing back and forth along their boundary lines to show themselves. The short-eared owl cracks its wings together to emphasize the limits of its territory.

When night falls anywhere on earth and the first owl voice is heard, or the buzzing cries of the nighthawks go arcing across the blackness, the birds of night lay a powerful hold on the imaginations of landbound men. They are the stuff of legends and mysteries, and as long as they flourish on earth, man may be reminded that none of his senses, or his machines, gives him such freedom as these wild creatures enjoy in their mastery of the night hours.

177. There are many fallacies about owls, including the belief that they are blind in daylight and can see in total darkness. In truth, a number of species are diurnal hunters. And while owls' eyesight is indeed acute at night, most of them are as helpless in absolute darkness as a human being would be. For many owls, sound is as important as sight in their forays, and their superbly developed powers of hearing are aided by facial disks that concentrate sound waves like parabolic reflectors, by ears that are directional, and of course by their silent flight. Most awesome of all owls is the great horned owl (Bubo virginianus) that hunts over nearly every kind of habitat, from forest to desert, in North and South America from the subarctic treeline to the Strait of Magellan. Standing two feet high, it is the scourge of any creature its own size or smaller—hawks, other owls, ducks, grouse, skunks, rabbits, snakes, even fish and scorpions.

178 overleaf. At times legend and fable become embedded in scientific ornithology. Such is the case with the family Caprimulgidae, which literally translates as "goatmilkers" or "goatsuckers." The origin of the myth can be traced back to early Greece, where superstitious goatherds, seeing nightjars hovering open-mouthed about their animals in the evening, believed that the birds were sucking milk from the teats of the goats. The truth, of course, is that the nightjars were seining bugs stirred up from the grass by the goats' feet. In North America the best known of these flying insect traps is the common nighthawk (Chordeiles minor), which often nests on the flat rooftops of towns and cities and swoops over the streets on summer evenings, filling the air with its incessant buzzing cry. Scientists studying the insect prey of nighthawks found 500 mosquitoes in one bird's stomach and 2175 flying ants in another.

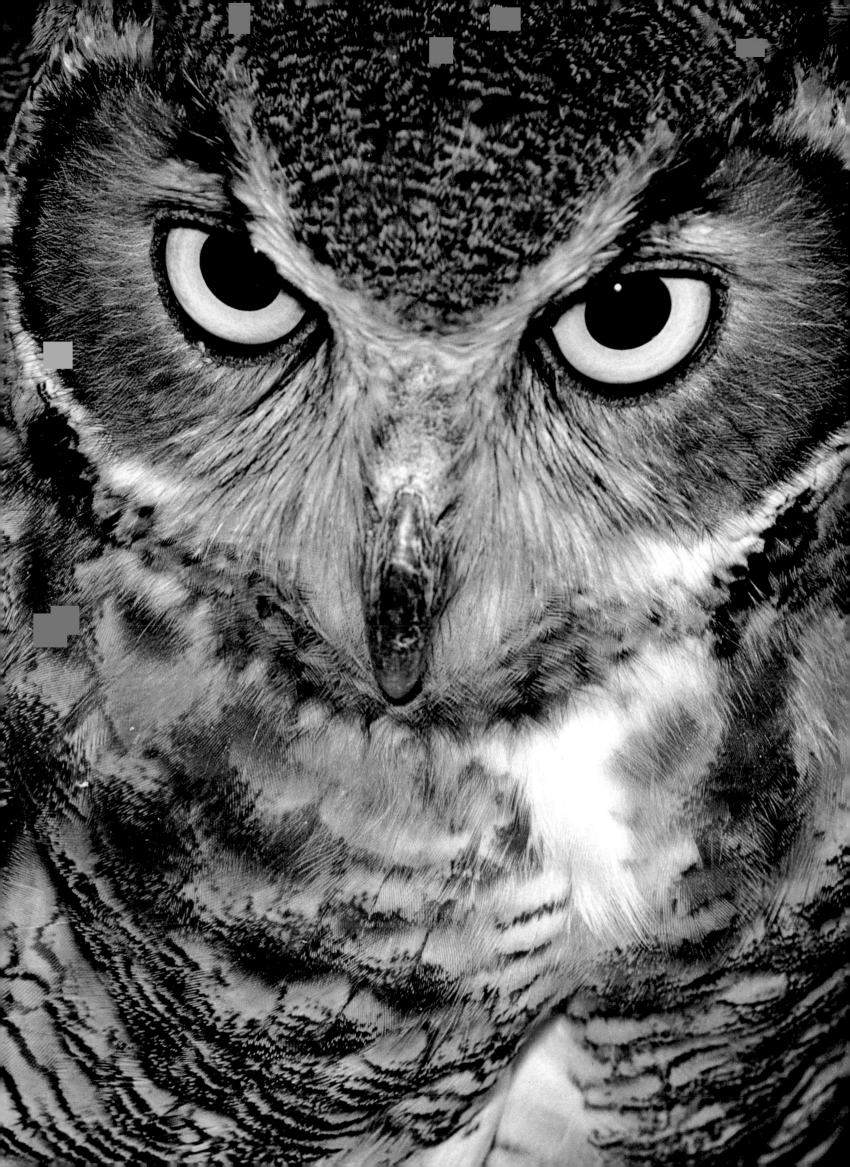

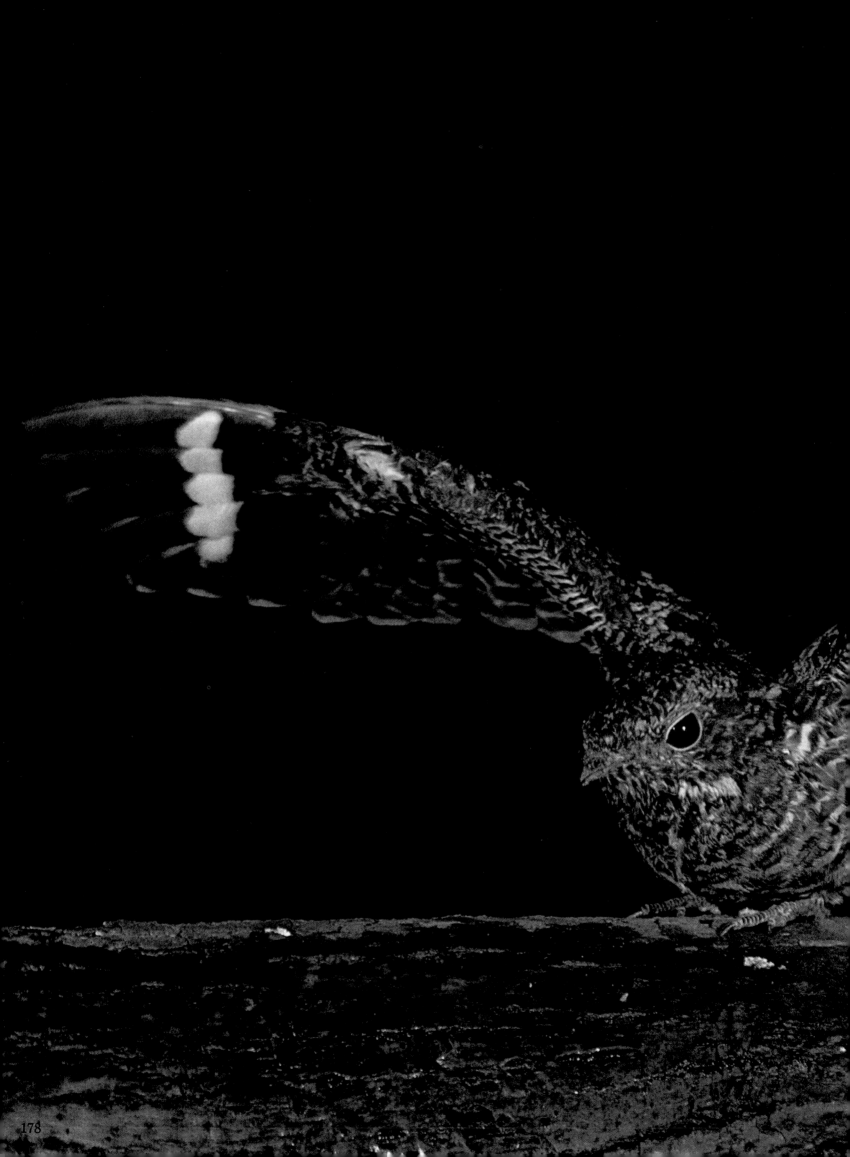

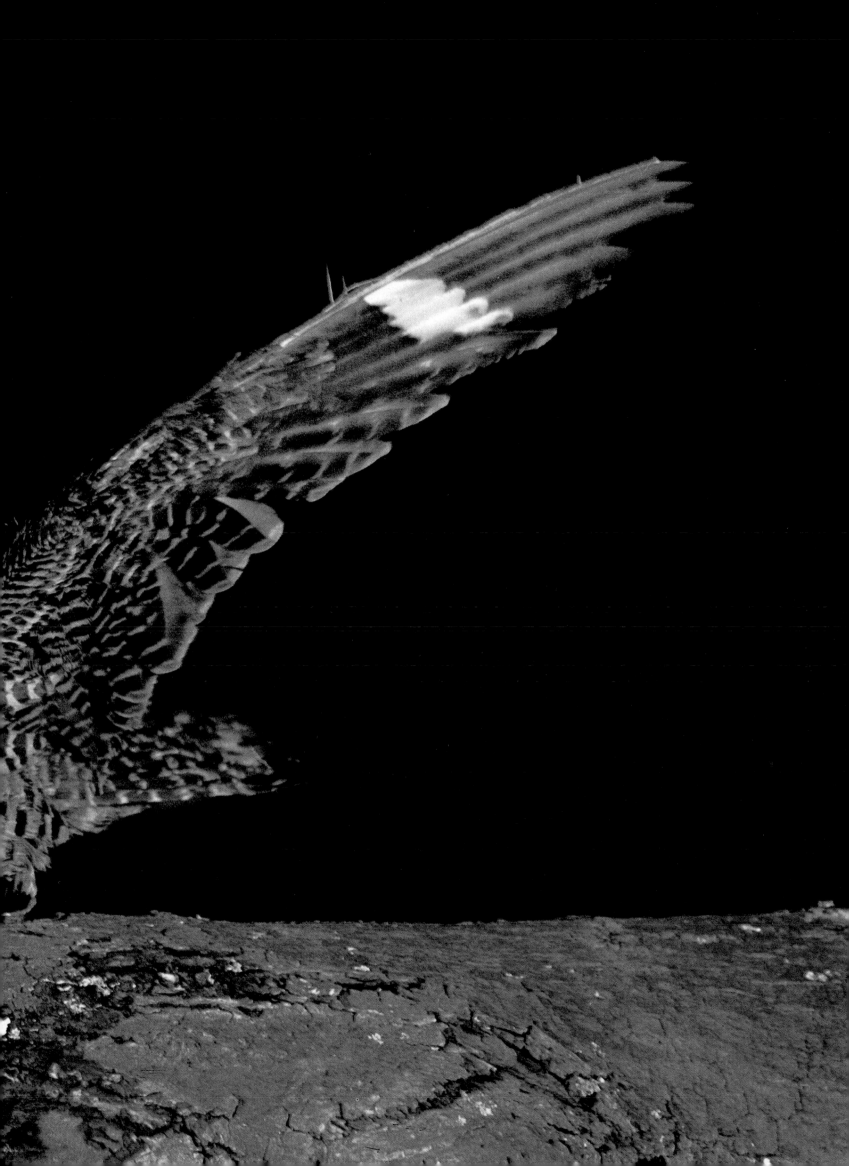

181 *right. A Jamaican brown owl* (Pseudoscops grammicus) *watches from a ledge in a limestone cave. Found only on the West Indian island, the brown owl nests in caves and sinkholes, where it lays its two eggs on bare rock and in hollow trees and ruins. Its diet is diverse: rats, frogs, lizards, small birds, beetles and spiders. Natives call this tawny hunter "patoo," from the African word for owl, and they know that a brown owl nesting near their home is as good as having a watchdog, for it utters a loud barklike cry at the approach of an intruder.*

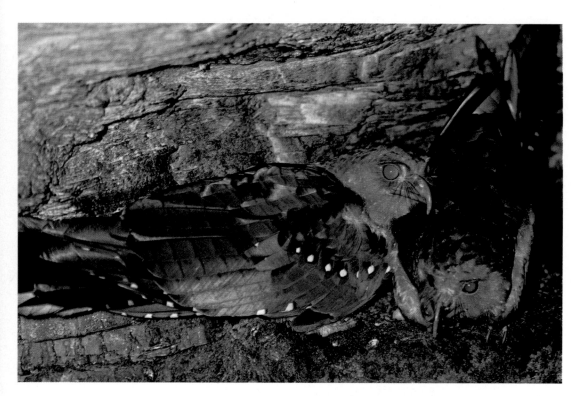

180. *A nocturnal vegetarian, the oilbird* (Steatornis caripensis) *of Trinidad and South America lives in colonies on the ledges of pitch-black caves. It ventures into the tropical forest after dusk, navigating by echo-location, to feast on aromatic fruits that it finds by smell. The oilbird hovers by a tree, often a palm, plucks the fruit with its hooked bill and swallows it whole. Young oilbirds, grown fat on this rich diet, are boiled down by natives to produce oil for cooking and lighting.*

182 *overleaf. Carrying a rat to feed its nestlings, a barn owl* (Tyto alba) *returns to the turret of a country church in Surrey, England. Although never common, the barn owl is a truly cosmopolitan species, for it inhabits nearly every corner of the world except for the polar regions, New Zealand and some remote oceanic islands. Tales of haunted houses may owe their origin to the barn owl's affinity for empty old ruins coupled with its spooky night cry, sinister face and ghostly way of flying.*

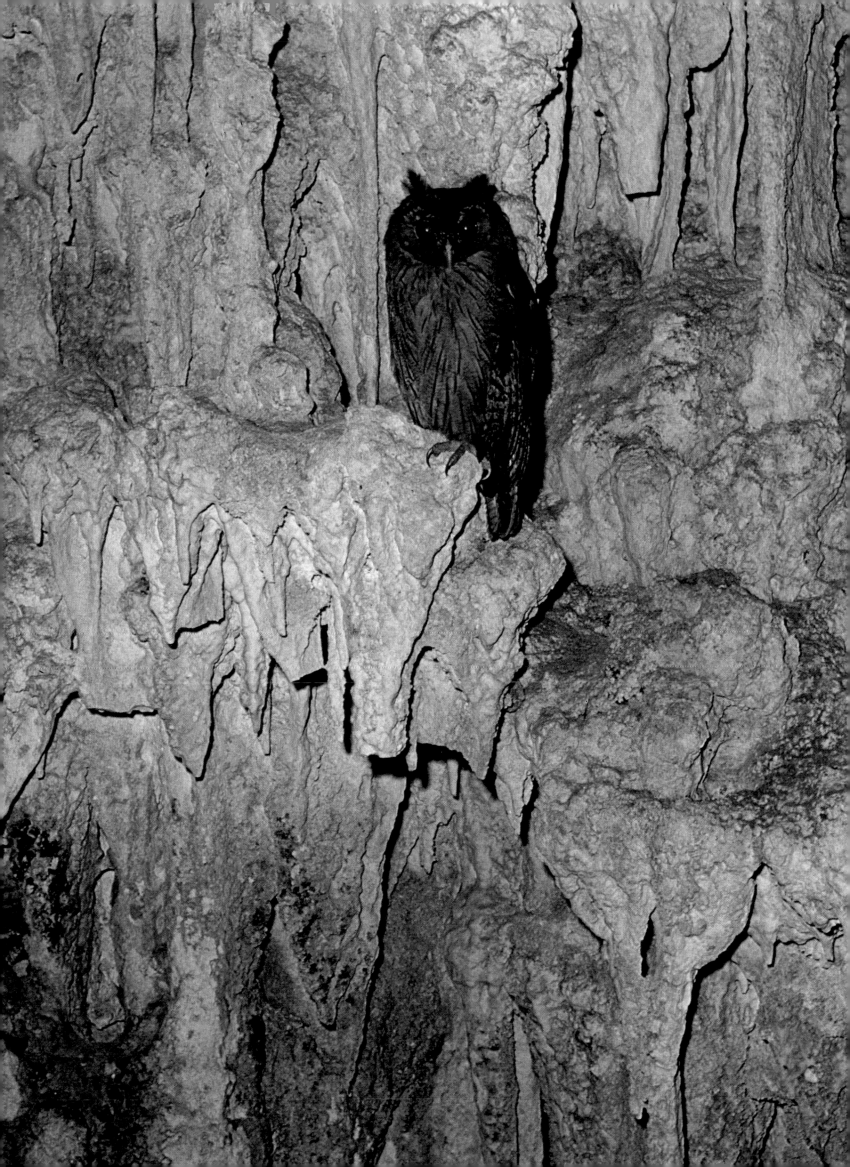

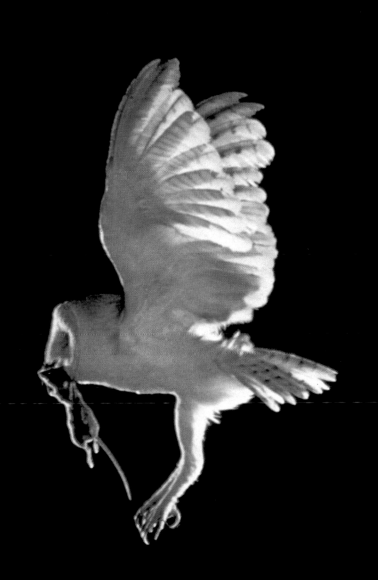

Photographic credits for the preceding illustrations:

Birds on the Ground

In the early evening a flock of turkeys flies across the water prairies of the Okefenokee Swamp in Georgia and lofts up gracefully to the top of a tall cypress. In a few moments it is dark. The turkeys have gone to roost without being seen by any other creature. But the spectacle of their flight gives the watcher another insight into the wonder of bird life. These large, pheasant-like ground birds have exactly divined the dangers around them and have placed themselves with perfect accuracy in an area best suited to their survival.

The turkey was domesticated originally by the earlier American Indian cultures, then taken to Europe by the Spaniards. Subsequently, domestic turkeys have interbred with local populations of wild turkeys in the southern United States mountains to produce a series of races, or strains, that are not quite like either the original wild turkey or the domestic animal. The wild turkey has a special fascination for man because it has proved so amenable to domestication while also remaining in many of its original habitats.

The surface of the earth teems with creeping life forms, with seeds waiting to germinate, plants burgeoning out of recent rains, low bush fruits ripening. Here is gathered a special group of birds to exploit the opportunities of living close to the earth at all times, the gallinaceous birds. Here are creatures that have chosen to walk more than fly, to be secretive but also conspicuous, to be camouflaged but also brilliantly colored. They are a large, varied, interesting group.

They have special interest for man because of their adaptability to man's civilization. All the domesticated fowl of the world come from this gallinaceous group. They include the guineafowl of Africa which, although tropical creatures, thrive outdoors in freezing North American winters. They include many kinds of quail, notably those of the New World, the bobwhite, the California, and others.

They are birds of greatly varied appearance and habit. The blood pheasants of the Himalayas, with their rich colors, have evolved quite differently from the tropical American guans and curassows with their duller plumage. The secrecy of the group is exemplified by the Congo peacock, a large and spectacular bird that was not discovered until the 1930s. Their great range of behavior is shown by the megapodes of Australia, which build large nests of rotting, hot vegetation that incubates the eggs.

The American turkey was decimated in the nineteenth century by guns, traps and the relentless pressure of the hunting men. Its survival today makes one point decisively: ground birds generally have a remarkable hold on their environments. Despite their apparent vulnerability, they have fitted precisely into a world teeming with fleet-footed enemies that relish their flesh.

The turkey illustrates some of the contradictions of this group of birds. At first sighting it appears to be a relatively dull creature. But, when seen close up, it is extremely handsome, its plumage dark green with touches of copper, bronze and gold. Originally it prowled most of the eastern and middle western United States, stretching clear down through Mexico almost to the Yucatan Peninsula and even climbing high into 10,000-foot ranges in southern Mexico. There it gave way to another species, the ocellated turkey. This extraordinary-looking creature, restricted to the Yucatan, resembles the peacocks in the richness of its coloring. Seen in courtship, it throws out its gorgeous brown chest in an expansive curve, topped by a mantle of light green feathers. The pale blue skin of its head and neck is the final, surprising color. At the same time, it droops its black-and-white banded wings and fans the thick, shortish feathers of its tail like a peacock.

The peacock, even more brilliantly colored, compensates for its conspicuous appearance with its

exceptional wariness. Its haunting cries, a series of childlike wails, warns all creatures that danger is approaching, usually in the form of a tiger or leopard. It displays its tail frequently. Its cries usually precede tumultuous flight, tail streaming behind it as it flies powerfully across a clearing in the Indian woods. Wariness is a quality shared by all the other brightly colored Asian pheasants, particularly the golden pheasant, one of the most beautiful of all birds. It is richly caparisoned in orange, gold and russet plumage, and black and spotted markings esthetically touch its feathers.

Wariness warns the ground birds of approaching danger, but it is explosive flight that takes them to safety. All of them share short, extremely powerful wings, which give them rocket-like launches, usually followed by brief glides to safety. These qualities make them quite distinct from those birds that have elected to find refuge in trees or in swamps or at sea. In addition, some species of ground birds have developed a special hierarchical system of behavior where the emergence of a dominant male usually results in him gaining the right to mate with many females. This probably helps keep the specialized skills of the ground birds refined and at their peak by the almost exclusive use of the exceptional males.

The North American sage grouse establish large, almost communal arenas, each up to 2500 feet long and 200 feet wide. The males occupy this territory to display and dance and set up the correct order of dominance. Once this is achieved, the dominant male bird mates with as many hens as he can, sometimes thirty or forty females a day. Meanwhile, he is attended by the second bird in the order of dominance, who helps beat off those male birds lower in the order. The attendant earns his reward occasionally to mate when the dominant bird is himself preoccupied.

In displaying, or dancing, ground birds everywhere are torn by the need to show themselves as vividly as possible yet also to preserve at least some of the need to blend in with their backgrounds. All the grouse of North American forests are secretive during their off-breeding season. But in the spring they are transformed, and although they are not as colorful as the pheasant of Asia, the drab males

rearrange their feathers so well that they can show contrasting colors with great effectiveness.

While the Asiatic birds of the ground all permanently display their brilliant plumages throughout the year, the American grouse achieve their effect with more subtlety. Some can erect brilliantly colored combs for display, then fold them away out of sight. The ruffed grouse can arrange their neck feathers into a collar which, when combined with head shaking, creates a halo of moving color around their heads. But the moment danger threatens, the ruff collapses, the colors disappear and the grouse is drab and melts into its background.

The blue grouse has even more spectacular capacity to display, and to conceal. It can bend its neck feathers so that they flash their white bases while revealing the raspberry red skin beneath. Combs curving over the eyes of the blue grouse can be changed in color at display time, and in size, so that a clear yellow comb can be transformed to brilliant red as blood flows through their tissues, then quickly reduced and brought back to their original color.

The gorgeous fanned tail of the peacock is the best example of the great significance of display in the lives of the gallinaceous birds. However, display may have little to do with either arresting plumage or color. The European black grouse is not so beautifully adorned as the peacock, but what it lacks in colors it makes up for in energy. Each male has its individual dancing ground where, its feathers blown up greatly, it challenges any rival with shaking body and swollen red eye combs. Meanwhile, other males are dancing and working in their preliminary moves to establish territorial boundaries. Once territory is decided, the male awaits the arrival of any female at his property, where he has earned the privilege of mating.

The North American prairie chicken blows up its orange neck sacs, struts and booms hollow sounds into the emptiness of its flat world. Its dancing is so distinctive, head down and tail up, the feet stamping quickly, that it has become a part of Cree Indian ritual. This is but one impact that the ground birds of the world have had on human affairs. They have yielded to man and given him the chicken, the turkey, the egg and the basis of most cooking. But they have also resisted him in remaining forever wild and free in their own worlds.

189. *In its breeding finery, the cock ring-necked pheasant (Phasianus colchicus) is an impressive sight both to the harem of hens he wants to woo and to a human observer. Bright red patches of bare skin on the face stand out from the iridescent violet and green feathers of head and neck. Much of the bird's body is a rich bronze marked with black and white, but the rump feathers are powder blue. As the cock runs circles around a hen, he trails a magnificent tail that may be two feet long. Native to Asia, the ring-necked pheasant was introduced to Oregon from northern China in the 1880s and quickly became North America's most popular game bird. Widely stocked by sportsmen and by game and fish agencies, it found a ready-made niche in farming country across southern Canada and the northern United States, where in a good year more than 16 million ringnecks will be bagged by gunners. But pheasant populations are now declining in many areas because modern "clean farming" techniques leave the birds with little cover and food to help them survive cruel winter months.*

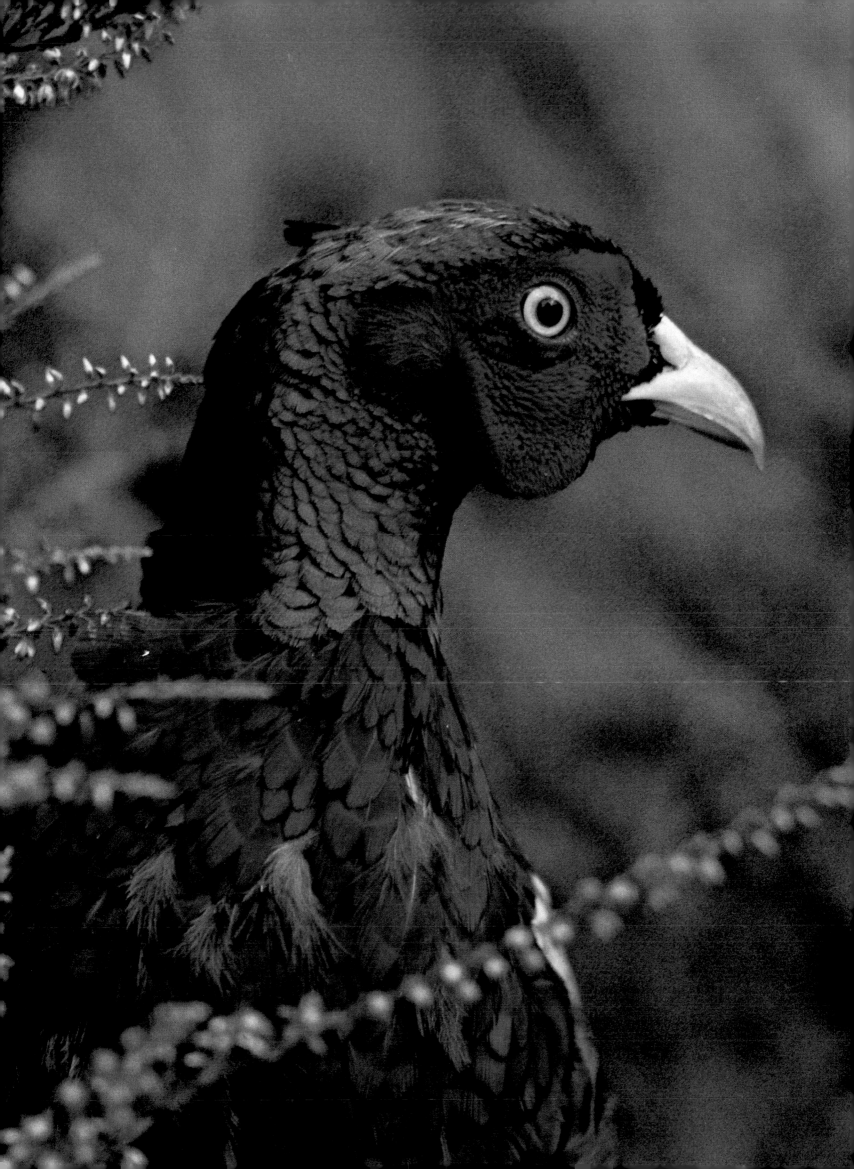

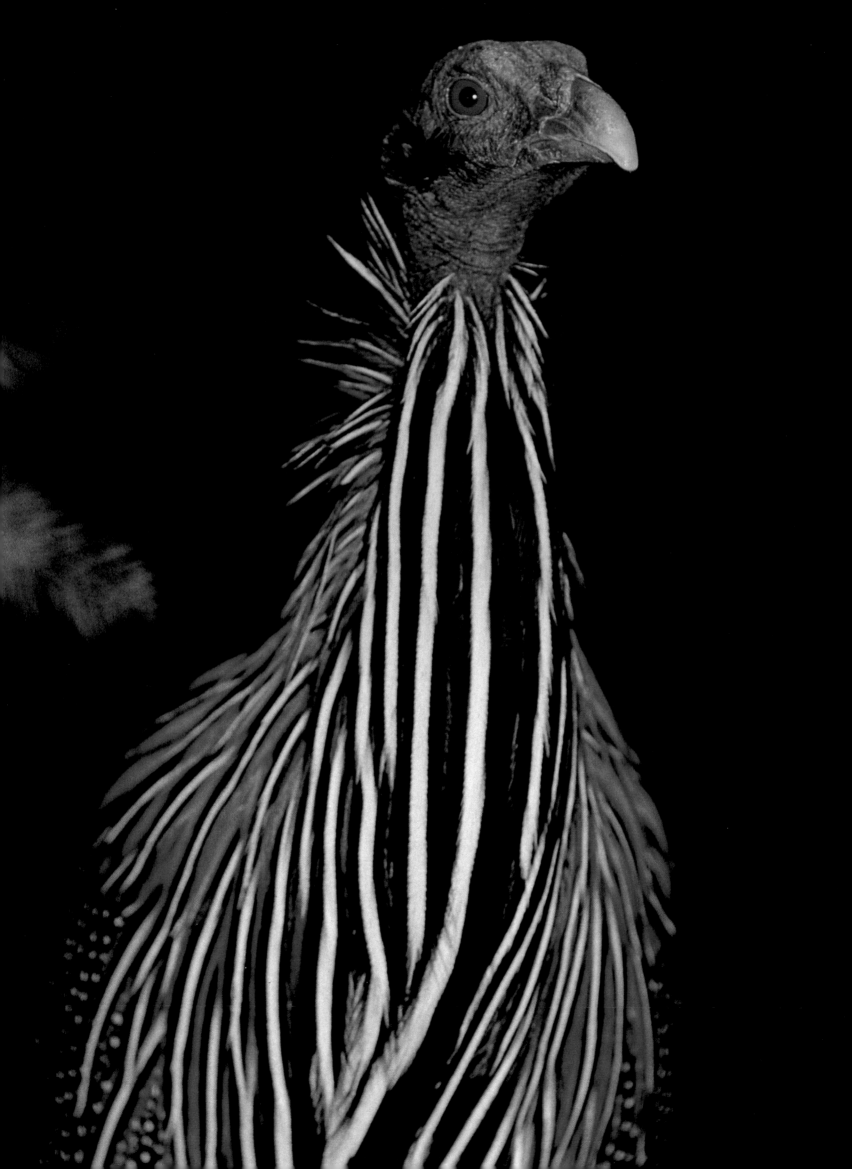

190 *left. The name of the vulturine guineafowl* (Acryllium vulturinum) *is explained by the vulture-like appearance of its featherless head and neck. But a flowing striped ruff makes this the handsomest of a family of African birds that includes the widely domesticated helmeted guineafowl. A bird of East Africa's thornbush plains, the vulturine guineafowl lays as many as twenty eggs in a scrape in the desert.*

191. *Tragopans are exceptional members of the large and wonderfully varied pheasant family because these shy birds of the high Himalayan forests construct bulky stick nests in trees. The elaborate plumage displayed by the male satyr tragopan* (Tragopan satyra) *is typical of the cocks, which suggest, in the words of one ornithologist, "brilliantly colored and patterned pieces of silk."*

192 *overleaf. Although it may weigh twenty pounds and prefers to run—at speeds reaching fifteen miles an hour—the American wild turkey* (Meleagris gallapavo) *is a strong flier. It can easily clear treetops and sail for a mile on wings that span up to sixty inches.*

192

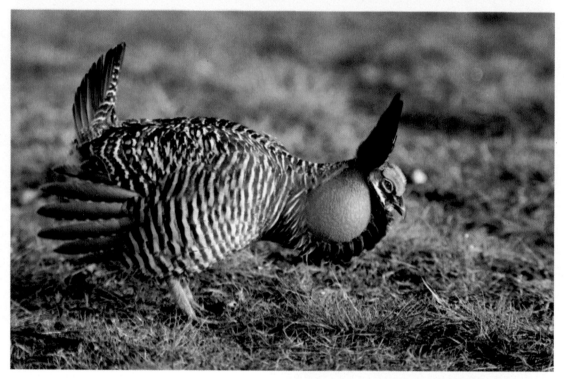

194-195. *At first light on a March dawn, a prairie hilltop in Missouri bustles with the nuptial dancing of greater prairie chickens (Tympanuchus cupido). Orange air sacs inflated, black neck feathers erected into "horns," the cocks squabble over small sections of a courting ground that may cover an area the size of a city block. With head held low, tail high and wings dragging, a cock will stamp its feet, dash forward, pause, emit a hollow booming that triggers a chorus of booms from every other male, and then with a loud cackle leap over the nearest opponent. All the while the females walk about seemingly unimpressed, or watch from a handy rock or the bleached skull of a buffalo. By sunrise the ceremony has ended, but it will be repeated at sunset, and every morning until the hens have been mated and wandered off to lay their clutches of a dozen eggs in the deep prairie grass.*

196 *overleaf. Among the eighteen species of grouse spread around the Northern Hemisphere, the sage grouse (Centrocercus urophasianus) of the American West is second in size only to the capercaillie of Eurasian evergreen forests. As its name suggests, it is an inhabitant of sagebrush plains where, each spring, flocks that may number several hundred birds gather for their annual mating rites. On courting arenas that have been trampled into dust under the birds' pounding feet, the cocks splay spiked tails, puff out collars of white feathers, inflate air sacs to produce a popping noise that can be heard a mile away, and perform quick little dance steps that may be repeated twelve times in a minute. Unlike other grouse, which have tough gizzards for grinding grains, the sage grouse eats mostly sage leaves and cannot digest harsh foods. In autumn the flocks, augmented by young birds raised by the females alone, regroup to make a vertical migration from the foothills to warmer desert areas.*

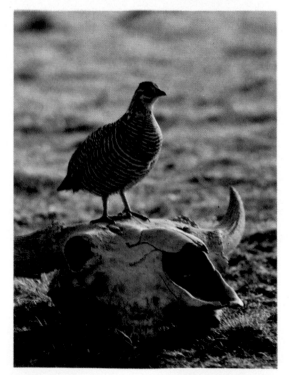

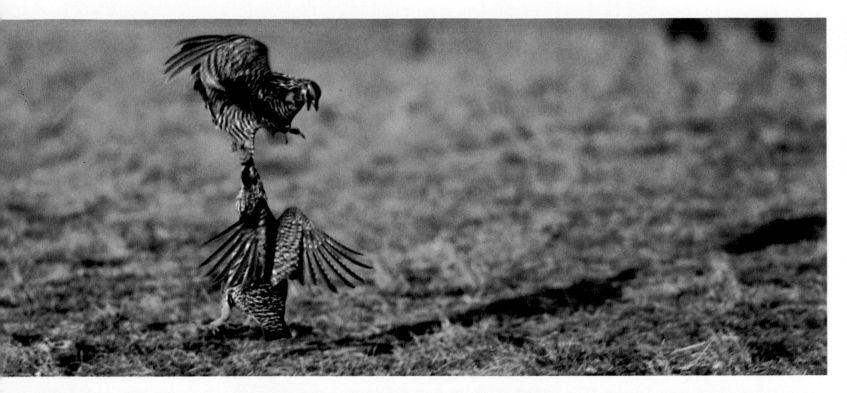

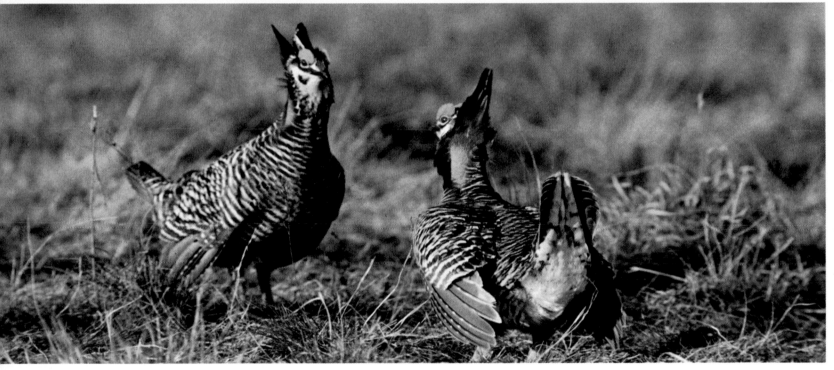

198 *left. Because of its fondness for grapes, the California quail* (Lophortyx californicus) *was once slaughtered by wine growers. Chaparral lowlands and mountain valleys along the Pacific coast, from British Columbia to Baja California, are the original home of this plump and handsome little bird with a jaunty head plume. Treasured by sportsmen, and serving as the official state bird of California, it has not only made a comeback there but has been successfully introduced in other parts of the West and in Hawaii, New Zealand and Chile.*

198 *below. The aptly named scaled quail* (Callipepla squamata) *of the thorny, arid scrublands in the southwestern United States and in Mexico prefers to run, not fly, from approaching danger. Although adults get all the moisture they require from their diet of insects, plant buds and wild fruits, their chicks need drinking water, so the birds time their nesting to the rainy season.*

199 *right. A conspicuous white throat and eye stripe distinguish the male bobwhite* (Colinus virginianus) *from his mate. One of the most familiar bird calls in rural North America is this quail's loud, whistled proclamation of its name.*

200. *Hooting from a log in its territorial display, the blue grouse* (Dendragapus obscurus) *of the Rocky Mountains flexes neck feathers to expose two snowy rosettes that surround its raspberry-red air sacs. Simultaneously, the bird erects combs above its eyes that change from yellow to orange to crimson as blood floods the thin tissues.*

201 *right. On Bathurst Island high in the Canadian Arctic, a female rock ptarmigan* (Lagopus mutus) *incubating her clutch of eggs is cryptic colored and blends with the tundra. She completed her molt from winter's white plumage about the time her last egg was laid. But her mate remains white long after the snow has melted, helping him decoy predators from the nest site.*

202 *overleaf. The wings of a drumming ruffed grouse (Bonasa umbellus) are a blur as morning's first light floods a Manitoba forest. No other grouse produces such powerful nonvocal sounds, which still defy explanation; once it was believed that the bird beat its breast or struck a log with its wings. The drumming performances are complex and precise. Every male in a particular area uses exactly the same number of strokes in each sequence; each begins with slow, hollow thumps and races to a speed of twenty strokes a second at the climax.*

Photographic credits for the preceding illustrations:

Birds in the Open

After the rains have fallen on the East African grasslands, a transformation of these great open areas begins. Within days, a flush of green spreads to every horizon. Seeds, dropped before the long drought of the previous year began, spring to life. Termites and ants, lions and antelopes, giraffes and mongooses—all the creatures of the grasslands respond to the gift of the rains.

But the most visible of all the aroused creatures are the birds. The clear blue African skies are laced with arrivals from other areas, migrants from Europe and from other parts of Africa. The quelea finches, or dioch birds, which have been ranging drought-struck central Africa for months, begin moving south in response to the rains. As flock folds into flock, the number of dioch birds grows astronomically until more than 20 million of the small finches are moving steadily south. They will time their arrival to coincide with the fruition of the grasses, the beginning of seeding.

The world's grasslands are host to many different kinds of birds, but they occupy a world that has one common denominator: this is much more of a two-dimensional world than most other environments. Except for the birds of prey, few birds here have need for much vertical movement. So they cling to the flat clear earth. The birds of these open spaces share more techniques of survival than birds in most other environments. They are molded in both form and behavior by openness all around them. Enemies can be seen far away. It is easier for many birds to escape on foot than to fly. The ostriches of Africa, the cassowaries of South America

and the emus of Australia have evolved large, powerful bodies, coupled with great speed on foot. These talents are shared in diminished form by the African and Asian bustards, and by the coursers and thick-knees of the same regions.

The birds of the grasslands, and of the open spaces in general, are therefore dependent on very specific methods of matching themselves to their environment. Camouflage is a favorite method of avoiding enemies. All of the North American sparrows have colors that match their grassland backgrounds, and the same is true of the African grass warblers. To camouflage themselves, many birds have the capacity to "freeze." Longspurs hide in the footprints of animals and are invisible until they move. European larks crouch down, flattening their camouflaged bodies until the last moment before exploding upward in wild and powerful flight.

The birds are united by their common habit of nesting on the ground. Many sparrows that hide their nests in thickets of grass, reach them along runways so that when they drop to the ground, a watching enemy will not know the exact position of the nest.

The flatness of the grassland world means that many species have developed special devices to make themselves visible, to be noticed by others of their species, most particularly when they are courting. Display flights are a common method of achieving this, and are practiced in North America by the pipits, the horned larks, the lark buntings and some of the blackbirds, particularly the bobolink. The skylark mounts to a high position in a clear blue sky and then pours down song, hour after hour, while hovering on rapidly fluttering wings.

Birds that live in the open must be ready to range widely and, indeed, are often forced to do so under the stimulus of storm, drought, fire and food shortages. Snow buntings, driven from their tundra hunting grounds by savage winters, may travel thousands of miles in alien environments, including forests, in search of food. Longspurs, beset by winter, may suffer high mortalities in the American prairie lands when shortages of food, high winds and bitter cold all coincide.

The American goldfinches, in particular, are great travelers in pursuit of their food, and resemble the weaver finches of Africa in search of seeds maturing in widely separated places. They fly from the seeds of pitch

pines to those of goatsbeard, from catmint to burdock. Although their staple seed is the thistle, the late seeding of which is the main reason the goldfinch breeds so often in late August and early September, it also eats the seeds of sycamore and the buds of many trees as well as the larva and pupae and adults of many gall-making creatures in oak trees.

In Africa and Australia the movements and the habits of the birds living in open country are governed by the rain, or the lack of it, causing movements of millions of birds in response to the seasonal cycles. Hosts of Australian budgerigars cut green pathways across the sky in their massed flight toward food and water. When the dry season begins in many parts of Africa, the rollers arrive in great curved swoops across the pale blue skies.

Birds of the open country have fewer chances to modify their environment because they do not use that great dimension of vertical space. However, they interact with other animals. Some have made large animals their hosts. The tickbirds of Africa follow various grazing animals in their wanderings in the grasslands, and serve to rid their hosts of parasitic insects. The cowbirds of North America once followed the herds of American bison, feeding on insects stirred up by the feet of the moving animals, and were solely natives of the midcontinent's expansive grasslands. However, the cowbird could use vertical space. It perched in trees, laid its eggs in the nests of tree-nesting birds.

When the bison were brought close to extinction by ruthless hunting and the expansion of man's domestic livestock herds, the cowbird did not suffer. It frequented cattle pens and thus got its name, and expanded its range east as the forest was cleared and livestock moved in. This movement has put it within the breeding territories of many small birds, particularly those warblers that nest at the edge of open spaces—meadows, swales, prairies—and it has heavily parasitized many of these species. One of these warblers, the Kirtland's, is already rare, and the cowbirds would soon exterminate it were it not for man's efforts to keep local cowbird populations in check.

The cowbirds have displayed a special versatility not shared by most other birds of the open spaces. Lacking the ability to exploit the extra dimension of vertical space, the birds of the open occur in fewer

species than do the birds of most other environments. But once adapted to the open, some species can then survive in a variety of open environments. The savanna sparrow haunts the grassy islands of the Aleutians, the bogs of Labrador, the short-grass prairies of Canada and the salt marshes of California.

In the Aleutians the sparrows crouch down to sleep in the longish grasses. But when the prairie grasses of North America are grazed down, they huddle together in groups to sleep, perhaps to be safer from prowling owls, one of their great enemies. If attacked by an owl, a mass of sparrows flying upward suddenly may confuse the owl and prevent it from catching any of the small birds.

Open country is always much more subject to extremes of wind, rain, snow, freeze and fire. In blizzards, open-country birds often find shelter in snowdrifts. When fire strikes the African grasslands, the bustards are there, busily flanking the flames and catching the creatures struggling to escape the fire.

The grassland environment is a study in extremes, matching great abundance with extreme poverty, great cold with heat. The birds conform to these changing environments with precision and speed. Locusts swarm in open country, and birds pour in to exploit the harvest. Termites, a favorite food of many African and Australian birds, flourish only in grasslands and savanna lands.

When the dioch birds arrive on the African plains to breed, their arrival coincides precisely with the growth of enough length of grass to give them nesting material. Once there is enough material, no amount of predatory snakes, marabou storks, hawks, eagles, falcons, parasites and other creatures can delay their reproduction. The breeding of the dioch is a lesson in the economics of the open spaces. In space there is abundance and fruition available to those birds able to seize the opportunities.

209. *The rasping "song" of the yellow-headed blackbird* (Xanthocephalus xanthocephalus) *has been fairly described as resembling the noise made by a barn door with very rusty hinges. But the male of the species, though its voice leaves much to be desired, is a dapper bird that adds eye-catching color to the marshes of western North America. Its courtship of a potential mate is a sight worth beholding: the male chases the female about the marsh, then exhibits its finery in a contortionistic display from the top of a reed. The female always builds its nest above water two to four feet deep, presumably to protect its eggs and young from land-based predators. The bulky basket is made of water-soaked aquatic vegetation woven to reeds or cattails a foot or more above the water. The nest shrinks as it dries and thus becomes tightly anchored to its living supports. This species breeds in colonies that may number thousands of birds, and as many as thirty nests can be counted in a fifteen-foot-square area.*

210 *far left. Rollers are named for their tumbling nuptial flight displays. The lilac-breasted roller* (Coracias caudata) *of Africa, considered the loveliest of this colorful group of Old World birds, hunts lizards and large insects from any handy perch —a telephone pole, branch, tall reed or termite mound.*

210 *left. Termites are the favorite food of the red bishop* (Euplectes orix), *which slings its nest between tall reeds in African marshes. The polygamous male may have a harem of a half-dozen females, and it guards its territory by puffing up its rump feathers and clapping its wings in flight.*

210 *left below. Even at a distance it is impossible to mistake a scarlet-headed blackbird* (Amblyramphus

holosericeus) *perched atop a rush in an Argentine marsh. The local name for this handsome bird—both sexes have the flame-colored head and neck—means "oxherd," for its flute-like call suggests the whistle of a cattle drover.*

211 *above. Scarlet epaulets flash in the dusk as a vast flock of red-winged blackbirds* (Agelaius pheoniceus) *is routed from a field in Kansas, where the birds have been feasting on grain left from the harvest.*

213 *right. The familiar "wild canary" of farm country, a male American goldfinch* (Spinus tristis), *rips apart the ripe head of a bull thistle, harvesting the abundant seeds as their downy parachutes fly off in the warm August breeze. Goldfinches delay breeding until thistles bloom, for the thistledown is needed for nest-building and thistle seeds will fuel the growing nestlings. In Michigan, goldfinch nests with eggs have been found as late as September 25.*

212. *Most of the North American wood warblers are forest inhabitants, but the golden-winged warbler* (Vermivora chrysoptera) *is among the exceptions. It prefers fields, pastures or swampy openings that are overgrown with brush, briars and rank weeds. It conceals its nest on the ground amidst the stems of goldenrod. To pluck insects from the undersides of leaves, the golden-winged warbler swings upside-down like a chickadee.*
214 *overleaf. On strong legs and feet that are specially adapted to running, a kori bustard* (Ardeotis kori) *races ahead of a grass fire on the East African plains, hunting insects and small animals fleeing the flames.*

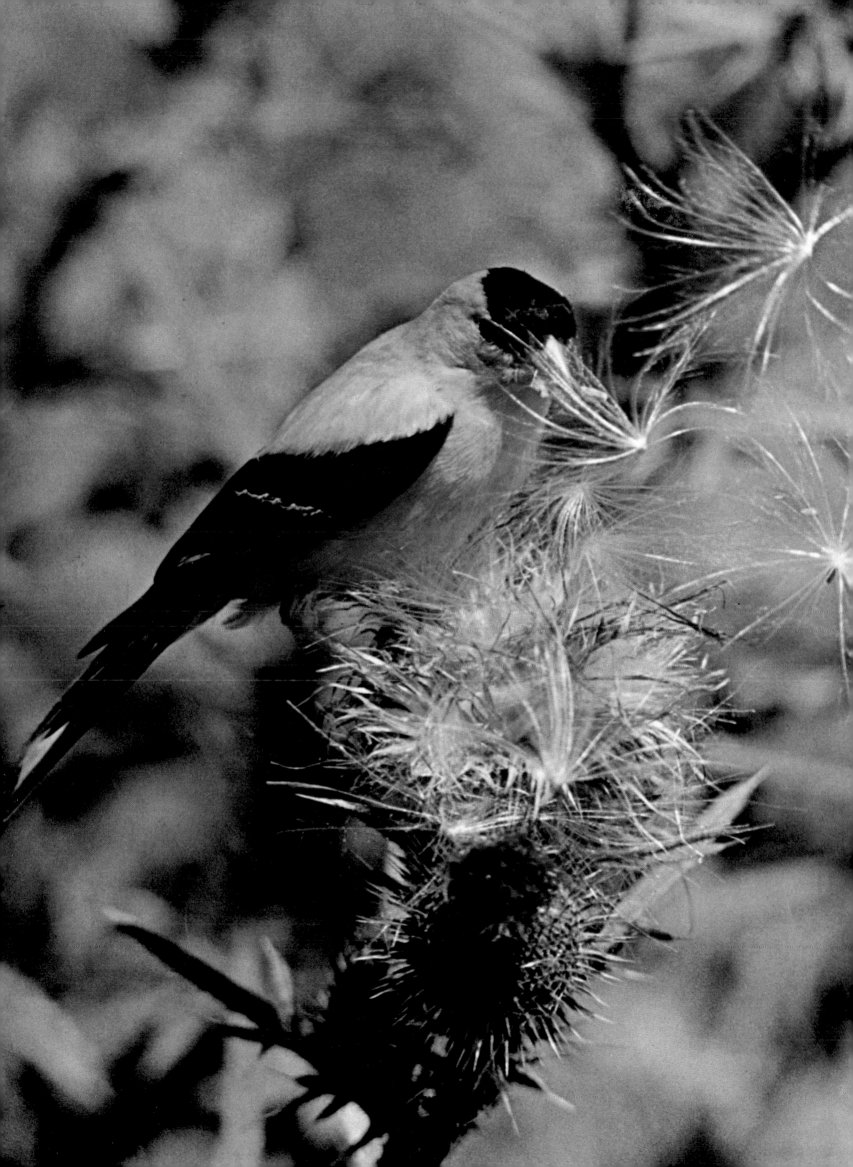

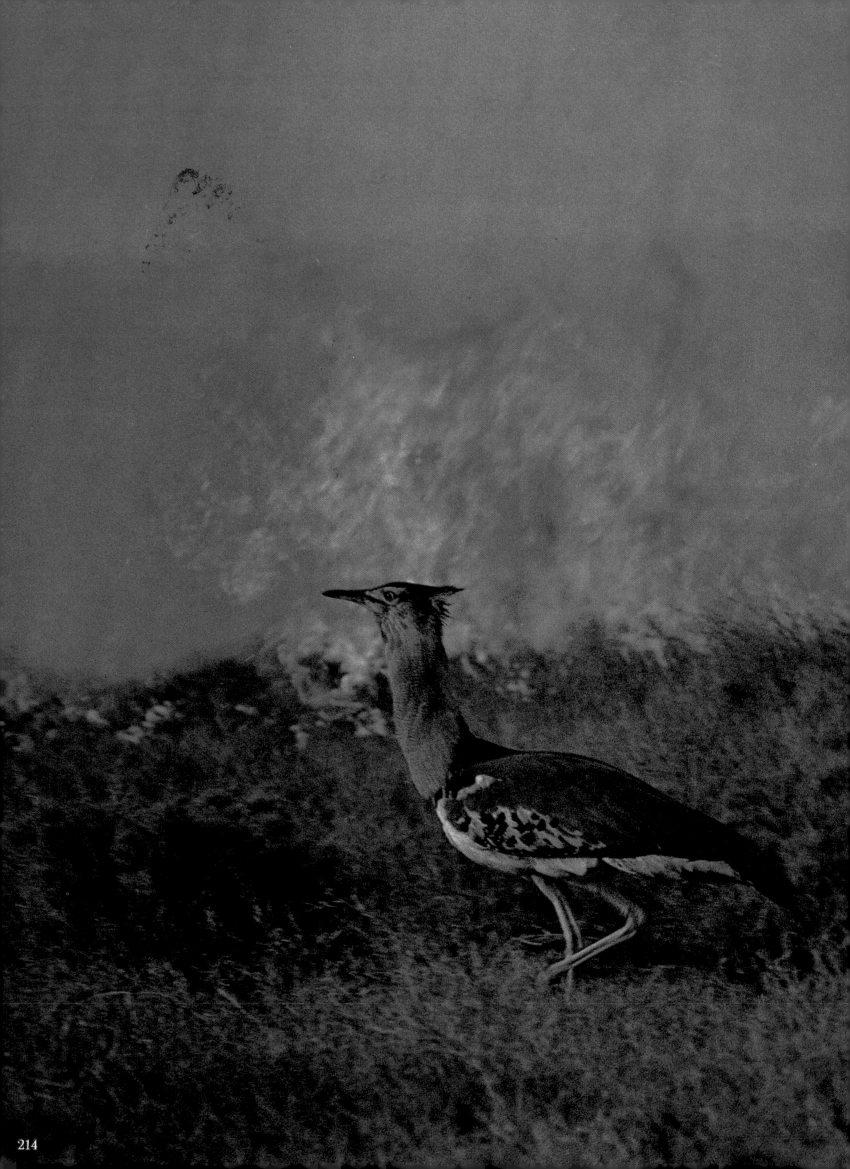

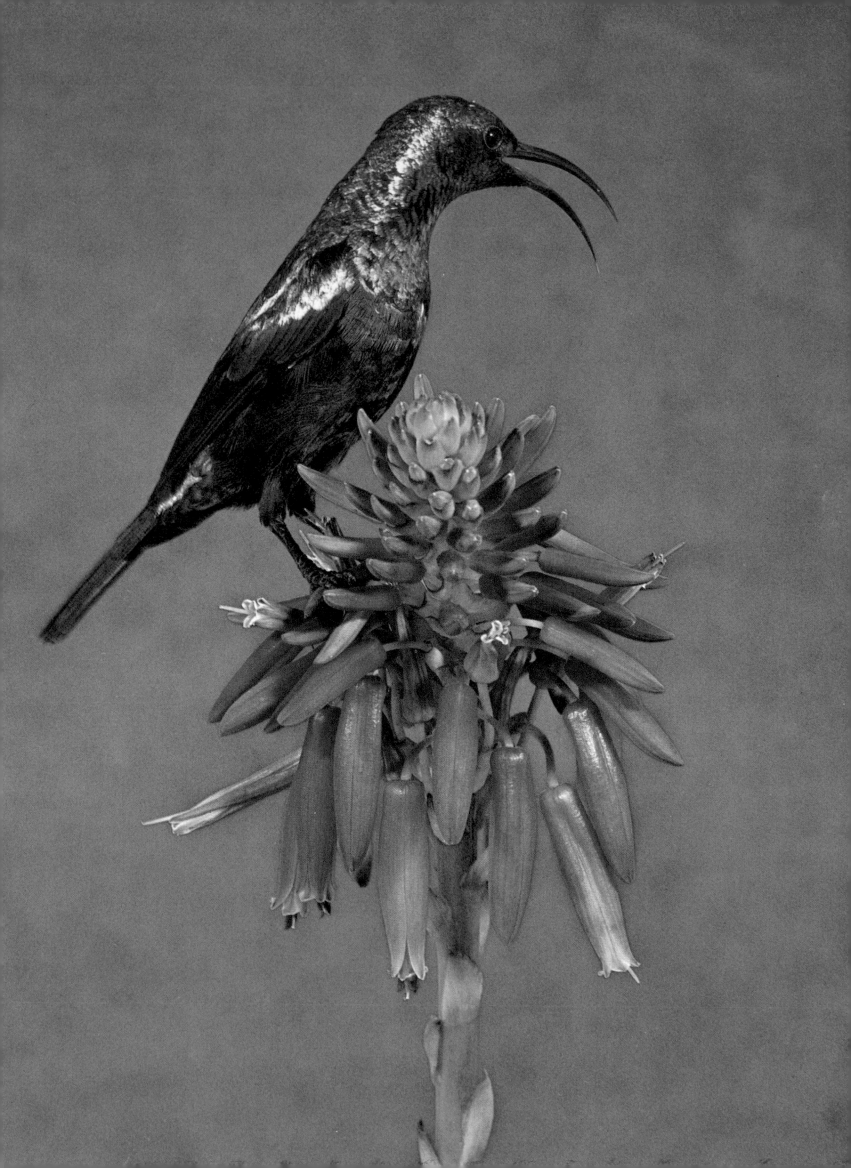

216 *left. With its long bill, a Mariqua sunbird* (Nectarinia mariquensis) *of South African savannas reaches into the corollas of flowers to sip their nectar or to collect any insects therein. If the blossom is particularly large, the sunbird will pierce its base and drink from the side.*

217. *An expert insect-catcher of arid African lands south of the Sahara Desert, the red-throated bee-eater* (Merops bulocki) *consumes vast quantities of bees and wasps nabbed in dashes from an exposed perch. One species of bee-eater uses a kori bustard's back as its hunting base, diving after insects stirred up by the huge bird's feet.*
218 *overleaf. At sundown on the arid plains of Rhodesia, ostriches* (Struthio camelus) *dust their masses of feathers to remove parasites. Squatting in hollows, they drive the dirt into their plumage, using their wings and feet, then shake the dust—and the parasites—loose. Largest surviving bird on the earth, an ostrich may weight more than 350 pounds and stand eight feet tall.*

Masters
of Nest-Building

The nest, when finished, consists of more than 300,000
pieces of fiber woven tightly together, often in
perfect knots, into a long bag-shaped tunnel that hangs
from the branches of an acacia tree. The birds,
a pair of African weaving birds, must enter the nest
vertically from the bottom, a difficult feat since
they must swing their bodies in midair, throw their
feet upward and clasp the rim of the tunnel's
entrance.
The work of the weaverbirds is one of the marvels of
bird life. They have developed ingenious con-
struction as a method of surviving the dangers of
breeding. Nesting is the most vulnerable time of any
bird's life, and the response to it gives us
insights into the scope of evolution. The hanging nest
is a common solution of birds to the problem of
breeding dangers. The Cayenne swift of South America
uses its saliva to cement together a three-foot-
long pendant tube of plant fibers, closes it at the top
end and constructs a tiny shelf about halfway up
the tube to hold the eggs in place. Some weavers,
although not related to the swifts, build an almost
identical barrier in their nests. The Cayenne swift,
though, can use its sticky saliva to fasten its
tube to the underside of a branch or ledge or to the
trunk of a tree.
Even more ingenious is the long-tailed tit of Eurasia,
which makes an ovoid nest so tightly woven that it is
smoother than a man-made blanket. The birds build the
entrance near the top and construct two flaps
that can be closed like doors to protect the nest when

it is not being used. In comparison, some spinetails
of South America build globular nests of thorny
twigs. A long, winding tunnel, also built of twigs, leads
to the heart of the nest.

Each nesting technique reveals some essential adapta-
tion to cope with an enemy, the weather or some
other danger. Swallows line up along rain puddles to
scoop up mud, mix it with their saliva, then
stick the mud against cave walls or to the rafters of
buildings, the compacted nests usually placed
beyond the reach of most enemies. As a builder, the
swallow has made an adaptation to man's works,
and so has the chimney swift. Before white men arrived
in North America, the swifts constructed their
nests in hollow trees. Now, however, they may be seen
pouring into disused industrial smokestacks to
fasten their nests inside.

The construction of the nest has deep significance for
most birds, often beyond the act of building
itself. For many weaverbirds, nest-building is an act
of courtship that later turns into an act of utility.
Hooded weavers become possessed in nest-building. They
rip old nests apart and strew the debris all
around while working frantically to
build new nests.

Often the building of the nest, usually by the male
weaver, is the enticement to breed. When the egg
chamber is completed in the complex structure,
it is an invitation for females to enter in prospect for
the best place to lay their eggs. A particularly
attractive nest may provoke two hens to fight for
possession of it, long before they have mated
with the patient builder, waiting in the background
for the hens to resolve their fight.

The beginning of a building mania among these male
weaverbirds is their sign that they are ready to
breed. Nest construction is their equivalent of the
dancing and displaying of other courting birds, but the
competition for females is not made easier by
their building ingenuity. Some birds may construct
twelve to fifteen nests before they are able to
attract a mate.

Each species of weaver builds its distinct type of nest,
expressing that diversity of response to the
environment that is exemplified, in quite a different
way, by the many different songs among other
birds. Some have entrance tunnels as long as eight

feet. Others consist of large untidy masses of material, sometimes a score of them bunched together in trees without form or apparent skill in construction. Some may be four feet wide and two feet thick. Many of the nests are communal. The largest of all the weaver nests is made by the sociable weaver of South Africa, whose nests may reach twenty-five feet in length and up to ten feet in height. Up to eighty pairs of birds work on these enormous nests and breed in them together.

The weavers are not alone in the variety and complexity of their nest construction. The South American oropendolas build beautifully-woven hanging nests that are extremely difficult for any predator to enter. But the competition for nesting material is hectic. The oropendolas' nests, built in small colonies, are placed close together, and the birds spend much of their time fighting each other. They raid their neighbors' nests, rip apart the nests of others, only to have the pirated material stolen from them by still other birds.

Nests abound in contrasts. The delicacy of the hummingbird's nest, which may be only an inch in diameter and usually contains two tiny eggs, is the smallest expression of the nest; the nests of some eagles may weigh a couple of tons and be twenty feet in depth. The crested treeswift lays a single egg in a down-filled saucer of bark glued in place. The largest nests of all are constructed by the mallee fowl of Australia, ground birds that use the heat of rotting vegetation to incubate their eggs. They work hard throughout the incubation period rebuilding their mounds of material so that the eggs will always be exactly the correct temperature. The largest of these nests weighs many thousands of pounds and shows the great industry that nest-building can demand.

Each bird has a different technique for constructing a safe nest. Cobwebs are a favorite binding material among many finches. But perhaps, after woven grasses, mud is the favorite building material of birds. The rufous ovenbird of South America binds together a mixture of sand and cow dung to make a mortar that dries iron-hard. Its ball-shaped nest, often placed on top of a fence post, is complete with a side entrance and a partitioned interior leading to the nesting chamber. Some swallows and martins

are skilled in sticking their mud nests against the sides of buildings or the walls of chimneys. Flamingos laboriously build up their nests, some of them nearly two feet high, by placing pellet after pellet of mud together, like small circular bricks, meticulously constructing nests designed to be above flood waters when rain comes.

Birds can choose almost any place to construct their nests, from the ground level, and below it, to the tops of the tallest trees. The tailorbird stitches leaves together to form a pendulous nest, which it lines with nesting material. The palm swift glues its two eggs on a pad stuck to a palm leaf. The leaf can turn upside down in a storm, but neither the swift nor the eggs are dislodged. Most of the seventy-odd species of swifts in the world make nests by using their own saliva, which hardens like cement when it dries. The edible-nest swiftlets of southeast Asia have extremely palatable saliva that gives man that so-called Chinese delicacy—bird's-nest soup.

There are many variations to this theme of master-building birds. One of the most fascinating is provided by the group of birds that use the constructions of others in which to breed. Yet they are not parasitic. The ruddy kingfisher of Borneo teams up with a deadly stinging bee to breed, laying its eggs inside the pendulous nests of the swarming insects and suffering no harm from them. But the kingfisher must surely be protected against its other enemies by the association. Many other species of birds, such as several species of Papuan, Brazilian and Australian parrots, along with five species of Australian kingfishers, lay their eggs inside termites' nests. It is doubtful whether the birds get any kind of protection from the termites, but the association suggests how highly competitive and specific is the drive for a nesting place.

The nest remains a part of the wonder of the bird, often a baffling manifestation of the long work of evolution. Birds do not seem intelligent, when measured against the mammals. But no mammal can come close to the artistry of their nest-building, or, for that matter, the scope of their singing, the range of their colors. In the nest, the bird shows itself to man as a miracle-maker almost, and a constant stimulus to wonder.

225. *Stop on a spring day by a farm pond where the margin has been trampled into mud under the hooves of thirsty cows. If there is an old-fashioned barn nearby, with a tall haymow and open doors, the pond will be a hive of activity. Darting about will be barn swallows* (Hirundo rustica) *gathering pellets of mud for the nests they are plastering to ancient timbers. At least a half-dozen nests will be in progress—as many as fifty-five nests have been found in a single barn—and both male and female swallows will be bringing bill-loads of mud every two or three minutes. Even so, it may take them eight days, working from dawn to dusk, to finish the masonry, which is laid down layer by layer, the tiny "bricks" of mud mixed with grass and straw, the cone topped with white poultry feathers. One nest, dissected by an ornithologist, contained seven and one-half ounces of dried earth, 1635 rootlets, 139 pine needles, 450 pieces of grass and 10 feathers. Not all barn swallow nests are built in farm outbuildings; bridges, culverts, wharves and vacant houses are often used, and barn swallow families have even been successfully raised on moving ferryboats or railroad trains.*

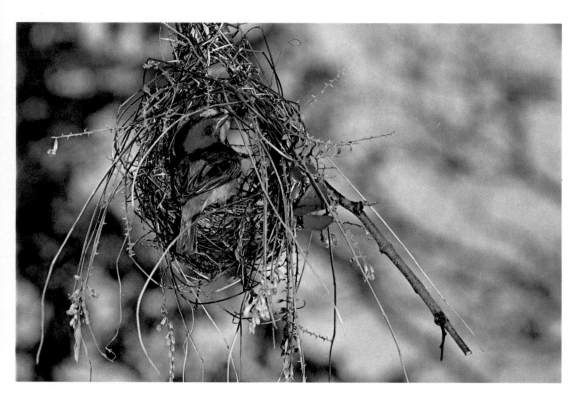

226. *Unlike many weaver nests that are made of grass, that of the red-headed weaver* (Malimbus rubriceps) *is virtually indestructible. The male plucks supple new shoots from a marula plum tree in a South African woodland and plaits them into a basket; when the twigs dry, the basket becomes so rigid that it is invulnerable to predators and can be used by other birds when the red-headed weavers abandon it.*

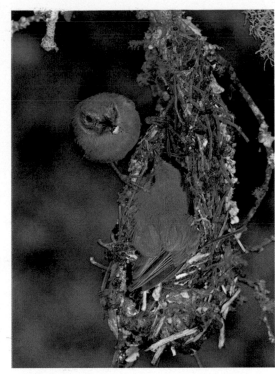
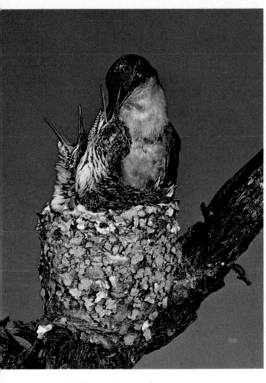
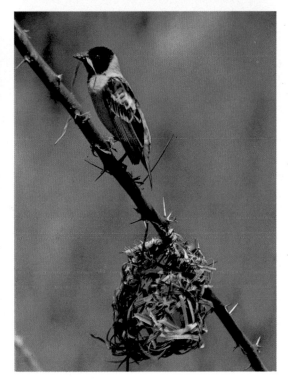
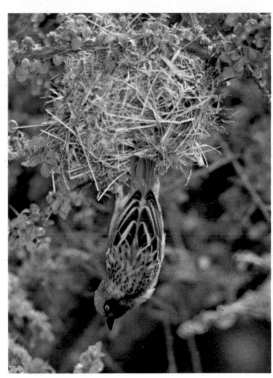

227 *above left. The orange-breasted waxbill (*Amandava subflava*), found in grasslands and cultivated areas throughout Africa below the Sahara, builds a barrel-shaped nest of grass with a side entrance and an overhead roof for roosting.*

227 *above center. The pouch nest of the variable sunbird (*Cinnyris venustus*), a familiar bird of East African gardens, is woven of grass and fibers, lined with feathers and plant down, and finished on the exterior with cobwebs and lichens. Though it drinks nectar, this sunbird also feeds on insects that it hawks in flight.*

227 *above right. A red-faced crombec (*Sylvietta whytii*) brings a spider to its nestling—nearly full-grown and crowding the purse-shaped nest,*

built of rootlets and grass and hung from a twig. One of the more than 300 species of Old World warblers— small, inconspicuous birds that are best identified by song and behavior —the red-faced crombec hunts insects in the East African bush in a restless manner like that of a nuthatch.

227 *below left. From twenty feet below, the lichen-camouflaged nest of a ruby-throated hummingbird (*Archilochus colubris*) in a New York woodland looks like a natural bump on a limb. It is only an inch and a half wide, but it took the female five days to construct out of bud scales, fibers, plant down and spider webs. She will continue to work on the nest until her two young leave their crowded little home.*

227 *below center. A male black-headed weaver (*Ploceus cucullatus*) has begun construction of a nest on a stripped thornbush twig over a Kenyan watercourse. Once he has finished, the female will line the interior with soft material and her polygamous mate will depart to start another nest.*

227 *below right. A commonly seen weaver in arid parts of Africa, the masked weaver (*Ploceus velatus*) enters its onion-shaped nest, built of blades of grass, through a large hole in the bottom.*

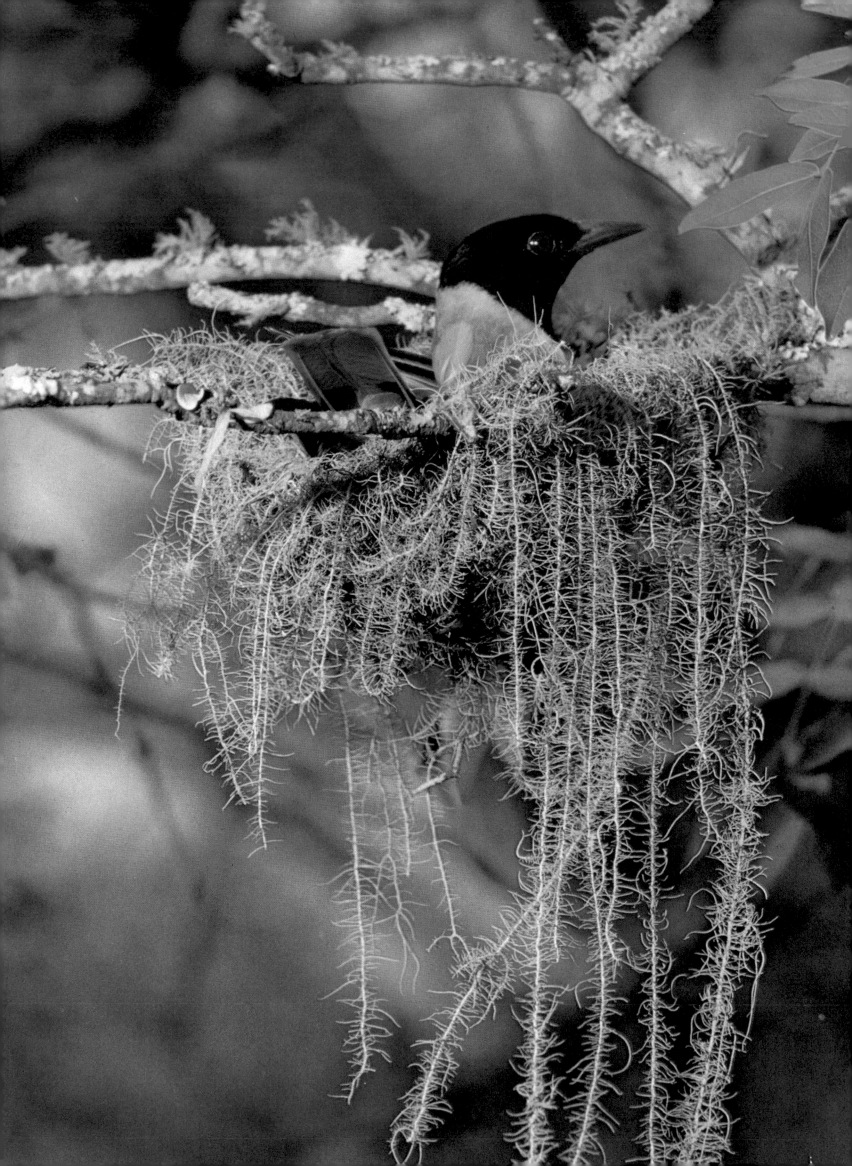

228 *left. Suspended from a forked branch high in a tree, hung with strands of usnea lichen, the basket nest of the African black-headed oriole* (Oriolus larvatus) *disappears into its surroundings.*

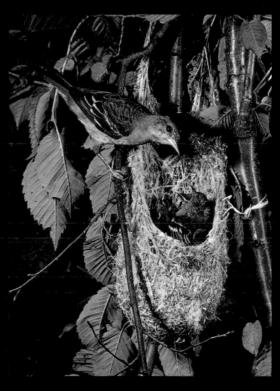

230 *overleaf. This is the underside of the largest bird nest in the world, built by a community of South African social weavers* (Philetairus socius). *As many as three hundred pairs will join efforts to construct a "hut" in an acacia tree, and their finished structure may be twenty feet wide and ten feet high. Once a waterproof thatched roof is completed, individual pairs weave nest chambers that are entered from the bottom through long tubes.*

229. *A female northern oriole* (Icterus galbula) *feeds her nearly fledged young, whose weight stretches their pouch nest high in an American elm. It takes the female five to eight days to construct the five-inch-deep pocket out of plant fibers, grapevine bark, bits of string or cloth or—in southern states—Spanish moss. Once, before horses were made obsolete by automobiles and tractors, oriole nests contained a large percentage of long hairs from horses' tails and manes. The fibers are brought one at a time, and the oriole, using her bill like the shuttle of a sewing machine, makes as many as one hundred thrust-and-draw movements to weave each item into the nest, which is replaced each spring.*

Nesters in Cavities

When the wood ducklings of North America are ready
to leave their tree trunk nest in late June or
July, they look down to the ground perhaps twenty to
thirty feet away. Not hesitating, they come out
of the hole in a rush and fling their tiny bodies outward
as though they already know how to fly. But they
fall, bounce and in a moment are ready to follow their
mother, voicing her concern from a nearby thicket.
The wood duck is one of a number of waterfowl to use
a cavity to build its nest. Cavity-seekers are
spread through almost every other family of birds:
flycatchers, owls, penguins, auks, hawks,
sparrows, starlings, jackdaws, swallows, woodpeckers
and many others. The search for the right cavity
becomes a study in the art of survival. There are rarely
enough cavities. Those birds that do not find
suitable cavities do not raise families.
The bluebird of North America, which has long
accustomed itself to seeking low cavities in hollow trees
so that it would not be in such fierce competition
with all the woodpeckers, now must contest the
ubiquitous starling. The cactus wren waits until a
gila woodpecker has drilled a hole in a large
organ-pipe cactus, then seeks to take over the cavity.
Owls vie with day birds for a chance at the hollow
tree cavities.
Birds so well occupy every level of the environments
of earth from the darkest caves to the highest
mountains that it was inevitable that they would make
such good use of holes in trees, or in caves, or in
sandy and clay banks. They have extended the

possibility of their survival, not merely by accommo-
dating themselves to natural holes but also by building
their own, as do the many woodboring woodpeckers,
the burrowing owls of the American prairies,
the bank-digging bee-eaters of Africa and Australia.
The bank swallows of North America dig long
tunnels in soft banks, despite their relatively weak
beaks and feeble feet.
The puffins of the North Atlantic, members of the auk
family, dig deep burrows in offshore islands
and so find sanctuary from prowling peregrine falcons,
from jaegers and foxes. The urge to dig, to
burrow, to drill wood, to seek complete concealment
is an innate force of evolution as each species
seeks the same result with different means.
The cavity-seekers are not united by species or in
physical form or geography. They include many
seabirds as well as owls, wrens as well as parrots,
hoopoes as well as flycatchers, warblers as well
as kingfishers. And there is no conformity to the types
of cavities sought, or the methods used to nest
in them, to build them, to acquire them or to commandeer
them. Each species has conformed to the availability
of cavities and has evolved accordingly.
Puffins dig underground tunnels close together to create
widespread underground refuges of nesting birds.
The rhinoceros auklet of British Columbia digs out
individual tunnels, which may be as long as thirty feet,
making it virtually impossible for any predator to reach
the eggs buried so deeply in the ground.
The burrowers, it would seem, should be physically
powerful, but this is not always true. The bee-eaters
are quite slight physically, and so are all of the
smaller kingfishers. But this does not prevent them
from digging with their beaks and kicking out
the loose earth with their feet like digging mammals.
Even the smallest of the kingfishers, which
includes the Asiatic kingfisher, can dig nearly two
feet in an hour of working jointly in pairs.
The woodpeckers are the master builders of the cavity-
makers, as opposed to the cavity-seekers, and
they are specially adapted to the work. They have
heavy skulls, strong gripping feet and stiff tails
to support them while clinging to the tree, powerful
beaks with capability of making staccato blows—
all of which enable them to dig into solid wood.
But not even physical adaptation is necessary to make

a cavity-digger. Some of the titmice dig holes in trees but, unequipped with either heavy heads or strong bills, they search for trees already rotted and so are able to excavate as effectively as the woodpeckers can chisel. After the titmice come an array of birds that search for existing cavities, either naturally formed or made by others. The nuthatches look for chinks in trees, formed by branches partially broken from the trunk and then healed into place. If the entrance is too big, they will partially seal it with clay, allowing just enough room for their slight bodies to slip to safety.

The tree creepers are adept at plastering the openings to their nests with mud to restrict the entranceway. The hornbills have carried this technique a step forward. Both male and female work together to build a mud wall, with the female sealed inside the cavity. A narrow slit, presumably small enough to prevent the entry of an egg-eating snake, is left for the passage of food from the male's long, narrow beak to the female inside. Throughout the incubation period of twenty-eight days, and through the feeding of both the female and the young after hatching, he feeds her through the slit. At the same time, she molts. When she does break free, with the nesting cavity then filled to capacity with the burgeoning nestlings, the youngsters attempt to rebuild the wall with excrement from the nest.

The cavity-seekers and cavity-builders are studies in the force of evolution. They have grouped themselves according to the sophistication of their evolution. Those that nest in natural holes—fissures in soil or rock, apertures between boulders along the seashore, such as razorbills and guillemots, or in caves along the seashore, such as Humboldt penguins—have not found it necessary to devise more complex shelters.

The next step in the evolution of the cavity nest is taken by those birds that use the burrow nest, although some are not much more highly evolved than the preceding group. The New Zealand kiwi, a flightless groundhunter, searches for cavities in the ground, between roots, then kicks away more earth to make a shallow burrow. The kiwi has powerful legs so this is sensible enough, but environmental conditions have forced some birds to go underground even though they are physically unsuitable for burrowing. The small petrels, for instance,

have weak, webbed feet and even smaller, weaker bills, but they somehow manage to dig deep burrows on the islands where they nest in offshore waters. Such burrowing is made even more extraordinary by the fact that it is done at night—the petrels are totally day birds during all the rest of their nonbreeding lives.

By digging a burrow the bird can greatly extend its range of breeding possibilities. Puffins are safe from gyrfalcons and peregrine falcons and eagles, which once constantly prowled their northern breeding islands. The petrels are safe from their great enemies, the gulls. Many birds of the Andes have been able to colonize the high mountains because of their capacity to dig in loose soil or under rocks, thus achieving not only safety from enemies but also more or less constant temperatures. There the technique is modified yet further by the Andean flicker which, lacking trees for its nesting place, has taken to burrowing into the ground.

The tree-cavity nesters include a more widely diffused group of birds. The woodlands and the forest edges give more opportunities for breeding and feeding than do less diverse environments, such as open grasslands. Thus many species have had the chance to exploit the opportunities of cavity-nesting. Here both owls and parrots find similar refuges, as do the hoopoes and the rollers, the pigeons and the toucans, the trogons and some of the ducks, the flycatchers and the starlings, the tits and the barbets.

In one sense, at least, the cavity-seekers are all more successful forms of evolution than the nest-builders, despite the great skill of the weavers and the others that make complicated master constructions. Only about half of the eggs laid in open nests in North America hatch into nestlings, but two-thirds of those eggs laid in cavities are hatched out. It does not matter whether the pied flycatcher must fight off so many of its own species, including tits, to make its cavity nesting successful. It does not matter that the wryneck invades the cavity and throws out all the nesting material of the flycatchers, and the eggs and chicks as well, if necessary. Cavity nesting is a fine point of evolution, and the cavity-seekers exemplify the ingenuity of the bird to use every part of its environment to survive in a world of enemies.

237. *A glowing spark of color in the dark depths of swamp forests and cypress lagoons, the prothonotary warbler* (Protonotaria citrea) *is one of only two North American wood warblers that build their nests in tree cavities. It prefers a site alongside or directly above water, often appropriating old woodpecker holes, occasionally tucking its cup of mosses, bark and rootlets into a niche under a bridge—or even into a mailbox or discarded glass jar. The song of this warbler is a ringing, whistled cadence that fills gloomy river bottoms and flooded woodland with melody, for where the habitat is ideal there will be a nesting pair for every two or three acres.*

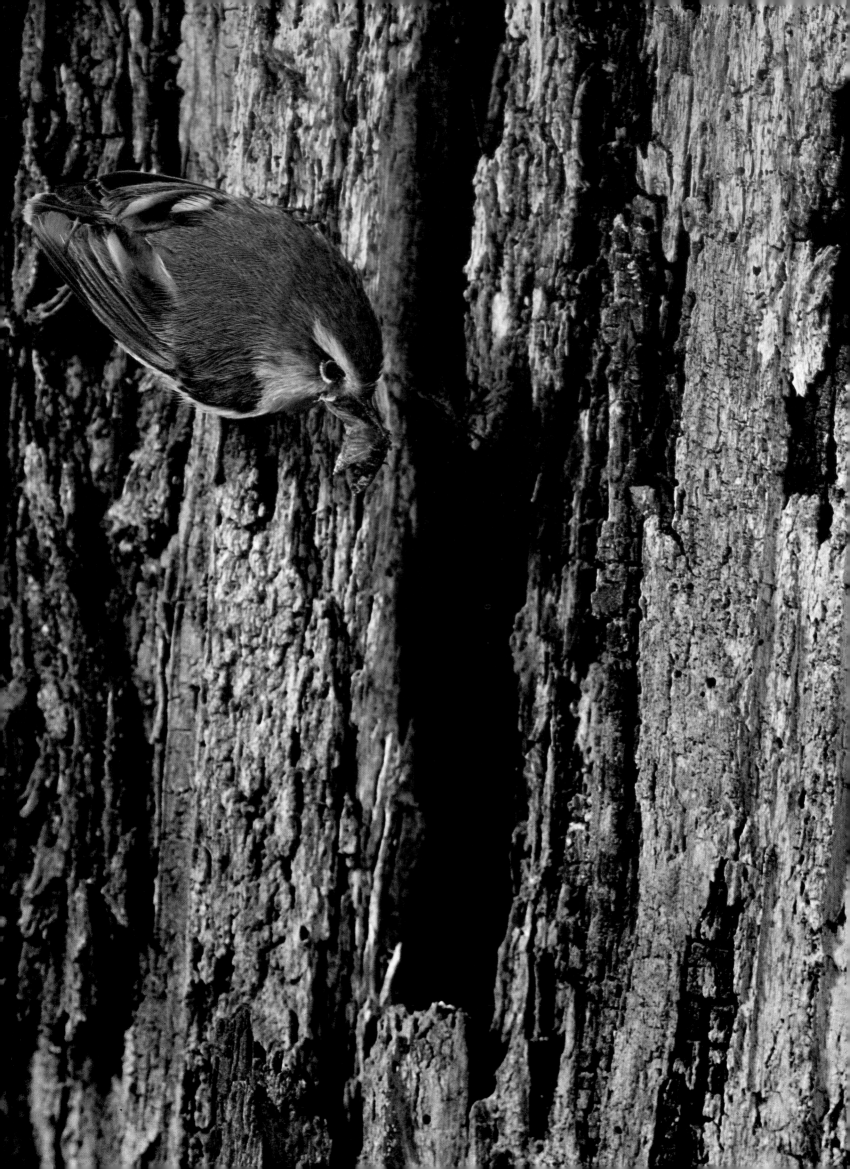

238 *left. Once there were four species of New Zealand wrens—tiny, plump birds with only remnant tails. One species was seen alive only by a lighthouse keeper on an offshore islet; his pet cat promptly exterminated it. Two others, the bush wren and the rock wren, are rare and seldom observed. But the rifleman* (Acanthisitta chloris), *whose call suggests a gunshot, is fairly common. Three inches long, it scurries about tree trunks and branches, probing the bark for insects and spiders. The rifleman raises two broods a year in a cavity or crevice, the first chicks helping their parents feed the second brood.*

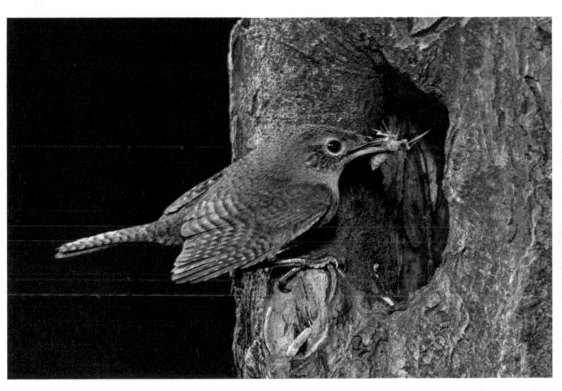

239. *Although they loudly and fiercely defend their nesting territory against any intruders of their own species, most songbirds tolerate the presence of other birds. That is not always so with the house wren* (Troglodytes aedon), *which is known to puncture the eggs or kill the nestlings of other songbirds that choose to nest within its declared domain. With the exception of the winter wren, which reached Eurasia from Alaska, all sixty-three members of the wren family belong to the New World. The house wren is the most widespread, nesting from Canada to Cape Horn.*

240 *overleaf. Nearly full grown and crowding the cavity of an old apple tree, a nestling eastern bluebird* (Sialia sialis) *begs for food from the male parent. Its natural nesting sites usurped by alien starlings, its numbers decimated by agricultural poisons such as DDT, this lovely thrush has become an uncommon sight in rural North America. But conservationists have lent the bluebird a helping hand, erecting thousands of nesting boxes that also benefit other native birds.*

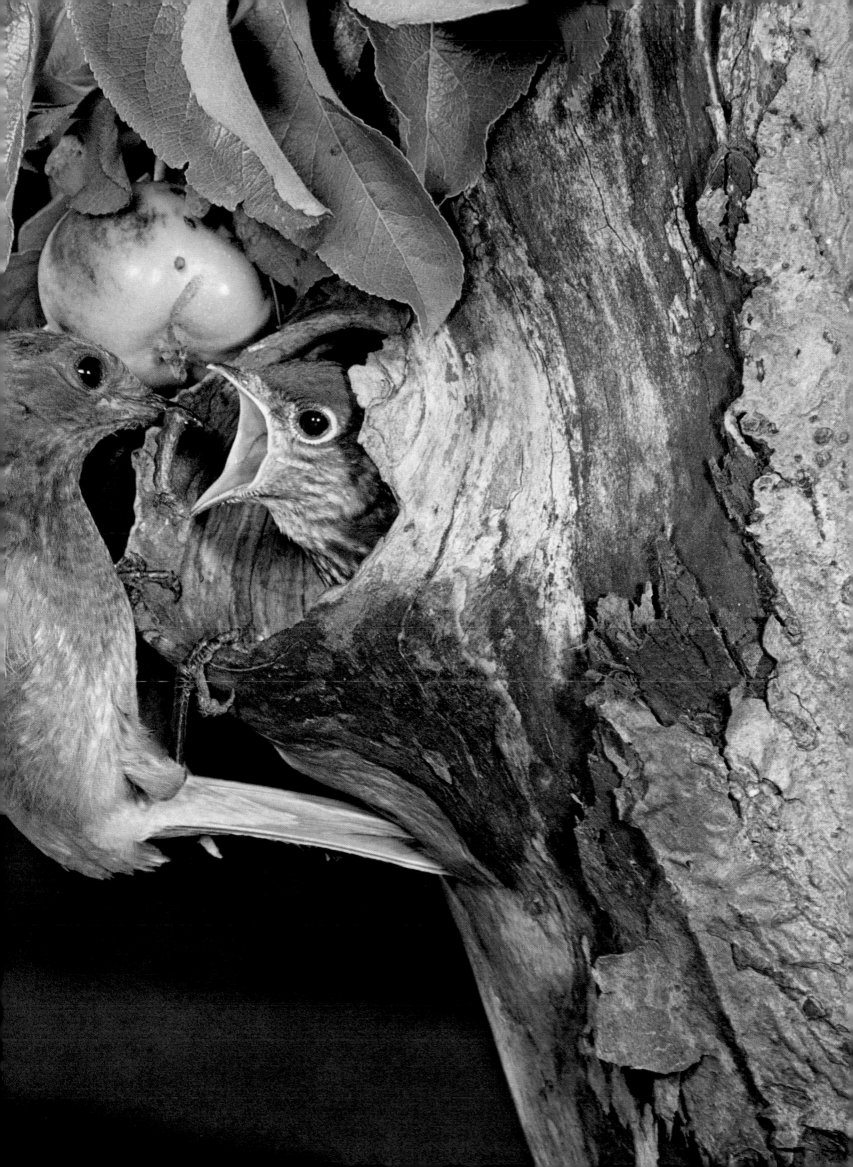

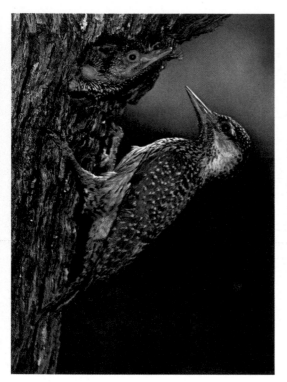

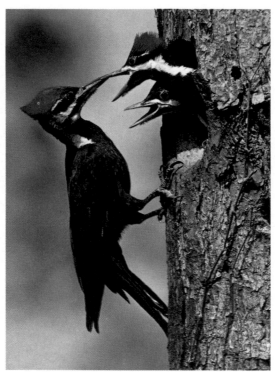

242 *left. The woodpecker family, with 210 species, has managed to occupy nearly every forest in the world except on Madagascar, New Guinea, Australia, New Zealand and smaller oceanic islands. An uncommon African species, the golden-tailed woodpecker* (Campethera abingoni), *ranges from Senegal and Somaliland to South Africa, feeding on ants and grubs.*

242 *center. Trying to avoid their anxious jabs, a female pileated woodpecker* (Dryocopus pileatus) *feeds her nearly fledged young. Their home was carved out of the stub of a dead pine in a Florida forest. The woodpecker's stiff tail is used as a support when the bird is climbing, and bristle-like feathers cover the nostrils to keep out wood dust as the bird chisels with its hard bill in search of tree-boring insects.*
242 *right. Like other wood hoopoes of the African forests, the green wood hoopoe* (Phoeniculus purpureus) *is a noisy, gregarious bird with distinctly unsavory nesting habits. It allows droppings and food debris to accumulate in its nest. The preen gland of brooding females emits a skunk-like odor.*

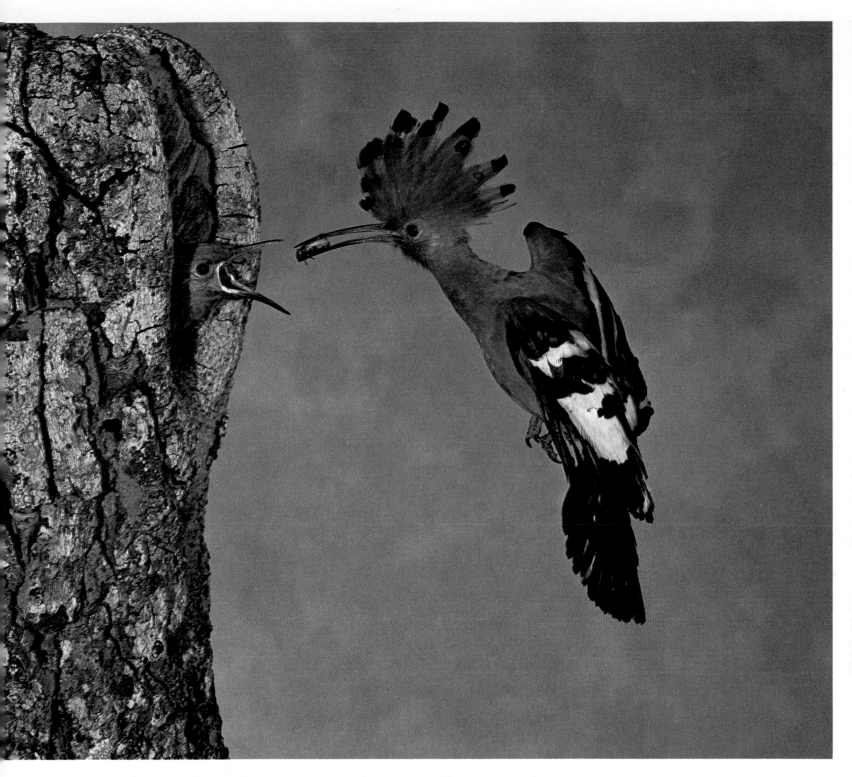

243. *Crest erect, hovering like a butterfly, a male hoopoe* (Upupa epops) *brings food to a nestling. This eye-catching Old World species, named for its call, feeds on the ground, running about on well-developed feet as it probes for insects and larvae. The female hoopoe remains on the nest during the eighteen-day incubation period and until her young are feathered.*

244 *overleaf. The feeding habits of the great spotted woodpecker* (Dendrocopus major), *the most widespread woodpecker in Europe, are exceptional. In addition to drilling holes in search of insects and larvae, it also jams pine cones into a slit in a tree, then hacks them apart and eats the pine seeds.*

246 *second overleaf. When seasonal rains begin in the Australian drylands, nesting budgerigars* (Melopsittacus undulatus) *seem to occupy every available cavity. A dozen pairs may breed in the same tree, and they will raise two or three broods in succession. Fledglings are tended by their parents for only a few days, and are themselves ready to breed in three months. Flocks of thousands of these parakeets will descend on a watering place, drinking by floating on the surface with wings held above their backs.*

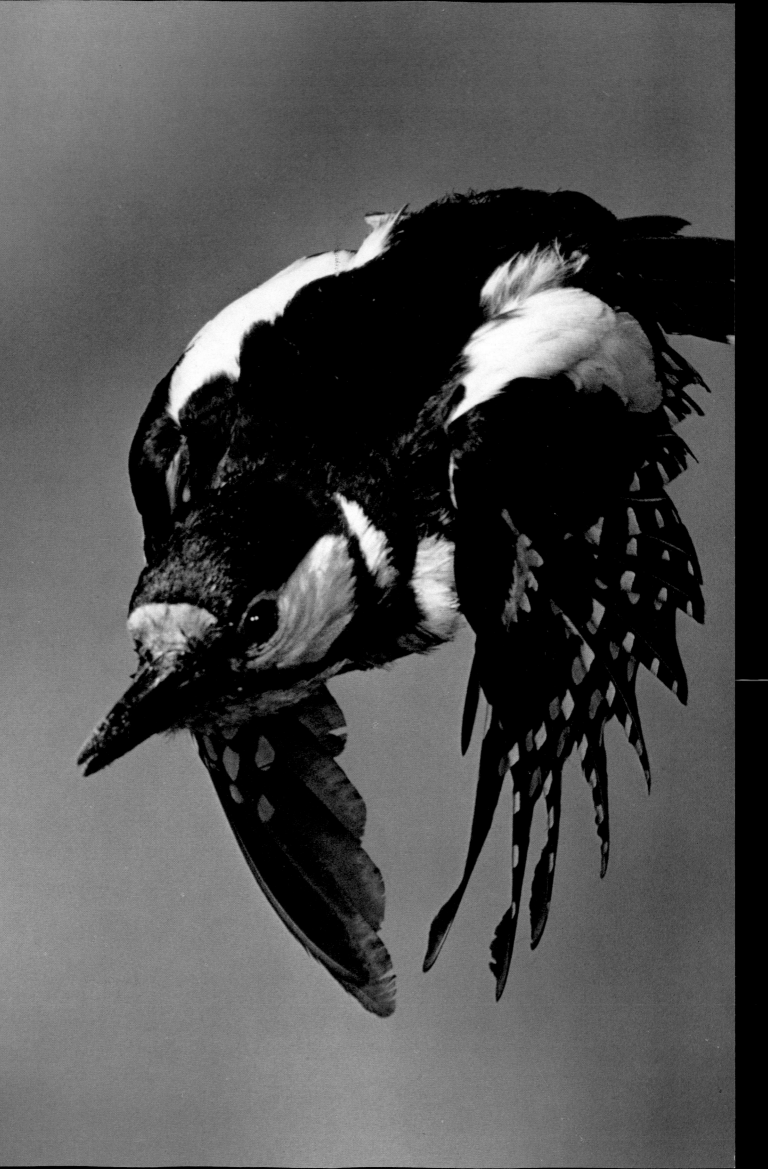

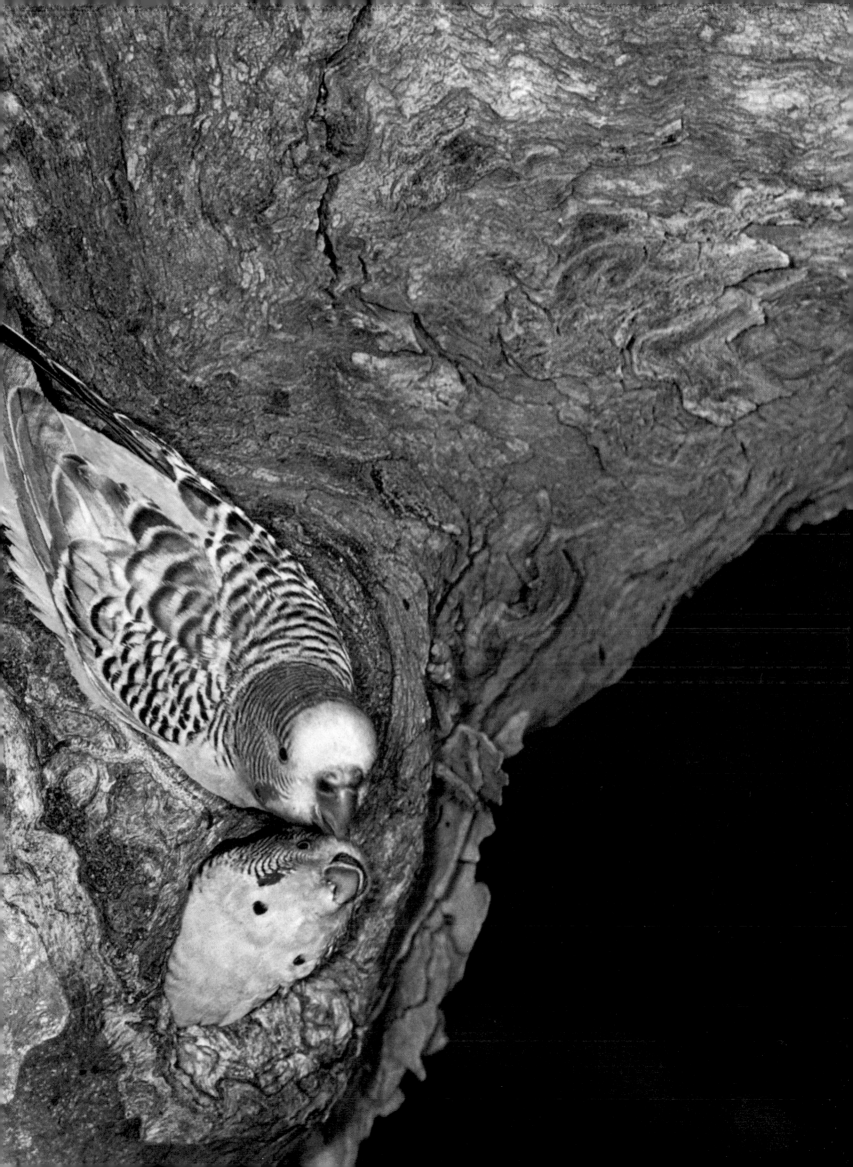

Photographic credits for the preceding illustrations:

Wings in the Jungles

Shrieking, a flock of parrots pours through a narrow
opening in the dense canopy of the Amazonian
jungle and emerges into the hot moist air. The sun
catches on the rich mixture of their plumage
colors—greens, yellows, reds. Half hidden in the foliage,
two macaws, the largest of the parrots, bow to
each other in solemn courtship dancing. The yellows,
reds and oranges of their plumage appear to be a part
of the same scheme of color that makes the flock
above them so spectacular.
Bird color is spread so generously through the world's
tropical rain forests that it appears to be an
expression of sheer quantity rather than of some quality
useful for survival. But there is nothing useless in
bird life. Everything has its reason. Some of the reasons
are known, or suspected, in this great color parade.
The tropical jungles, which stretch clear around the
world, encompass the larger part of South
America, the western coast of Africa and some of that
continent's central regions, large areas of India,
southeast Asia, Indonesia and northern Australia.
There color may serve a function similar to that
of song for the birds of the temperate northern wood-
lands. It identifies individual species. It is a marker
for the birds to find each other when the light
is dim, or when they are far apart. Above all, perhaps,
it matches the almost equal brilliance of the
countless flowers studding the branches, vines, shrubs
and treetops throughout this great humid region.
Bird and plant are caught in an endless display of
color. Perhaps each speaks to the world with the same

voice: the flowers must attract insects and honey-
sucking birds to ensure survival for themselves.
The colors may be breathtaking, but they are not always
readily visible to the wandering observer. The
birds keep to the privacy of the canopy, which may be
a few hundred feet overhead. They may be traced
only by their other great identifier: the shriek, scream,
hoot and whistle of their uncommonly loud voices.
The cries combine to give the birds sure
placement of their kind. At the same time, the cries
mark out territories.
How are the colors chosen, and why? The predominance
of bright, almost garish greens is understandable
enough since it helps birds blend into the foliage. But
the stunning colors of macaws are too gaudy, surely,
to be merely markers for the species. And the
colors within the species of macaws are vastly
different, ranging from basic crimson marked with
green and yellow in the red macaw, to the
fundamental blue and yellow and orange of the blue
macaw, to the equally startling purples and
pinks of the hyacinth macaw. The human watcher might
begin to perceive, a bit dimly, that some of this
color is there for its own sake. And why not?
It has been argued that the easier living living conditions
in the tropical jungles have given the birds
there more "leisure," since they can get their living
with but a fraction of the energy cost of birds
struggling to survive in the temperate or northern
forests. With their "leisure," or whatever it
should be called, they have been freer to metabolize
the pigments and colors that make up their present
diversity. But such a theory is not consistent with
fundamental laws of natural selection. Color is
evolved for a purpose or else it would be selected against
and eventually disappear.
The reasons for bright colors or, for that matter, any
color at all, must be multitudinous. Certainly some
of the purposes of colors in birds are to be seen, to be
displayed and even to be used as threats. The
blue-fronted Amazon parrot tries to defend itself, or
to intimidate enemies, by the use of color. If it
is frightened, this brightly colored bird throws its body
forward so that it is almost horizontal on its
perch. It spreads it wings, fans its tail and raises blue-
and-green throat feathers into a large ruffle. This
peculiar attitude exposes red feathers in the parrot's

wings and tail, feathers that are normally covered with green. The danger signal seems unmistakable.

The vital function of color is suggested by the fact that most of the brilliant jungle birds live in and above the canopy. There metallic glosses, brilliant hues and bold movements are all caught and dramatized by the bright sun. Beneath the canopy, where the light is made dimmer by the thick foliage, the birds are much less brightly colored, even though they may belong to the same families as those displaying themselves above the canopy. Most of the South American hummingbirds are brightly colored as they flash from flower to flower among the treetops. But the plumage of one species, which lives in the undergrowth of the forest, is mostly brownish. Nearly all the African sunbirds are brilliantly colored and live in the sun-struck treetops except for one species, which lives at the lower levels and is a dull olive-gray. Contradictorily, some dull-colored species live in completely different habitats where they mingle with brightly colored birds.

Color, therefore, exemplifies the mystery of all life. Because the duller-colored birds of the lower levels blend better with their backgrounds, it may also be true that the brightly colored birds of the sunlight are successfully matching the backgrounds of flower and foliage behind them. Color, in that sense, may make them less conspicuous.

However, the tropical rain forest contains the most complex system of animals and plants on earth. While the number of birds is not high, the variety of their species is large. No other environment has produced such specialized birds in so many species. There must be competition, or at least competitive advantage, for various species of birds to quickly identify birds of the opposite sex. With the colors of the jungle behind them, and with the bright sun above them, the colors pour forth.

Color apparently has many other meanings, many other functions. It is known that really bright plumage in some birds indicates unpalatable flesh, at least when measured by the tastes of such common hunters as members of the cat family. This has led to the belief that it is actually hunting pressure that has forced the duller-colored birds into concealment— because they taste better—and has allowed the more brightly colored birds to range conspicuously.

The hummingbirds combine most of the spectacular colors and seem to suggest that evolution's point is to use color for its own sake. To color they add iridescence, that fascinating enhancer. Iridescence, colors that appear to change constantly as the bird moves, is common among the tropical forest birds. But it is only comparatively recently that an exact description of it has been possible. A film of tiny platelets covers the iridescent feathers. This film reflects light to produce a changing succession of spectral colors of extraordinary purity.

Birds display all the colors of the spectrum. The tanagers show such pure colors they seem to prove that color is a method of species identification. Some of them dart through the trees like lines of flame drawn through the air. Others are pure blue. Others have startling combinations of colors.

Trogons, which are commonest in South America but also range through Africa and Asia, are among the most gaudy of all tropical birds. Their brilliant reds, oranges and yellows are set against violets, goldish greens and many subtler-hued touches of color. The crimson cock-of-the-rock, with its great fan-shaped comb on top of its head, lives in high cloud forests in northern South America, where it decorates dense greenery with what one naturalist has called "a ball of flame."

Perhaps the most spectacular of all the tropical jungle birds is one of the trogons, the legendary quetzal, the sacred bird of the Aztecs. It lives in the cloud forests from Mexico to Panama. Here, color is shown with an abandon that is pure art in human terms. Its head and neck, back and wings are a gorgeous golden-green that shimmers in the tropical sun. Its belly is red and its tail feathers are white. But in enhancement of an already richly caparisoned bird is the long green train of curved feathers that stream decoratively away from its body.

Colors among these birds may indeed have only a utilitarian use. But to the human eye, at least, they are yet another aspect to the wonder of all birds. Colors are used with such a perfect balancing of shades and purities that they appear prepared for the delectation of our eyes. That is the reality and the wonder of the bird in the tropical rain forests of the world.

253. *That many of the most beautiful birds are also the most difficult to see is always a challenge and often a frustration to birdwatchers. This is particularly true of the pittas—extraordinarily colorful but exceedingly secretive inhabitants of tropical forests from Africa to the Solomon Islands. Short-tailed ground-dwellers that live on the insect life of the forest floor, pittas seldom emerge from the dense undergrowth, and their loud ventriloquial whistles are impossible to trace. If disturbed they hop quickly away on long legs, although they are strong fliers and many species are long-distance migrants. Like others of its kind, the banded pitta (Pitta guajana) of Southeast Asia builds a huge domed nest on or near the ground, and the male shares incubation and feeding duties with his white-throated and slightly less colorful mate.*

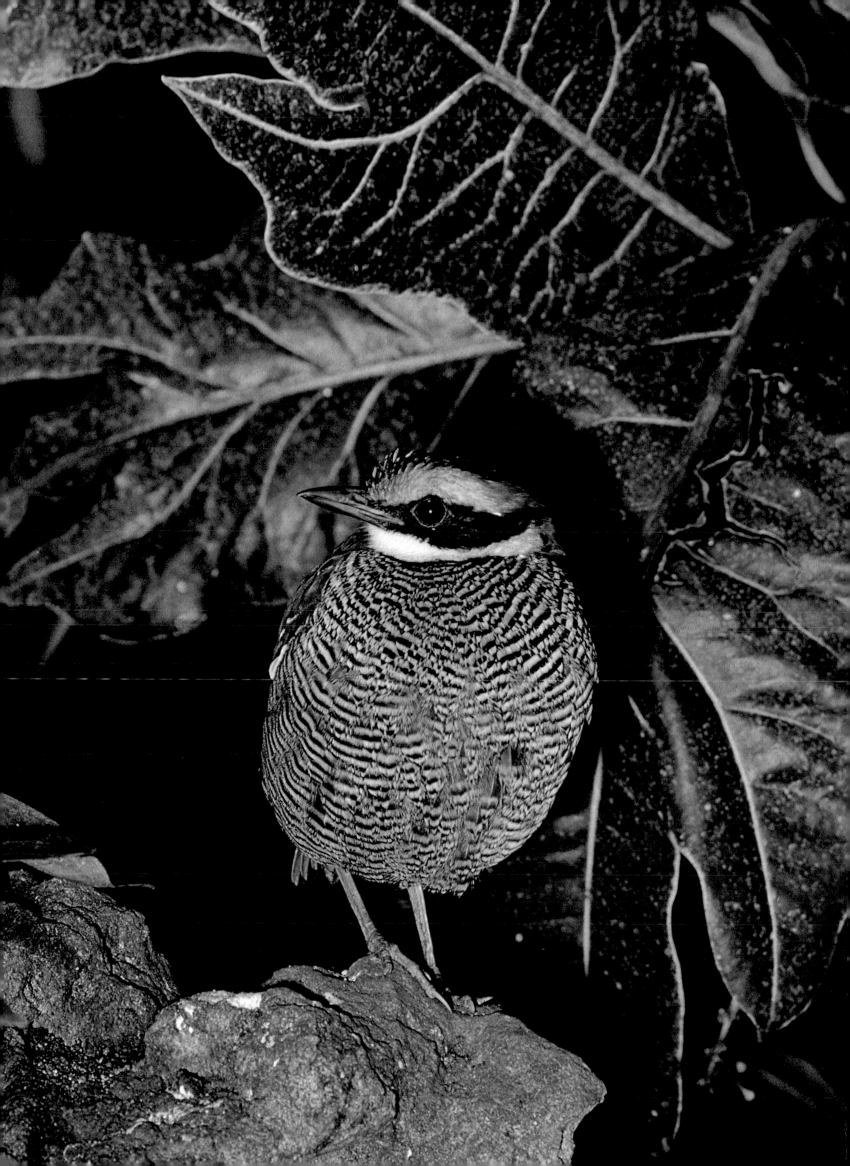

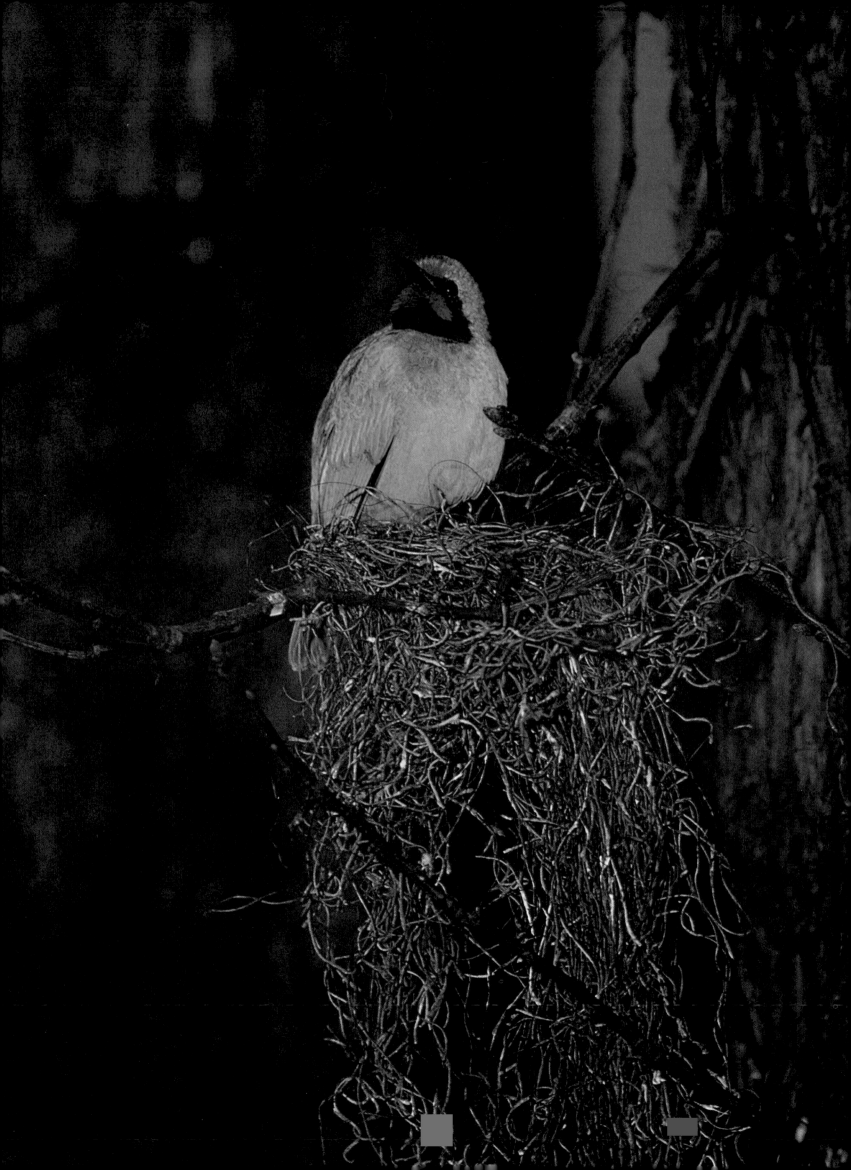

254 *left. The leafbirds of Southeast Asian forests are predominantly bright green, as the name would suggest. Though they are common, gregarious, and noisy birds, they are rarely seen as they forage high in the treetops for fruit and nectar. Typically, the golden-fronted leafbird* (Chloropsis aurifrons), *found from northern India to Sumatra, has a melodious voice and is an accomplished mimic.*

255. *Among the odder birds of the evergreen forests of Indonesia is the green broadbill* (Calyptomena viridis), *a round, chunky bird with an outsized head and feathers that nearly hide the flattened bill. In flight it suggests a bright-green owl. The green broadbill's nest, a gourd-shaped structure hung over a jungle stream, is entered from the side via a doorstep perch.*

256 *overleaf. A ring of white feathers around the eye is the only distinguishing mark of the eighty or more species of white-eyes found from Africa to the Pacific Islands. Typical of these warbler-like birds that live in the forest canopy and eat insects, berries, and nectar is the Japanese white-eye* (Zosterops japonicus).

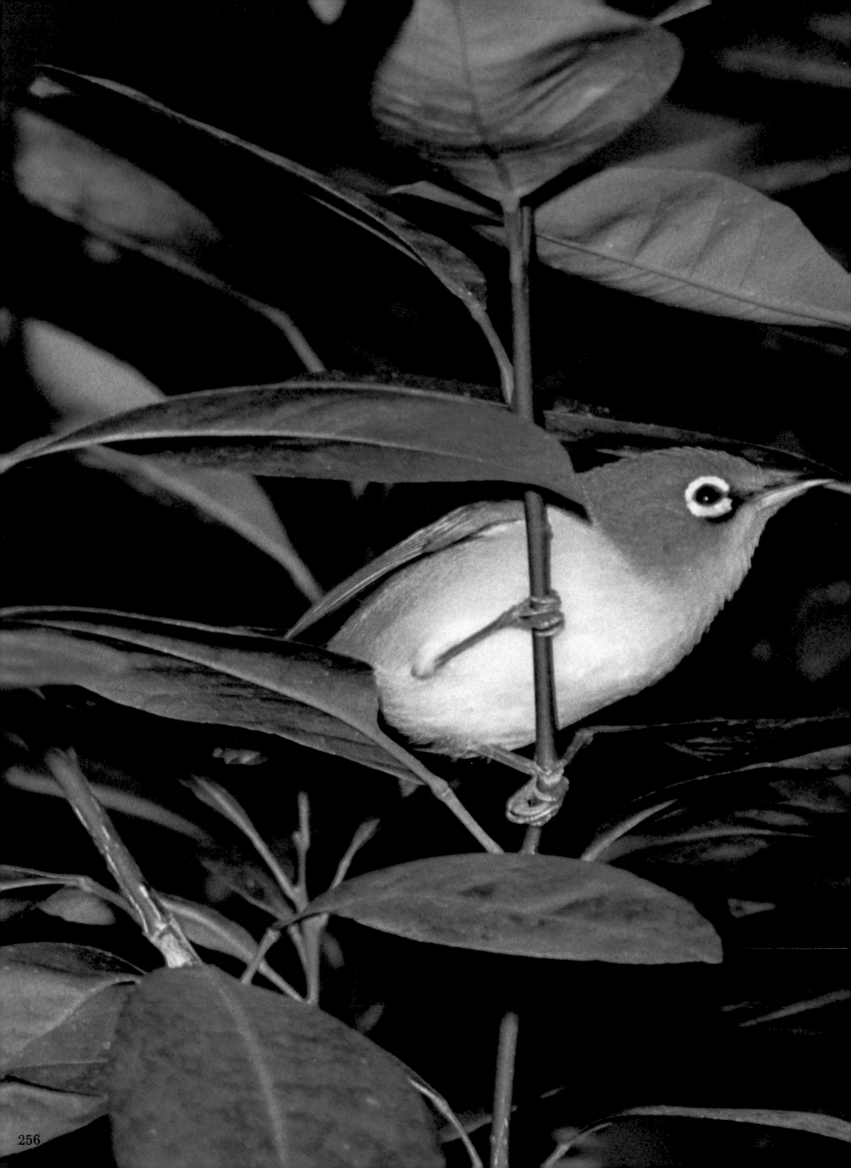

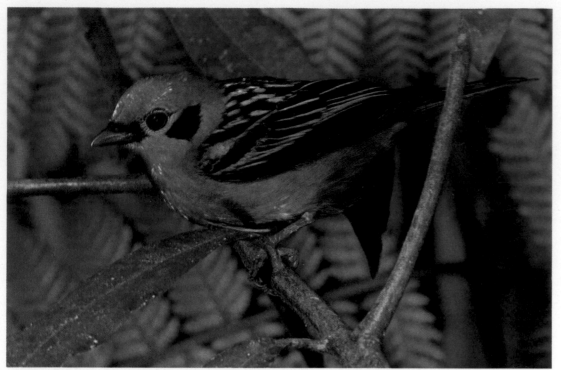

259 *right. Depending on the light, the plumage of the male Brazilian tanager* (Ramphocelus bresilius) *will appear velvety black or brightest crimson. He will bring his mate food while she incubates or, if she is absent from the nest, will present it to the eggs as though anticipating their hatching.*

260 *overleaf. In a West Indian garden bananaquits* (Coereba flaveola) *swarm over the octopus-like branches of a Schefflera shrub, sucking the pulp of the ripe berries. The bill and tongue of this abundant Latin American bird are adapted for nectar-feeding.*

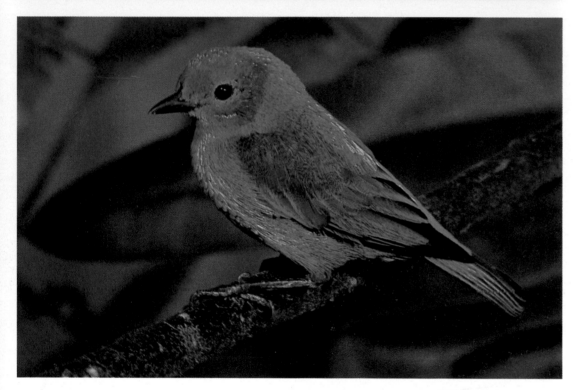

258 *above. Even in the darkest tropical forests of South America, where it often travels with mixed flocks of many other birds, the golden tanager* (Tangara arthus) *stands out. "Tanager" is one of a number of bird names that have been derived from the language of Amazonian Indians.*

258 *below. The beautiful glistening-green tanager* (Chlorochrysa phoenicotis) *may be doomed to extinction because the mountain forests of its limited range, in Colombia and Ecuador, are fast being destroyed. In most species of tanagers, male and female are equally bright-colored.*

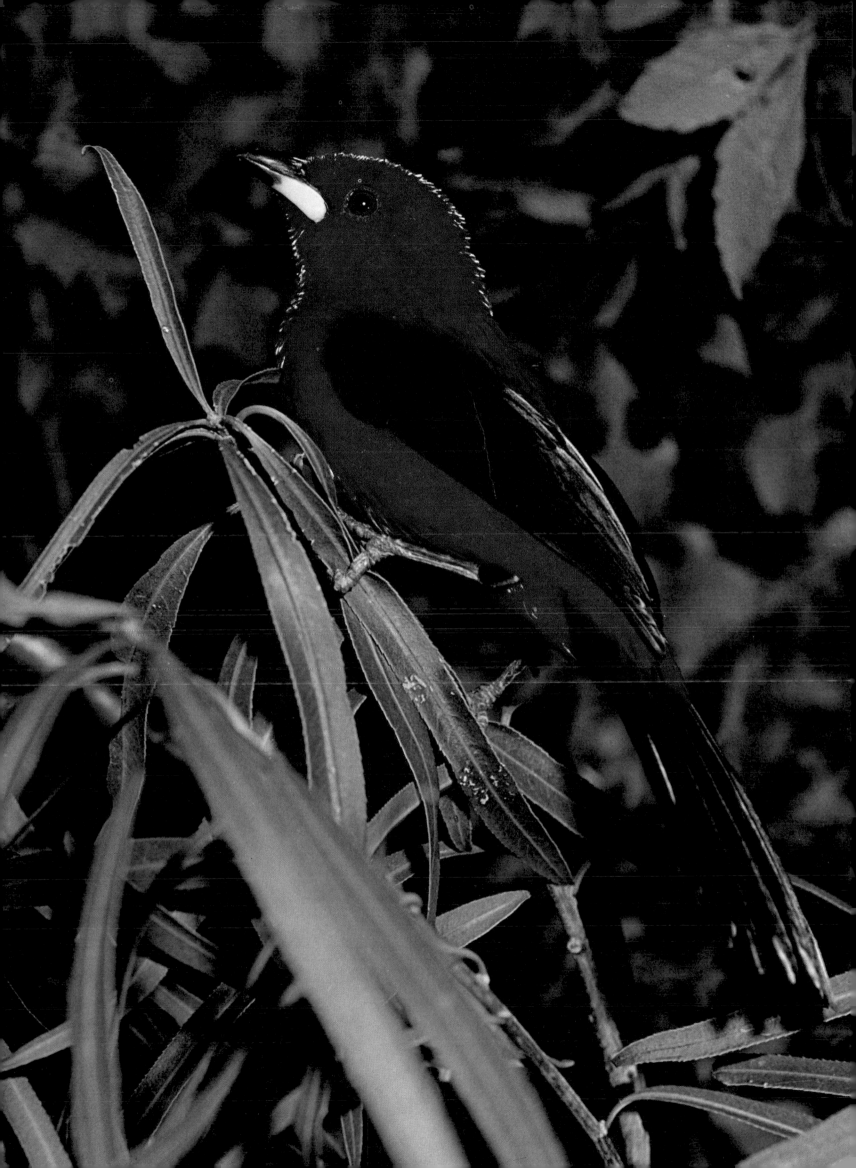

262 *left. Gaudy colors and bold markings are hallmarks of the parrot family, which numbers more than 300 species. The macaws of Central and South America not only are the largest of all parrots, averaging forty inches in length, but are among the most brilliantly colored. With its long tail streaming behind as it flies swiftly across palm groves in the Brazilian interior, the hyacinth macaw* (Anodorhynchus hyacinthinus) *is one of the most spectacular sights of the jungle, where it nests in tree cavities and feasts on palm nuts.*

263. *Since the era of the Incas, the feathers of macaws have been coveted by the Indians of Latin America. As in this green-winged macaw* (Ara chloroptera), *which is widely distributed from Panama to northern Argentina, the plumage often consists of sharply defined patches of solid colors, red or green abutting gold or blue. The powerful and huge macaw bill is used for climbing about treetops and crushing nuts and fruits, and the alarmed screams of tame macaws is said to have saved Caribbean villagers from the raids of marauding Spaniards.*

265 *right. Whenever a cockatoo alights in a tree or becomes alarmed, it erects the crest of long pointed feathers that distinguishes this group of parrots from New Guinea and Australia. The palm cockatoo* (Probosciger aterrimus) *is further distinguished by an enormous projecting bill that can crack the hardest nut; and by bare cheek patches that change color from pink to deep red when the bird is excited. In flight, the great bill is held against the bird's breast. Cockatoos bathe by fluttering among wet leaves in the forest canopy or hanging upside-down in the rain.*

264. *In its threat display, the hawk-headed parrot* (Deroptyus accipitrinus) *of the Amazon Basin erects an imposing collar of red feathers that seem dipped in blue. The courtship display of this medium-size parrot likewise is notable: several birds will fly upward to the same height, glide down on outstretched wings, then swoop back up on rapid wingbeats. Although the hawk-headed parrot feeds and rests in the treetops, it travels through—not above—the forest.*

Songsters in the Woodlands

Before the first ray of light moves among the trees of the woodlands, a solitary voice sounds. It is the first tentative cry of almost any songbird, perhaps a cardinal or a robin, a phoebe or a warbler. But it signals the beginning of a swell of music. The cries and songs of many birds herald the arrival of the new day. The woodlands of the Northern Hemisphere host the largest number of the world's songbirds. They also shelter the greatest number of species of singing birds. The best songs on earth are heard mostly among the trees. The wood thrush's sweet phrases come from the deepest part of the woods. The nightingale's loud eloquence pours out from the embrace of branches and leaves. The red-eyed vireo sings again and again in woods, thousands of songs each day.

The woodlands are a natural place for singing. If the singer chooses to expose itself on a high perch, its sweeping view gives it early warning of enemies. If it chooses to sing in shelter, its enemies find it difficult to attack.

Within the woodlands are countless different environments stretching all around the Northern Hemisphere. They include the thinly treed taiga, which gives way to open tundra in the far north. South of the taiga begins the thicker evergreen forests which, in turn, gradually give way to an intrusion of deciduous trees, leading eventually to the totally deciduous forest masses. Thus there is every opportunity for songbirds to find any kind of shelter that their specialized adaptation demands. Their needs are satisfied by the almost constant changes

taking place within all the woodlands, changes
wrought by fire, disease, storm damage, drought,
torrential rain and flood. The woodlands are a living
mix of trees and insects and birds and songs.
The role of singing is so complex that complete
understanding of its function is not always
possible. Certainly, when a song sparrow spends nine
hours a day singing, it is expending great
amounts of energy, and that may be the function of its
song: to discharge nervous energy. But why it
sings so much and why other birds sing so little is
not explicable.
Songs help birds locate themselves. The pine siskin
gives call notes in the woodlands, where vision
is limited, but is silent in open country. Many birds sing
only until they acquire a mate, then fall silent. There
is a language of bird calls, complex in some
species, simple in others. One call may instruct young
birds to freeze, while another instructs them to
flee. The song sparrow probably identifies itself with
its individual song, and 900 different songs have
been recorded within the species.
Although song has been analyzed, probed and recorded,
it still retains qualities that cannot be measured.
In some experiments songbirds put into their territories
in cages could keep out all intruders just by
singing inside the cages. There is even record of some
caged songbirds, transported into alien territory,
driving out the residents of the territory
with their singing.
Song is thus a tool of the songbird. It helps sort out the
complex rituals of breeding life. It assists in
establishing and defending territory. It helps avoid
fighting, and it speeds the courtship process. It
warns of danger. It threatens, it bonds. Without song,
these birds of the woodlands would be helpless
to function.
Call notes are something quite different. These help birds
warn each other of danger; signal them to flock, migrate
or feed; and indicate sex or readiness to breed. They
are used to indicate distress, concern for young and
a whole gamut of other situations.
Song can be broken down into many different levels.
Primarily song is usually loud and may attract
the other partner or warn birds of the same sex, or it
may serve both functions at once. Then there is
signal song, which appears to help coordinate a pair

that has already mated, but may also be indistinguishable in some species from the primary song. One last category of song, not yet satisfactorily explained, is the loosely designated emotional singing of many birds. It may be an outlet for the bird's excess energy built during the breeding season, but that seems contradictory. The wood peewee sings at twilight, long after breeding is over. Some of the New World flycatchers sing at dawn, also long after breeding is over. Since this is also the molting time for many species, the meaning of the singing becomes a double puzzle, since molting is in itself an exhausting process.

Other contradictions of song abound. Many females sing, some of them better than the males. This seems to prove a connection to sexual activity. The best female singers are often those that do not incubate the eggs, and the males do not sing at all.

To the uninitiated, the flood of song from the woodlands appears to be an incomprehensible mixture of sound, but to the birds themselves it has highly specific meanings. Each song sparrow comes out of the egg with its own individual song. Theoretically, every song sparrow can recognize every other song sparrow. White-breasted nuthatches of the Michigan woodlands have different calls from those in the Chisos Mountains of Texas. The white-crowned sparrow of the western United States has different songs from one local population to another. Of course, it must be true that the birds themselves can recognize the voice, or the song style, of the bird to which they are mated.

Less easy to understand is the role of mimicking. It is quite common, although nobody is quite sure why some American mockingbirds seem to mimic more than similar mockingbirds in other regions. In Michigan woods a mockingbird can imitate the bobwhite quail, great-crested flycatcher, titmouse, wood thrush, blue jay, oriole, scarlet tanager and goldfinch. Whatever the reasons, many of the best mimics live in the woods and are strongly territorial.

The strong assertive singing of a robin may mask other more beautiful sounds. A soft warbling song, running up and down a melodic scale, reveals a purple finch, its wings drooped and vibrating like that of a hummingbird as it tries to court a female with some nesting material in its bill.

There is competition in song. Two purple finches chase a female, both of them singing furiously. They spread wings and tails, dance up and down and pour out their songs with great passion and intensity.

Song is ambiguous. Some birds sing only at certain times of day, others throughout. Some sing only in the evening. The red-eyed vireo can sing more than 20,000 songs a day. Many birds commonly sing thousands of songs every eighteen hours.

Some day birds also sing at night, particularly the mockingbird, nightingale, willie wagtail, yellow-breasted chat and many others. Some birds sing while they are incubating, notably the rose-breasted grosbeak of the northern woodlands.

For all the puzzles of birds song, there are some comprehensible measurables. Birds of the forest have deeper, richer and more melodious voices, and their songs can deeply penetrate foliage and shrubbery. Grassland birds, on the other hand, have higher pitched voices that carry well in the open but not so well in cover. Environment may therefore be one of the main keys to the abundance of good singing in the woodlands.

Whatever the contradictions, song pouring out of the woodlands delights the human ear with its sheer diversity. No other group of animals has evolved such a variety of sounds, such beauty of vocal expression, and that is the essential wonder of this group of birds.

The songbird is enshrined in the literature and poetry of man: "Hark! how the cheerefull birds do chaunt theyr laies" as Spenser put it. They will always play a vital part in communicating directly to all humanity the wonder and mystery of wildlife in general, of birds in particular.

Happily, many songbirds have come out of their secretive places to join man in what appears to be a mutuality of safety. The wood thrush, one of the shyest of the woodland birds, has deliberately moved closer to towns, farmhouses, villages, and even into suburbs of cities. Here its enemies are repelled by the presence of man. The thrush may display itself more boldly and be heard more clearly. The rose-breasted grosbeak, robin, grackle, phoebe and many sparrows cluster their nests near farmhouses.

Their songs speak a language that is universal.

271. *Bristling with quill-like feather tubes, a six-day-old black-billed cuckoo* (Coccyzus erythropthalmus) *begs for a katydid offered by one of its parents. In a day or two, having yanked off the tubes with its own bill to free its juvenile feathers, the young cuckoo will leave its fragile nest platform and clamber about the pine branches. There are 127 species of cuckoos distributed through temperate and tropical habitats, and many of them—including all forty-two species in one Old World subfamily—are parasitic, depositing their eggs in the nests of other birds. The two cuckoos most commonly seen in North America, the yellow-billed and the black-billed, only occasionally resort to such tactics, which lead to the death of the foster bird's own offspring.*

272 *overleaf. The rosy-red plumage of a male summer tanager* (Piranga rubra) *glows amidst the bright green of new cypress needles in a Louisiana swamp. The 222 species in the tanager family are exclusively New World in distribution, and except for four migrant species that breed in the temperate forests of North America, they are also exclusively birds of the tropics and subtropics. Birdwatchers who have little opportunity to visit those regions are truly unfortunate, for tanagers are the most beautifully colored of all songbirds, boldly patterned with reds, oranges, yellows, purples, greens, blues and black and white. The summer tanager, which nests in dry open woodlands, certainly shares those showy colors but does not advertise its presence: its song attracts little attention, and it keeps to the leafy heights where it snatches insects on the wing.*

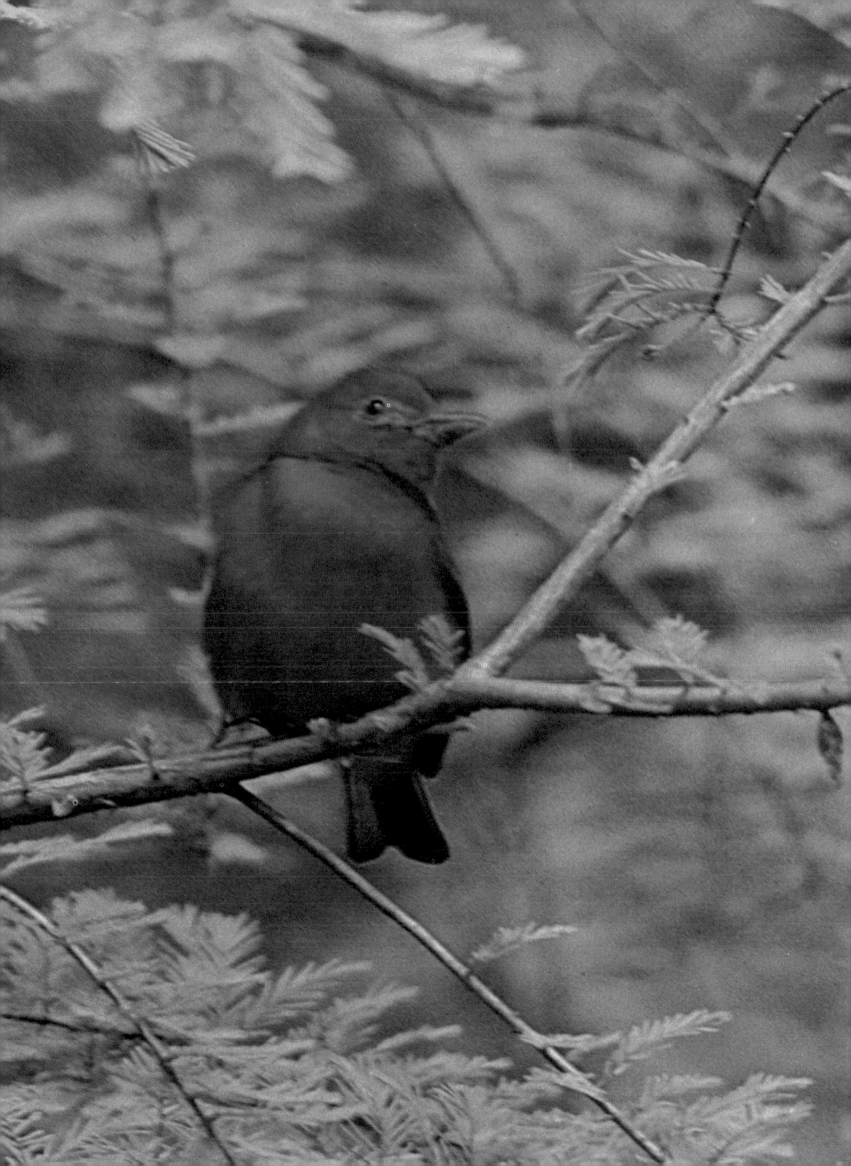

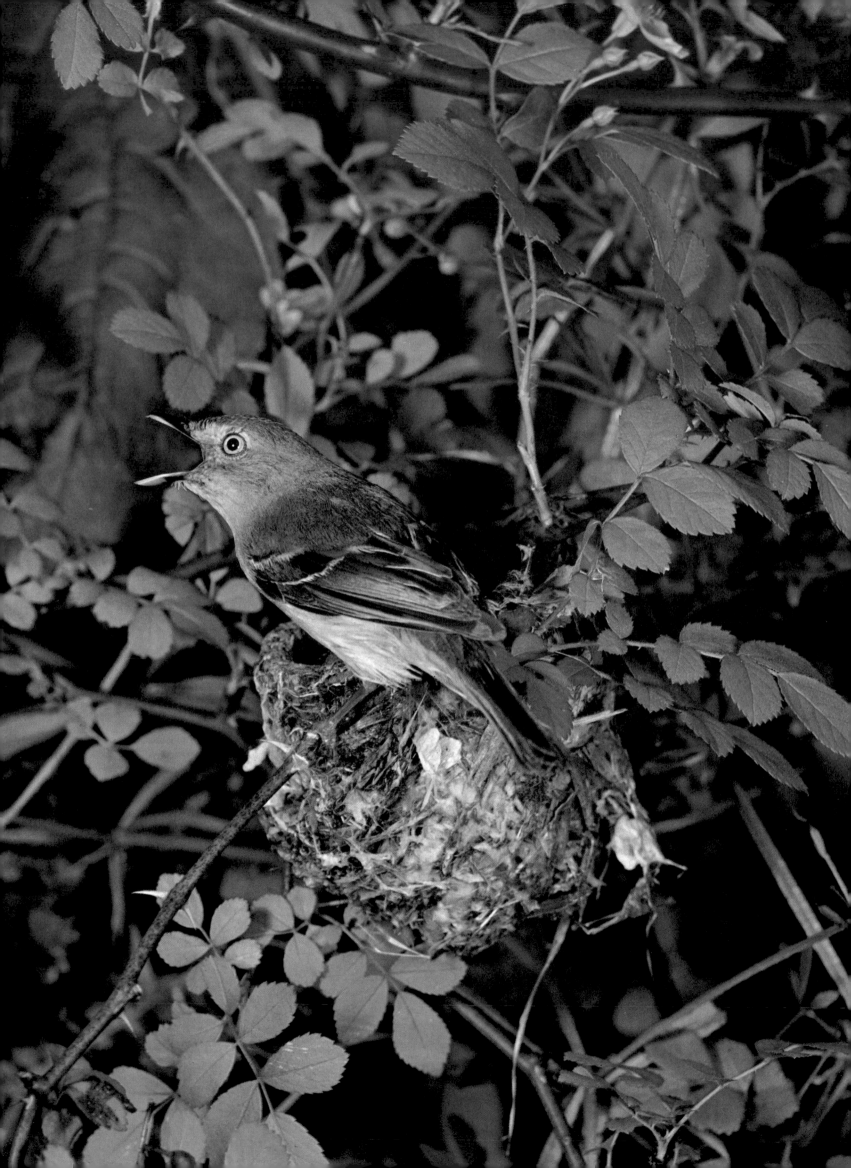

274 *left. A forked branch in a bramble tangle supports the nest of a white-eyed vireo* (Vireo griseus)— *a cup woven of shreds of bark, woody fibers and grass, held together with spider webs and decorated with moss, lichens and paper from wasp nests.*

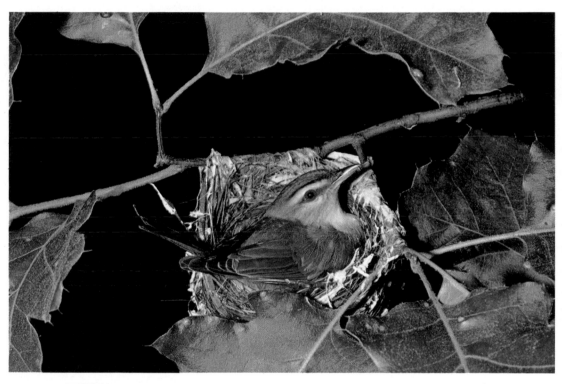

275. *Distributed from Canada to Argentina, vireos are drably garbed in greens, yellows, browns and grays, and they are also mediocre singers. Persistence is another matter. For instance, the red-eyed vireo* (Vireo olivaceus) *sings nonstop from dawn to dusk all spring and all summer, pausing only long enough to pluck insects from leaves. One equally persistent ornithologist counted the songs sung by one red-eyed vireo in a single day. The astonishing total was 22,197, more than 1000 songs every hour during a twenty-hour June day.*

276 *overleaf. Tossing aside a leaf with its bill, a marsh tit* (Parus palustris) *rummages for food in an English woodland. In harsh winters the marsh tit survives on food that it* stored away the previous autumn. Its hoards are hidden under bark, among pine needles or in the ground.

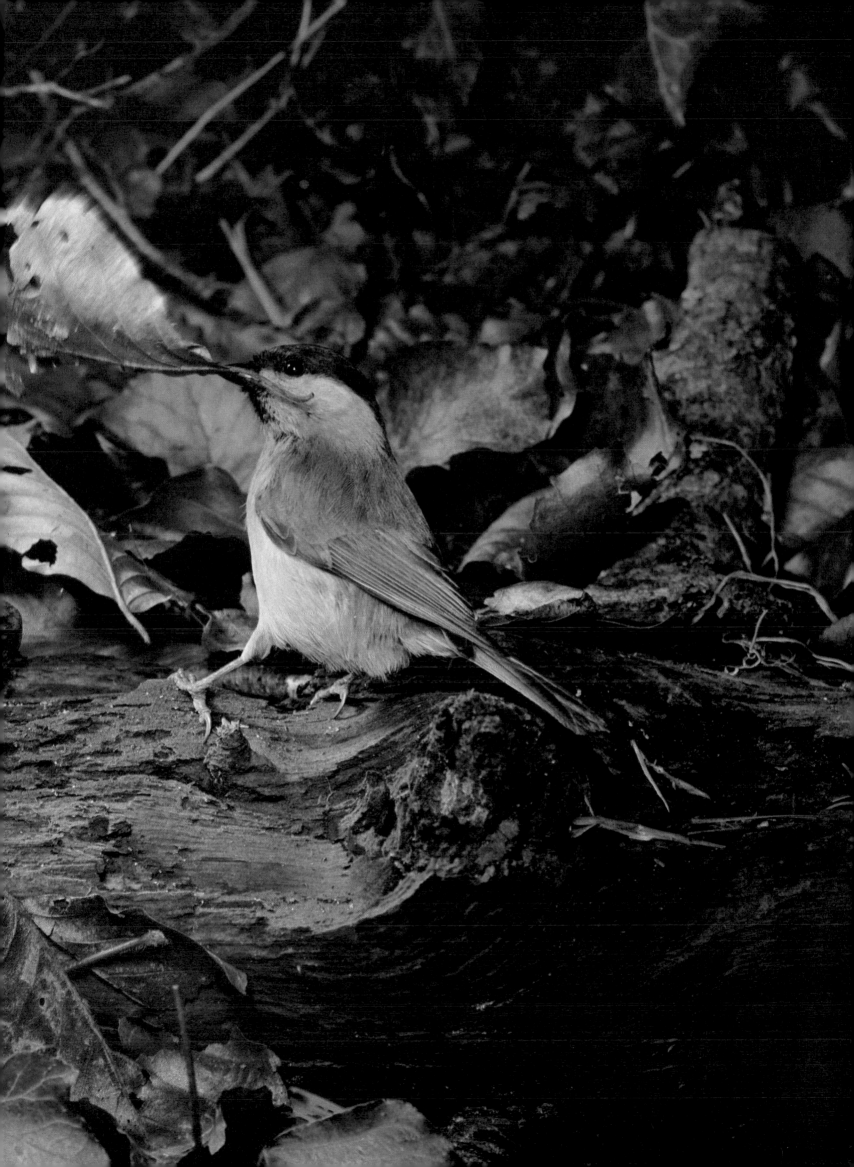

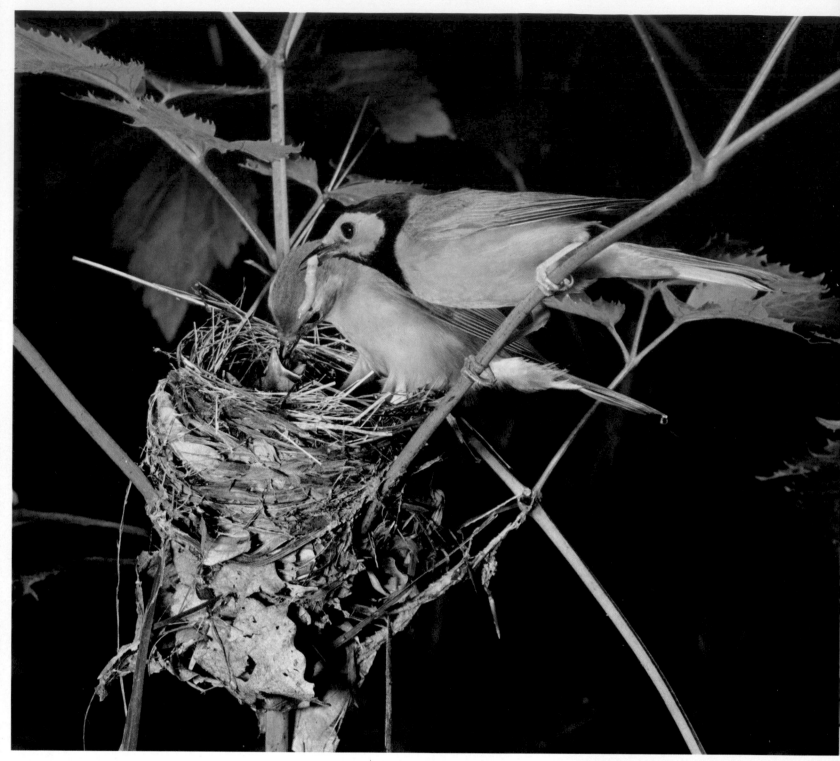

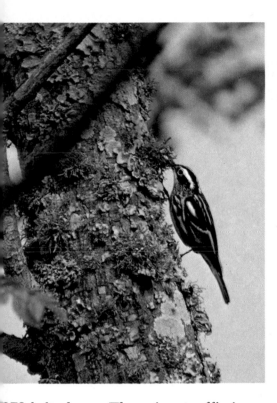

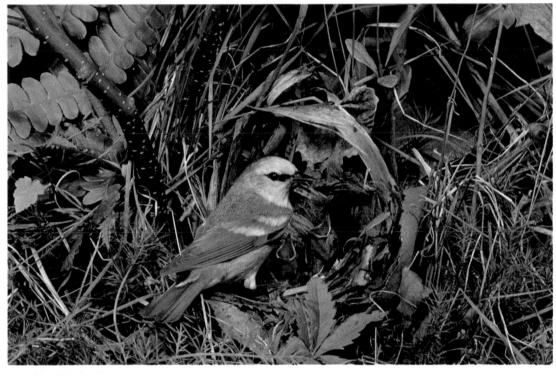

278 *left above. There is a traffic jam at the nest of a pair of hooded warblers* (Wilsonia citrina) *as both parents, the male distinctly marked with a black hood, arrive simultaneously with food for their nestlings.*
278 *left. Begging for food, young olive-sided flycatchers* (Nuttallornis borealis) *crowd their nest in a Michigan spruce bog. This flycatcher's song, clearly translated as "Quick three beers," can be heard for a mile.*
279 *above. Among the American wood warblers, the black-and-white warbler* (Mniotilta varia) *is unique, for it climbs about trunks and branches like a nuthatch or creeper, probing the bark for insect pupae and eggs.*

279 *above right. Bark shreds from wild grape vines are a distinctive component of the ground-level nests of the blue-winged warbler* (Vermivora pinus).
280 *overleaf. Although widely disliked because of its bullying tactics at winter bird-feeders and its egg-stealing habits, the blue jay* (Cyanocitta cristata) *is unquestionably one of North America's handsomest birds. The blue jay also has a large repertoire of quite musical calls that surprise people familiar only with its raucous jeers.*

282 *left. When spring or fall migration is in full swing, one of the best places to find a variety of birdlife is a forest niche with fresh-flowing water and perhaps a small cataract. Bathing in a moss- and fern-edged pool in the Appalachian Mountains of Virginia is a male rufous-sided towhee* (Pipilo erythrophthalmus), *whose song in spring orders everyone within hearing: "Drink your tea." The towhee is heard more often than seen, for it keeps mostly to the ground, digging through the dead leaves to find the rich insect life of the forest humus.*

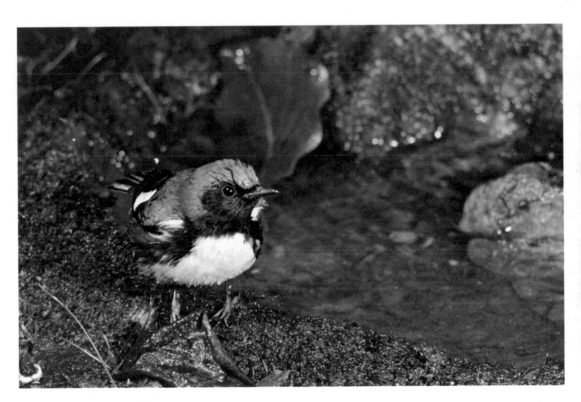

283. *A woodland spring lures a male black-throated blue warbler* (Dendroica caerulescens), *a five-inch tuft of beauty that one ornithologist described as "neat but not gaudy." On migration, the black-throated blue warbler is just as likely to appear in a city park or suburban garden as in the deep forest. And it is so tame that one can approach much closer than any binoculars can focus, leaving no question about its identification.*

284 *below. For most of their brief stay in the nest—a period of two weeks—young mourning doves (Zenaidura macroura) feed on an extremely nutritious liquid called pigeon's milk, which is secreted by the lining of their parents' crops. The milk, which bears a chemical resemblance to the milk of rabbits, is pumped up from the crop so the young doves can feed merely by inserting the tips of their bills into the base of the adult's bill. The mourning dove breeds across North America, from the edge of the tundra south, in nearly every kind of habitat except dense forest. Using the same nest, it will raise several broods a year.*

285 *right. Highly adaptable in its choice of nesting sites, the eastern phoebe (Sayornis phoebe) plasters its cup of mosses, grass and mud to any suitable natural or man-made niche —a windowsill, a ledge over a door, a barn rafter, a railroad trestle or a bridge girder. In this case it has chosen a mossy ledge in a rocky ravine, where the male phoebe is bringing food to his incubating mate. By tying silver thread to the legs of phoebes, John James Audubon discovered long before bird bands were developed that these North American flycatchers return each year to the same nesting place.*

286 *overleaf. As one would expect from a bird named for a musical instrument, the superb lyrebird (Menura superba) of Australia's temperate zone rain forests and scrublands is one of the bird world's most accomplished singers. Like the mockingbird of North America, it is an extraordinary mimic. Standing atop one of the four-foot-wide mounds of soil he rakes up in his half-mile-wide territory, the male runs through a repertoire that includes exact imitations of a score of other birds' songs, intermixed with his own rich, clear notes. And if civilization is nearby, he may include the sounds of farm animals, chainsaws, or vehicle horns. But the lyrebird does not owe its name to its remarkable vocalizations. Rather, at the end of his performance he expands and raises his tail and for a moment it forms a perfect lyre, the curved outer tail feathers, two feet long, supporting the "strings"— six pairs of quills whose lacy vanes veil the bird's body from view.*

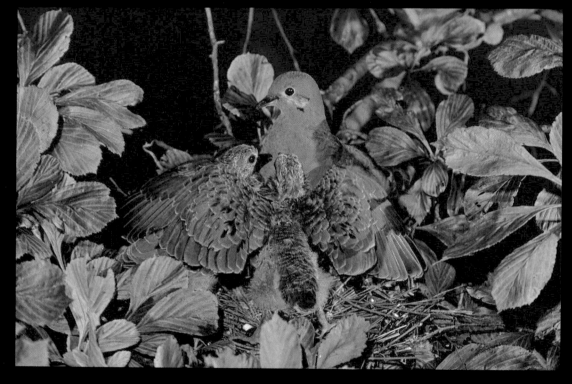

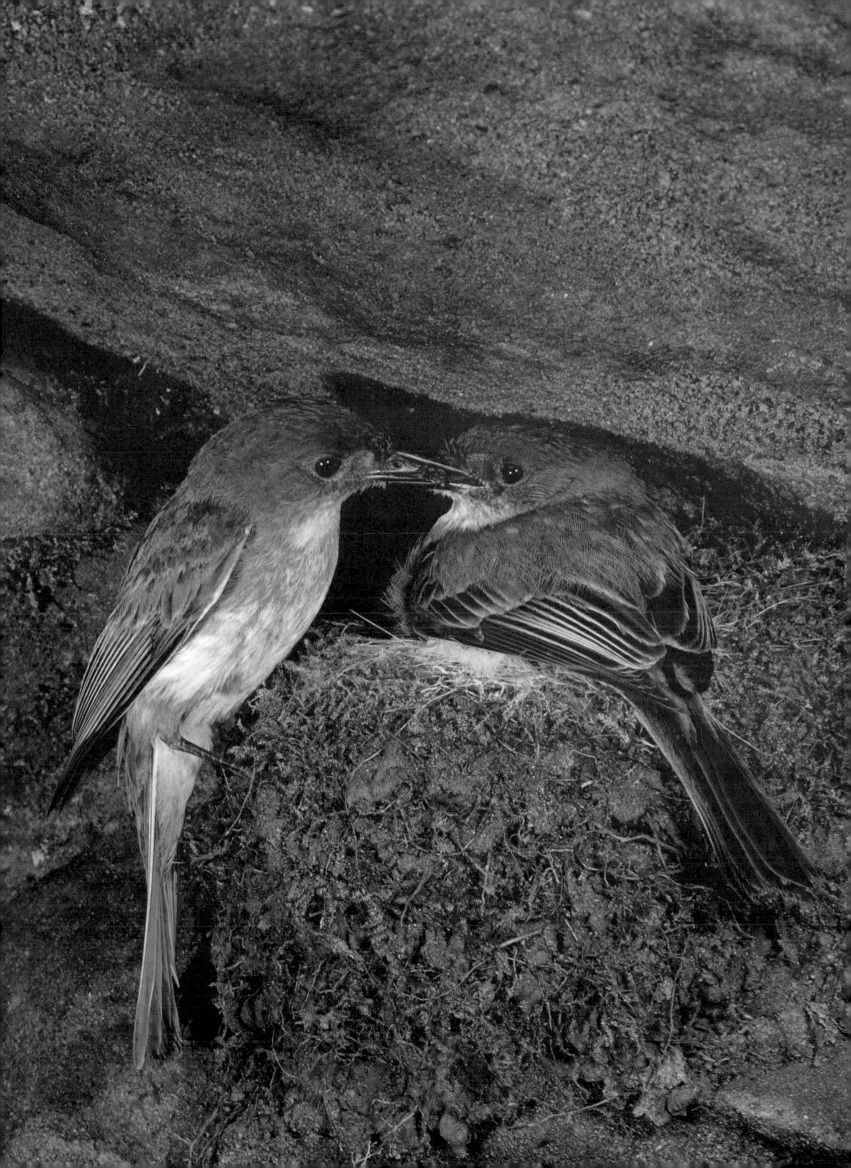

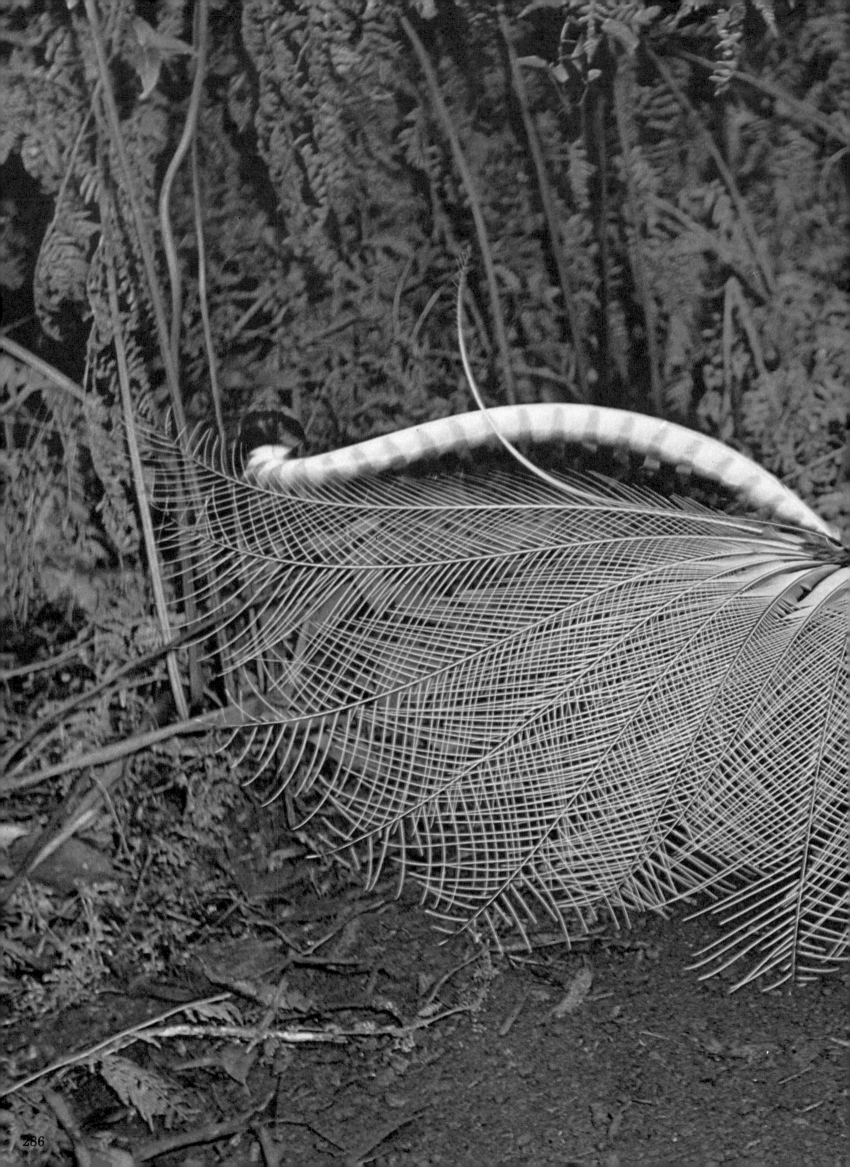

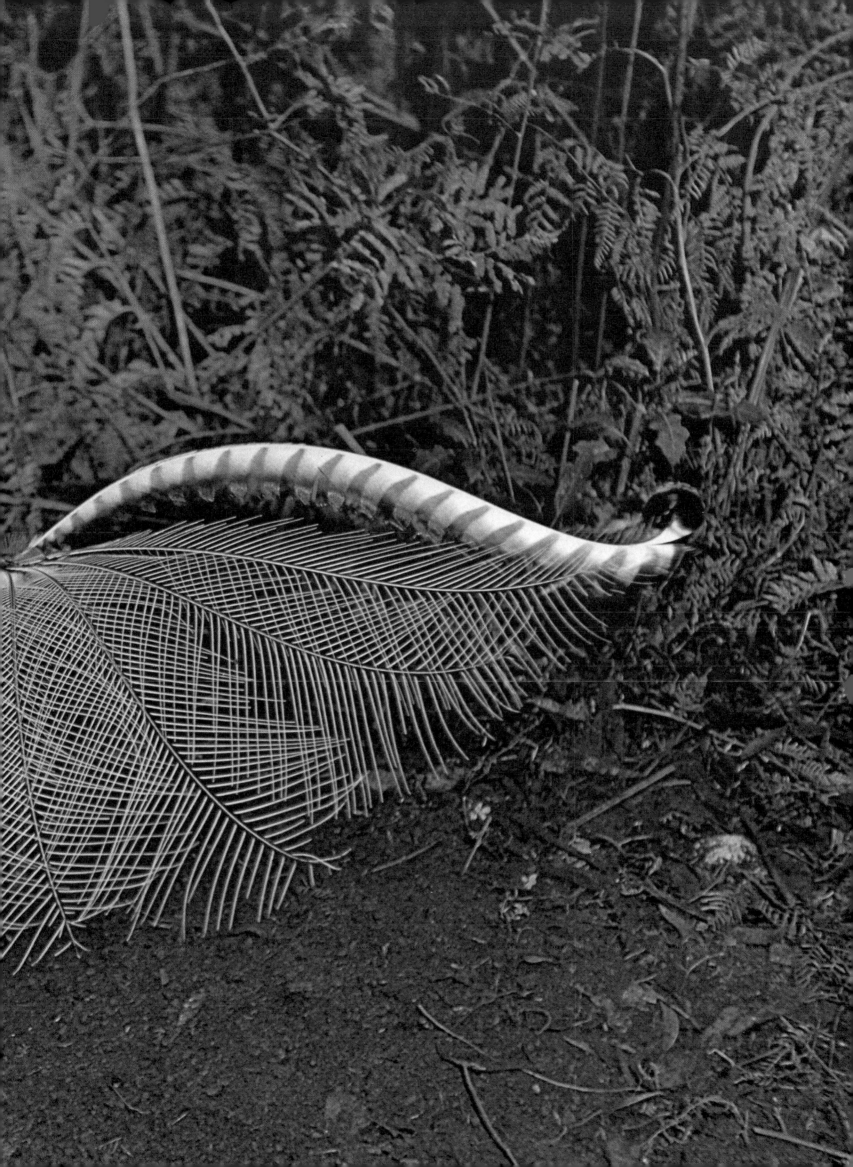

Notes on Photographers

Ron Austing (212), a county park ranger in Ohio, is known for his photographs of birds of prey. He is the author of *The Red-tailed Hawk* and *I Went to the Woods*.

Bob Barrett (198 above) traded his bicycle for binoculars a few years ago and moved to Missouri's countryside. His photographs of birds in their natural habitats have appeared in *National Wildlife, Audubon* and the Time/Life Wilderness Series.

Jen and Des Bartlett (168, 209) are Australians known for wildlife films (including the notable *Flight of the Snow Goose*) and stills made on every continent.

David C. Berta (275) makes his photographic debut in these pages. A science teacher in South Bend, Indiana, he uses his hobby, photography, as an aid in his classes.

R. M. Bloomfield (227 above left, 228) emigrated from the United Kingdom to Rhodesia after World War II. He now lives in South Africa where for the past 27 years he has pursued his hobby, bird photography.

Douglas Botting's (54) work has appeared in numerous international publications. He is author of *Humboldt and the Cosmos* and *Pirates of the Spanish Main*.

Stanley and Kay Breeden (246) are Australian wildlife photographers whose work has appeared in *National Geographic* and *Audubon*. The first two of their outstanding four-volume series *A Natural History of Australia*, have been published, and the third, *Australia's North*, is on the way.

Fred Bruemmer (34) was a newspaper photographer and reporter in Canada before becoming a freelancer specializing in the Arctic. He has written 300 articles and four books, including *The Arctic*.

Sonja Bullaty and Angelo Lomeo (126 above) are a husband-wife team whose picture essays have appeared in *Life, Horizon* and various wildlife books. She was born in Prague, Czechoslovakia, he in New York.

Leslie Campbell (239, 240, 279 right) has long been a photographer of nature subjects. He is the organizer of several major photographic conferences, including those at the University of Massachusetts and Mt. Holyoke College.

James H. Carmichael, Jr. (71, 109 below, 128, 177, 181, 262, 265) has been represented in many books and magazines, including *National Geographic* and *National Wildlife*. He teaches nature photography at the University of South Florida in Sarasota.

Jon Cates (163), a writer and art collector as well as photographer, has written articles and photographed wildlife for national magazines, and has recently completed a book on the wildlife of North America.

Arthur Christiansen (30, 120, 121 both) is a Danish nature photographer whose special interest is birds in action. Thousands of his photographs have appeared in books and magazines throughout the world. He has also prepared educational films for television.

Lois Cox (37) is part of a husband-wife team from Duarte, California, whose photographs have been published in *National Wildlife* and *Ranger Rick's Nature Magazine*.

Stephen Dalton (182, 244) studied photography in London. His illustrations have appeared in numerous books and magazines. His latest work, *Borne on the Wind*, deals with flying insects.

Thase Daniel (25, 28 below, 36 all, 51, 52, 65, 68 below, 69, 70, 122, 126 below, 227 below center, 260, 272, 279 left), born in Arkansas, first taught music but has since devoted herself to photographing animals and especially birds on various continents. She has contributed to many wildlife magazines and books.

Edward R. Degginger (29, 84, 88 right, 256) is both professional chemist and photographer of wildlife. Over 3200 of his pictures have appeared in exhibitions, books, magazines and encyclopedias.

Jack Dermid (237) is an associate professor of biology at the University of North Carolina. He is co-author of *The World of the Wood Duck* and is presently making a motion picture on salt marsh ecology.

Tui De Roy's (94, 106 above) family moved from Belguim to the Galápagos Islands when she was a baby. Her unique opportunity to explore the islands' animal and plant life has resulted in articles and photographs in many publications.

Larry Ditto (66) is a wildlife refuge manager for the U.S. Fish & Wildlife Service. His photographs have appeared in many outdoor and conservation publications. He is also a freelance writer.

Hans Dossenbach (85 all, 217, 227 above center, 227 below right, 263) was born in Switzerland and studied animal behavior in Vienna and photography in Zurich. He is the author and photographer of twelve books, including *The Family Life of Birds*.

John S. Dunning (258 both), author of *Portrait of Tropical Birds*, hopes his photographs will help protect and save tropical forest birds. He is on the administrative board of the Cornell Laboratory of Ornithology.

Francisco Erize (106 below, 107, 141 below right, 210 left and below, 264) lives in Argentina and has photographed wildlife in South American jungles, the Galápagos and Antarctica. His photographs and articles have appeared in many wildlife publications, including *International Wildlife*.

Kenneth W. Fink (45, 190, 191, 196, 230), a former Kansan, is a teacher in San Diego, California. His photographs have appeared in publications worldwide.

M. P. L. Fogden (253, 255) has done wildlife research in England, Borneo, Uganda and Mexico. Photographs taken in these countries have appeared in many publications and in *Animals and Their Colours*, a book he co-authored with his wife.

Clem Haagner (50, 166) is a South African poultry breeder whose hobby is photographing wildlife. His work has been widely published, and he has prepared a book on the Kalahari Desert.

Brian Hawkes (28 above), a writer and field naturalist, uses his photographic talent to illustrate lectures he delivers around the world.

Peter Hinchliffe (276) became interested in wildlife photography while working as a woodsman in Derbyshire. He is a Ministry of Defence photographer and teaches photography at the Buckinghamshire College of Higher Education.

George Holton (78, 80, 87 both, 88 left, 142, 143 both, 144, 145, 148, 149, 218) is a New York photographer specializing in natural history, archaeology and primitive peoples. Photographs taken on his worldwide travels, including Antarctica and the Galápagos, have appeared in many publications. Among his recent books is *The Human Aviary*.

Joseph R. Jehl, Jr. (146) is Curator of Birds and Mammals, Natural History Museum, San Diego, California. His research has taken him from Arctic Canada to Tierra del Fuego, and his photographs have been reproduced in many scientific and popular publications.

Isidor Jeklin (178), Canadian naturalist and wildlife photographer, has won top honors in international exhibitions. His pictures have been reproduced on posters, calendars and in publications around the world.

Peter Johnson (101, 150, 226, 242 right), wildlife journalist and a conservation officer in South Africa, has traveled widely to cover all aspects of nature. His articles have appeared in journals throughout the world.

M. Philip Kahl's (32 above, 38, 46 both, 47, 48, 56 right, 58, 68 left and above) work has been reproduced in many books and publications including *National Geographic* and *Audubon*. Research grants from the

National Geographic Society have assisted in his study of storks and flamingos of the world.

Peter B. Kaplan (169) specializes in nature and wildlife photography, and has had a National Endowment for the Arts grant in the field of architecture. His photographs have appeared in *Audubon, National History* and other magazines.

G. C. Kelly (140 above, 141 below left) lives in Alaska where he has been photographing wildlife since 1966. *Audubon, National Geographic, National Wildlife* and the Sierra Club have reproduced his work in books and calendars.

Fred L. Knapp (32 below) spends most of each year in Maine. His photographs decorate the regional offices of Eastman Kodak, and his work has appeared in *Audubon*.

Carl Kurtz (130, 225), whose specialty is prairie botany, lives in Iowa where he freelances for national publications. He is a naturalist, writer, photographer and part-time farmer.

Cyril Laubscher (57, 124 above, 216, 227 above right, 242 left, 243) specializes in bird photography. He lives in South Africa and his work has appeared in numerous publications, including the *Encyclopaedia Britannica*.

George Laycock (77), writer, photographer and Field Editor of *Audubon*, has been photographing for magazines and books for more than 25 years. Most of his 30 books have been illustrated with his own photographs.

Les Line (82 both, 83, 86, 89, 105 both, 108 left, 117, 118, 127, 137, 138, 140 below, 141 above right and left, 213), born in Michigan, won many prizes for news photography and conservation reporting before becoming editor of *Audubon* in 1966. The magazine has since become known for its excellent graphics, color photography and environmental reporting.

S. D. MacDonald (104, 200, 201 above) is curator of vertebrate ethology at the Museum of Natural Sciences in Ottawa. His pictures have been reproduced in *Nature Canada, Life* and *Audubon*.

Geoff Moon (92, 109 above), a veterinarian, was elected an Associate of the Royal Photographic Society of Great Britain for his photographs of British birds. He lives in New Zealand and produces movies and writes books on New Zealand wildlife.

Michael Morcombe (93), naturalist, photographer and writer, has developed techniques for photographing shy, rarely seen bush life. He has written several books, including *Wild Australia, Australia's Western Wildflowers* and *Birds of Australia*.

Norman Myers' (170, 214) work has appeared in scores of books and magazines in 23 countries. He is a roving editor of *International Wildlife* and author of *The Long African Day*.

Harvey A. Pengelly (202, 284) studied zoology at the University of Guelph in Ontario, Canada, and photography at Rochester, New York. His major interest is Canadian wildlife.

S. C. Porter (10), a retired chemical engineer, devotes most of his time to freelance nature photography. His travels have taken him from the Orkney Islands to Ethiopia, from the Canadian Rockies to Florida.

Hans Reinhard (189) lives on a small farm outside of Heidelberg with his family and a host of wild animals. He is author of *Die Technik der Wildphotografie*.

Hector Rivarola's (259) photographs of birds have been published in England, South Africa, Spain, France and the United States.

Len Robinson (286) is an Australian wildlife photographer and nature-tour guide. He has worked on wildlife documentaries for television, and is author/photographer of *Australian Parrots in Colour*.

Richard D. Robinson's (164) photographs of birds have been appearing in books since 1941. He was granted the Fellowship of the Royal Photographic Society in 1963 for his bird photographs.

Allen Rokach (108 right, 110) teaches photography at the American Museum of Natural History and the New York Botanical Garden. He is a geologist and has contributed articles and photographs to leading periodicals.

Edward S. Ross (108, 210 right), Curator of Entomology at the California Academy of Sciences, pioneered in candid insect photography in his *Insects Close Up* (1953). He has photographed nature in almost every part of the world. His work has appeared in many publications, including those of Chanticleer Press and the Audubon Society.

Charles W. Schwartz (194-195 all) has been associated for 36 years with the Missouri Department of Conservation as biologist, motion picture photographer, wildlife artist and author. He has received international recognition for his work.

Perry Shankle's (192) photographs have appeared in *Field & Stream*, *True* and *National Geographic*. He lives in Texas and has prepared wildlife films for Texas and Ohio public schools.

Caulion Singletary (56 left, 90-91 all), a Floridian, is a printer by trade. Photographing nature, and especially birds, has long been his main avocation. His work has appeared in major nature publications.

M. F. Soper (238) is a physician. His principal photographic interest is birds of the subantarctic, and he has participated in many wildlife expeditions to the subantarctic islands.

Alvin E. Staffan (274, 278 above, 285) is both nature artist and photographer for the Ohio Department of Natural Resources. His photographs appear in many magazines, books and encyclopedias.

Philip Taylor (201 below) is a biologist who spends most of his time researching birds in the Canadian Arctic. His photographs appear in publications in the United States and Europe.

Mary Tremaine (124 below, 125) is associate professor of Medical Microbiology and Director of the Antibiotic Laboratory, University of Nebraska Medical Center. She has contributed photographs and articles to such publications as *Audubon* and *Petersen's Photographic*.

John Trott (280, 282, 283) began photographing birds in North Carolina at an early age. His work appears in a variety of National Geographic publications.

Frederick Kent Truslow (157, 158, 227 below left, 229, 242 center), a former businessman, is a specialist in North American bird behavior in the wild. He has produced both photographs and text for two books and numerous articles for *National Geographic*. His work has also appeared in *Audubon* and *National Wildlife*.

Larry West (33, 278 below) is a nature photographer whose pictures have appeared in many books and magazines, and he has lectured on photography. He lives beside a woodlot near where he was born in Mason, Michigan.

Gus Wolfe (160, 162) lives in Montana where for the past 5 years he has studied and filmed the high plains birds of prey. He has sold pictures to *National Geographic*, Time/Life books and Sierra Club publications.

Michael Wotton (102) grew up in England and now lives in the Pacific Northwest where he is associated with the Weyerhaeuser Company's Forestry Research Association. His bird photographs have appeared in the publications of Chanticleer Press and the Audubon Society.

Gary R. Zahm (2, 4, 6, 26, 211) is a freelance wildlife photographer/writer based in the southwestern United States. His action photographs have been included in many travel and outdoor publications.

Leonard Zorn (271) emigrated from Austria to Canada in 1955. His specialty is bird photography, and he has won many awards in international exhibitions.